I learned so much about the artists in *Van Gogh Has a Broken Heart* that I hadn't known before—the perseverance and long-suffering of Artemisia Gentileschi and the civil rights advocacy by Norman Rockwell—but it was the way Russ Ramsey personally opened up about the paintings that allowed me to see them better. To read this book is to hover over the shoulder of Picasso, share a drink with Gauguin, and suffer heartbreak with van Gogh. You don't want it to end.

JESSICA HOOTEN WILSON (PhD, Baylor University), the Fletcher Jones Chair of Great Books at Pepperdine University

You might be an art expert who can see an entire history in a Rembrandt painting, an amateur who can't tell the difference between van Gogh and Van Halen, or somewhere in between. In any case, you will find in this book the best kind of education—the kind that doesn't feel like education at all. In classic Russ Ramsey fashion, the storytelling is gripping and the insights are surprising. After reading this, you will walk into your next museum, or gaze up at the night sky outside it, with very different eyes.

RUSSELL MOORE, editor in chief, *Christianity Today*

Russ Ramsey is a gifted storyteller, a keen student of human nature and a genuine art connoisseur. In *Van Gogh Has a Broken Heart*, Ramsey makes classic artists relatable, building a bridge of empathy across time. He also helps readers discover for themselves the power of visual art as a channel for tackling big questions of meaning, injustice, and suffering in a broken world.

DR. KATIE KRESSER, professor of art history, Seattle Pacific University

Russ Ramsey takes us beyond the canvas to the very human stories behind it. I found myself teary at some point in every chapter. He respectfully sheds light on the shadowy parts of artists' lives, as well as his own, making the reader feel less alone.

LAUREN CHANDLER, author, singer, songwriter

The gift this book gives us is the rare opportunity to slow down and simply look at the images that have shaped our visual world. If you wonder what the legacy of our world's visual culture might tell us about each other and ourselves, then *Van Gogh Has a Broken Heart* is for you.

JOHN HENDRIX, *New York Times* bestselling author and illustrator of *The Faithful Spy*

Russ Ramsey is a master storyteller who weaves together the stories of some of the world's greatest artists, whose lives are marked by both hope and suffering. He reminds us that, although "wonderful and terrible things happen in this world," the beauty of the gospel is everywhere if we just keep looking.

WINFIELD BEVINS, artist, author, director of Creo Arts

You approach Russ Ramsey's writings expecting to learn about art and artists, only to realize he has flung open a window to your own deepest griefs, hopes, and longings. Ramsey's essays are highly entertaining and informative, yes, but in the end they reveal themselves as hospitable invitations to get to the transcendent heart of things.

DOUGLAS MCKELVEY, author of *Every Moment Holy*

The large questions of art are the large questions of life. *Van Gogh Has a Broken Heart* will help you unlock the inner secret that all great art holds—that in the end we are all working to make peace with suffering. Russ Ramsey has presented us with a rare gift—a careful and tender book that boldly guides us to the spiritual core of some of our culture's great treasures and, through them, to a better knowledge of our own ever-breaking hearts.

PAUL J. PASTOR, contributing editor for *Ekstasis* and author of *Bower Lodge: Poems*

If you find yourself uncomfortable and overwhelmed when you look at fine art, you will enjoy this book as both a great read and as a mini crash course in Western art. Allow Ramsey's informal introductions to these artists to begin a lifetime of curiosity and start a new circle of friends to look for when you go museuming.

NED BUSTARD, artist and author of *History of Art: Creation to Contemporary*

The gospel shows us God's audacious longing to bind himself to our sorrow, knowing that he is the only cure for the pain. Russ Ramsey teaches us to see this marriage of beauty and sadness through the stories of great art and artists. He tears in two the unfair veil of pain that defines the lives of so many artists, refusing to allow us to remember them by their struggles alone. Instead, he invites us, with soft eyes and hearts, to bear witness to their bravery to triumphantly create beauty in the face of trials.

AMY HEYWOOD, multi-medium artist and owner of Amy Heywood Art

In Russ Ramsey's follow-up to *Rembrandt Is in the Wind*, he offers more welltold stories of artists, which becomes a door flung wide to big and urgent questions about the things that matter most. Among this book's many contributions are the realizations that great creativity can sometimes emerge from great sorrow and that we who also ache can therefore take comfort in the gestures, symbols, colors, and stories of great art.

BYRON BORGER, owner of Hearts & Minds Bookstore

VAN GOGH HAS A BROKEN HEART

WHAT ART TEACHES US ABOUT THE WONDER AND STRUGGLE OF BEING ALIVE

RUSS RAMSEY

ZONDERVAN REFLECTIVE

Van Gogh Has a Broken Heart
Copyright © 2024 by Russ Ramsey

Published in Grand Rapids, Michigan, by Zondervan. Zondervan is a registered trademark of The Zondervan Corporation, L.L.C., a wholly owned subsidiary of HarperCollins Christian Publishing, Inc.

Requests for information should be addressed to customercare@harpercollins.com.

Zondervan titles may be purchased in bulk for educational, business, fundraising, or sales promotional use. For information, please email SpecialMarkets@Zondervan.com.

ISBN 978-0-310-15559-1 (audio)

Library of Congress Cataloging-in-Publication Data

Names: Ramsey, Russ, 1973- author.
Title: Van Gogh has a broken heart : what art teaches us about the wonder and struggle of being alive / Russ Ramsey.
Description: Grand Rapids : Zondervan Reflective, [2024]
Identifiers: LCCN 2024003025 (print) | LCCN 2024003026 (ebook) | ISBN 9780310155577 (hardcover) | ISBN 9780310155584 (ebook)
Subjects: LCSH: Christianity and art. | Aesthetics—Religious aspects—Christianity. | Melancholy in art.
Classification: LCC BR115.A8 R365 2024 (print) | LCC BR115.A8 (ebook) | DDC 261.5/7—dc23/eng/20240328
LC record available at https://lccn.loc.gov/2024003025
LC ebook record available at https://lccn.loc.gov/2024003026

Unless otherwise noted, Scripture quotations are taken from the ESV® Bible (The Holy Bible, English Standard Version®). Copyright © 2001 by Crossway, a publishing ministry of Good News Publishers. Used by permission. All rights reserved.

Scripture quotations marked KJV are taken from the King James Version. Public domain.

Scripture quotations marked NIV are taken from The Holy Bible, New International Version®, NIV®. Copyright © 1973, 1978, 1984, 2011 by Biblica, Inc.® Used by permission of Zondervan. All rights reserved worldwide. www.Zondervan.com. The "NIV" and "New International Version" are trademarks registered in the United States Patent and Trademark Office by Biblica, Inc.®

The Scripture quotations marked NRSVCE are taken from the New Revised Standard Version Bible: Catholic Edition. Copyright © 1989, 1993 Division of Christian Education of the National Council of the Churches of Christ in the United States of America. Used by permission. All rights reserved.

Any internet addresses (websites, blogs, etc.) and telephone numbers in this book are offered as a resource. They are not intended in any way to be or imply an endorsement by Zondervan, nor does Zondervan vouch for the content of these sites and numbers for the life of this book.

All rights reserved. No part of this publication may be reproduced, stored in a retrieval system, or transmitted in any form or by any means—electronic, mechanical, photocopy, recording, or any other—except for brief quotations in printed reviews, without the prior permission of the publisher.

Published in association with the literary agency of Wolgemuth & Associates, Inc.

Cover design: Studio Gearbox
Cover image: © Musee d'Orsay, Paris, France / Bridgeman Images
Interior design: Kait Lamphere

Printed in the United States of America

24 25 26 27 28 LBC 7 6 5 4 3

For my faithful friend,
steward of beautiful words,
Andrew Peterson

CONTENTS

Foreword by W. David O. Taylor . ix

1. Something Utterly Heartbroken . 1
Gustave Doré and the Beauty of Sad Stories in a
Complicated World

2. Owning *Mona Lisa* . 15
Leonardo's Masterpiece and the Desire to Possess
More Than Life Can Give

3. Now Let Your Servant Go in Peace. 31
Rembrandt's Simeon in the Temple *and the Power*
of Suffering

4. The Allegory of Painting . 53
Artemisia Gentileschi and Inhabiting a Discipline
in an Unjust World

5. Keep Them Together. 75
Joseph Mallord William Turner and the Evolution
of an Inner Life

6. A Sort of Delightful Horror . 97
The Hudson River School, the Beautiful,
and the Sublime

7. The Yellow House 113
Vincent van Gogh, Paul Gauguin, and the Sacred
Work of Stewarding Another's Pain

8. Cultivate Your Own Half Acre 135
Norman Rockwell and Capturing a Changing Country

9. Through a Glass Darkly 153
Jimmy Abegg, Edgar Degas, and Learning to See as the
World Grows Dim

10. Our Personal Collections 171
Jeremiah's Lament, the Works We Carry, and the
Words on Which We Rest

Appendices .. 189
 1. *I Don't Like Donatello, and You Can Too.* 189
 2. *A Beginner's Guide to Symbols in Art.* 195
 3. *Lost, Stolen, and Recovered Art* 203
Discussion Guide 213
Selected Works .. 223
Notes .. 227

FOREWORD

In her 2002 film *Frida*, Julie Taymor, known for her exquisitely visceral and brightly colorful movies, recounts the life of the Mexican painter Frida Kahlo (1907–1954). The Frida we encounter in Taymor's telling is a fiery, indominable figure despite her many setbacks. As we witness early in the film, Frida suffers from the effects of polio as a child and then, at eighteen, is severely injured in a bus accident that fractures her pelvic bone and punctures her uterus, robbing her of any chance to bear children. This represents only the beginning of a lifelong struggle with pain.

Brought to life in an Academy Award–nominated performance by Salma Hayek, Frida aims to make sense of the many traumas of her life through art. The experience of multiple miscarriages, a struggle with alcoholism, recurring bouts of marital unhappiness, depression, loneliness, chronic pain, and the amputation of her right leg due to the spread of gangrene throughout her body—all of these afflictions served as the context in which she produced some of her greatest work, in a style that has been described as naive surrealism and magical realist.

Her paintings from this period of life include *The Broken Column* (1944), *Without Hope* (1945), *Tree of Hope*, and *The Wounded Deer* (1946), each a visual testament to the torment of living in a profoundly broken physical body. Experiencing in her flesh what she called "centuries of torture," at one point in the movie, Frida turns to Diego Rivera, her off-and-on-again

x Van Gogh Has a Broken Heart

husband, and bitterly quips, "I want you to burn this Judas of a body. Burn it." Pain, for Frida, served as the *cantus firmus* of her life. Some of that pain was caused by a sin-fractured heart; most of it was caused by being born into a very broken world, through no fault of her own.

In the final months of her life, Frida spent most of her free time drawing skeletons and angels in her diary, an ominous portent of her imminent death. Her last entry in her diary records these words: "I joyfully await the exit—and I hope never to return—Frida." She died at the age of forty-seven on July 13, 1954.

Less famous in life than posthumously, and struggling constantly to make a living from her work, Frida nonetheless became, according to the Tate Modern, one of the most significant artists of the twentieth century, the first Latin American artist to break the one-million-dollar threshold with the sale of her painting *Diego and I*, and so beloved by her home country that, in 1984, they declared her works part of the national cultural heritage. In the United States, she became the first Hispanic woman to be honored with a postage stamp, and seventeen years later, in 2018, Mattel unveiled a new Barbie doll of Kahlo in celebration of International Women's Day.

One of the reasons for Kahlo's popularity, as the art critic John Berger sees it, is owed to the fact that "the sharing of pain is one of the essential preconditions for a refinding of dignity and hope" for many in our society,[1] especially for those who may find themselves on its margin. In Kahlo's life, art and anguish are intimately and integrally related. In *Frida*, Alfred Molina's Rivera describes her work as "acid and tender; hard as steel and fine as a butterfly's wing, lovable as a smile, cruel as the bitterness of life. I don't believe that ever before has a woman put such agonized poetry on canvas."

"Art shows us back to ourselves," writes Russ Ramsey in this superb follow-up to his book *Rembrandt Is in the Wind*, "and the

best art doesn't flinch or look away. Rather, it acknowledges the complexity of struggles like poverty, weariness, and grief while defiantly holding forth beauty." This is a story, he argues, that needs to be told, because it is far too easy to perceive our suffering as a kind of failure in life rather than as a means of grace—as an obstacle to get over and around as quickly as possible rather than as an occasion for the broken beauty of Christ to be slowly but surely formed in us.

"Why are we so drawn to sad stories?" Ramsey wonders out loud, homing in on the heart of his project. We're drawn to them, he answers, because they prepare us for what's coming. "They remind us," he writes, "that we are not alone in our pain." Such stories "tell us that these sorrows we experience, which can leave us feeling so isolated, are, in fact, well-traveled roads." While Ramsey's book isn't a sad book, it is, nevertheless, a book full of sad stories. Why does this matter, in particular for those of us who may feel a pressure to ignore them or to get through them as swiftly as we can manage?

It matters, Ramsey explains, because this "is where much of the world's art is born—from struggle and sorrow." Artists, as Ramsey shows us throughout this poignant work, are especially equipped to prepare us to face our own struggles with humility and to feel our own sorrows deeply without being undone by them, and to feel the possibility of hope, not just on the other side of our sorrows but also in the very middle of them, as the trees that show up in Frida Kahlo's paintings suggest symbolically.

In painting her sorrows, Frida Kahlo not only sought to make sense of the often-senseless in her own life, but she also made space for viewers to find their own tragic sorrows, seemingly irreparable losses, and various experiences of rejection or loneliness named and dignified. Her life story gets retold on canvas and thereby becomes all of our story. Her pain becomes memorialized in pigment, line, texture, and color—and then again on the

silver screen in Taymor's *Frida*—and thus fixes before our eyes an image of the possibility of hope and wholeness.

If it is true, as Flannery O'Connor once wrote, that "a story is a way to say something that can't be said any other way,"[2] then Ramsey gives us here a collection of stories—of Doré and Degas, of Gauguin and Gentileschi—that together convey a truth that can only be revealed properly in this way: namely, that our sorrows are ultimately hallowed by the One who enters fully into the painful stories of our own lives in order to show us that our suffering matters, while also becoming the place from which the Spirit enables us to become agents of God's healing grace to those who find themselves lost and alone in their griefs.

This is a story that never gets old, and it is one that Ramsey tells beautifully throughout.

W. David O. Taylor, associate professor
of theology and culture at Fuller
Theological Seminary, author, *Prayers for
the Pilgrimage* and *Open and Unafraid*

CHAPTER 1

SOMETHING UTTERLY HEARTBROKEN

Gustave Doré and the Beauty of Sad Stories in a Complicated World

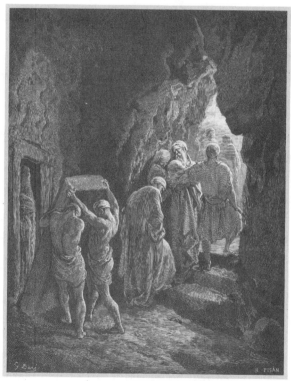

Gustave Doré, *The Burial of Sarah*, 1866, engraving, 33 cm x 25 cm, private collection.
Public domain

Have you noticed yet
that the old cab-horses in Paris
have big, beautiful heartbroken eyes,
like Christians sometimes?

Vincent van Gogh, letter to Theo van Gogh
and Jo van Gogh-Bonger. Saint-Rémy-
de-Provence, Thursday, 9 May 1889

I call him Vincent. I have ever since I was a teenager. It's hard not to.

My high school art teacher taught us to love art by loving art in front of us. She had her favorites—Georgia O'Keeffe, Frank Lloyd Wright, Edward Hopper, and especially Vincent van Gogh. For her, O'Keeffe was O'Keeffe and Hopper was Hopper, but van Gogh was Vincent. Always Vincent, like he was more than one of her favorite painters; he was a person in her life—a friend.

When she taught art history, she seemed to go to this other place when she started talking about the artists she particularly loved, as if she were trying to give us information that was very precious to her while also trying to hold something back. Though I couldn't express it at the time, there was something protective in the way she spoke about them. It was like she knew their secrets, or that she loved them in a way that called for some measure of discretion.

I noticed this about her but didn't think much of it as a teenager. What sixteen-year-old would? I just figured these artists produced the paintings and designs she liked to look at the most. But her care in how she handled their names and stories was

Something Utterly Heartbroken 3

about more than that, and I know this now because I took to heart her wise advice about how to cultivate a lifelong appreciation of the arts, which I will now share with you. Here's what she said:

> Find an artist you connect with and then pay attention to them for the rest of your life. Read articles and books about them. Go visit them in museums. When you do, they will introduce you to their friends and mentors—the others hanging beside them in the gallery and the artists they mention in the descriptions on the wall beside the paintings, some of whom may be just down the hall themselves. Soon you'll get to know their colleagues and heroes too. Do this, and you won't just get to know their art; you'll get to know them.

For me, it was Vincent. I wasn't sure what it was that I loved about his work, but I was so drawn to it—his blues and yellows, his thick application, the motion in his compositions. If you had asked me then why I favored his work, I probably would have said I liked it because it was cool. But the truth is I didn't know why—because I didn't know him yet. Three decades later, I now know; it's the sadness that runs through his work, and it's the beauty he found in everything. His paintings are not mere pictures of rivers, sunflowers, or night skies; they are his attempt to capture the wonder and struggle of being alive. Everything he saw was full of beauty and sadness—an increasingly familiar tension for him. They were present even in the way he described the ordinary scenes he wanted to paint, like this description of a bridge in Arles, France:

> I have a view of the Rhône—the iron bridge at Trinquetaille, where the sky and the river are the colour of absinthe—the quays a lilac tone, the people leaning on

the parapet almost black, the iron bridge an intense blue—with a bright orange note in the blue background and an intense Veronese green note. One more effort that's far from finished—but I am trying to get at something utterly heartbroken and therefore utterly heartbreaking.[1]

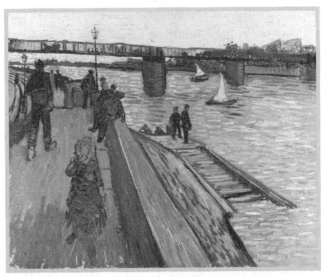

Vincent van Gogh, *Le pont de Trinquetaille*, 1888, oil on canvas, 65 cm x 81 cm, private collection.
Bridgeman Images

Much of the world's great art comes from places of sadness, and I believe that's often why we connect with it. It isn't that the works themselves are of a sorrowful subject matter; it's that the artists bring their personal experience to their work to say something meaningful about the world to the viewer. We want what we say to matter. We want it to connect. We want it to help people. So artists create, not just to show us a picture of a bridge, but to show us something of this world where bridges are necessary and used by people to get from one bank to the other without going under. Some cross alone, while others walk hand in hand as

the sun dances on the water and casts those leaning on the rail as silhouettes. But there we are, each living out our unfolding stories that are filled with all kinds of joy and difficulty.

Art shows us back to ourselves, and the best art doesn't flinch or look away. Rather, it acknowledges the complexity of struggles like poverty, weariness, and grief while defiantly holding forth beauty—reminding us that beauty is both scarce and everywhere we look. In its scarcity, beauty often surprises us. She walks into the room in her dinner dress, and every head turns. But it is also everywhere if we will just pay attention. It's in a child's laugh, in the watercolor sky of the setting sun, and in the aroma of baking bread and brewing coffee.

Beauty pulls us upward toward something that calls for some measure of discretion, something to be treated with dignity and care, something sacred. What does it pull us toward? The truth that we were made to exist in the presence of glory. But as with Moses hidden in the cleft of the rock, true glory is often more than we can bear. This world is filled with sorrows we cannot avoid. How are we supposed to navigate the tension between glory and sorrow?

In this book, I, like Vincent, am trying to get at something utterly heartbroken, and therefore utterly heartbreaking—the wonder and struggle of being alive. This book is for those of us who need the bridge. There's darkness in these pages, but there's also light. And the light is everywhere.

The Burial of Sarah

This is a book of stories, each of them filled with beauty, and most of them sad. It's not a sad book, but what story doesn't have some measure of sorrow, and what great story doesn't contain great sadness? Let's start with an old story filled with both wonder and sorrow and ask why we're drawn to the sad ones in the first place.

6 Van Gogh Has a Broken Heart

The entire time Abraham lived in the land promised to his descendants, he never owned so much as an acre. Nor would he, until he bought the cave in the field near Machpelah for his beloved Sarah. If the defining moments in Abraham's life were captured as paintings, each image would be of a place miles away from the one before and the one to follow. Each canvas would depict a journey with ever-changing geography, people, and struggles. But there was one constant for Abraham every step of the way—his wife Sarah. Lovely and dignified, filled with passion and imagination, she bore her husband's burdens as though they were her own. The journey they were on was as much hers as it was his, and Abraham loved her for it.

By the time we meet Sarah, she's already old. Her story is a race against time, with both the promise and improbability of bearing children following her from Ur to Canaan. She ages before our eyes as she proposes Hagar to her husband as her surrogate—an offer he accepts far too easily for her liking. She surrenders time as she tries and fails to accept Hagar's son Ishmael as part of her own family, and the boy proves that the problem of her and Abraham's infertility does, in fact, lie with her. Yet she miraculously becomes pregnant at the age of ninety and gives birth to Isaac, laying her body down a little more.

Abraham and Sarah loved Isaac and clung to him like a promise from God. So on the day Abraham came to tell Sarah about his most recent visit from the Lord, the look of vacant grief in his eyes told her that whatever they had discussed, it involved her beloved son, the one they called Laughter, and it was not happy news.

God wanted Abraham to do *what*?

He went to where he kept his knives. How could he choose? Did he study their length? The truth of their edge? Did he pick each one up, comparing their heft and balance? Was the one he chose heavier than he remembered, heavy as a stone?

Abraham and Isaac ascended the mountain alone. Sarah stayed back. She feared she would never see the boy again. Several days later, when she saw them return together, both alive, she wept.

Sarah died at the age of 127. "Abraham went in to mourn for Sarah and to weep for her."[2] She was the keeper of his secrets and one who spoke to him in ways no one else ever could. She was a miracle, a wellspring of life when all hope seemed lost. She was his traveling companion. She listened to his dreams and his descriptions of what it was like talking to God. She received the wounds he inflicted on her when the limits of his character were tested. When Abraham and Isaac disappeared over the horizon on their way to Mount Moriah, she prayed with a ferocity only mothers know.

After Abraham wept and mourned for Sarah, he went to some of the wealthy rulers in the land to buy a place to bury her. Knowing Abraham had become very wealthy in his own right, the Hittites said, "Hear us, my lord; you are a prince of God among us. Bury your dead in the choicest of our tombs. None of us will withhold from you his tomb to hinder you from burying your dead."[3]

Of course, no tomb would truly be free. It would be a loan that would become leverage for future favors. Abraham didn't want to borrow from the Hittites. He didn't want to become beholden to them by permitting them to own his beloved's grave. So when Ephron, the owner of the cave Abraham wanted, offered to loan it to him indefinitely, Abraham declined. Instead, he asked Ephron to name a price. If Ephron got his initial asking price without having to haggle, this would publicly verify that Abraham acquired the cave honestly and fairly. When Ephron said he wanted four hundred shekels of silver, Abraham paid it.[4]

The tomb, the field the tomb was in, and the fence around it were all deeded to Abraham. And so it was, at last, that the

8 Van Gogh Has a Broken Heart

father of nations took his first possession of the land the Lord swore to his descendants. It wasn't a fertile valley or a palace or a vineyard; it was a burial site. There he buried his wife, his queen, his beloved Sarah.

The etching *The Burial of Sarah* by the French artist Gustave Doré (1832–1883) presents the entire narrative of Genesis 23 in a single frame. Doré was a printmaker, painter, sculptor, and engraver who is best known for his illustrations in classic works of literature like Dante's *Divine Comedy*, Cervantes's *Don Quixote*, Milton's *Paradise Lost*, and a series of 241 wood engravings illustrating the Bible. A lot of little things are going on in Doré's *The Burial of Sarah* that most certainly did not all happen at once—like the sealing of Sarah's tomb as Abraham was led away. But good artists carefully arrange vignettes throughout the work that lead the viewer's eye through the scene in a certain sequence in order to tell a story. That's what a well-ordered composition does.

The story Doré tells here is a sad one. His etching calls to mind more than Sarah's funeral. Written into the old man's grief are reminders of when Abraham and Sarah were young and brave, setting off from their home in Ur in search of the land the Lord swore to give them. We remember her infertility and her deep desire to give her husband an heir. We remember how Sarah laughed at God when the angels visited them at Mamre and told Abraham she would have a son within the year, though she was already ninety. We remember how one year later Isaac was born. And we remember that day some years after when Sarah watched as Abraham and Isaac rode off—the knife in the old man's saddlebag and wood for a sacrifice bundled on the back of the boy's donkey.

Sarah's funeral signals more than the end of her life; it marks the end of a chapter. There are nine distinct people in Doré's

Something Utterly Heartbroken 9

etching, but his emotive composition leaves us feeling like there are only two—a dead woman and her grieving husband. *The Burial of Sarah* captures the last time Abraham would see his wife this side of eternity's door, as they are each ushered into the worlds to which they now belong, parted by death if only for a season. Abraham and Sarah had walked a long road together. Doré's *The Burial of Sarah* holds significant weight as he permits the old man one last look at his beloved's shrouded figure.

The Well-Traveled Road of Sorrow

Doré doesn't just give us a picture; he tells us a story. That's what art does—it tells a story. Flannery O'Connor said, "A story is a way to say something that can't be said any other way."[5] We spend our lives collecting stories. As people made in the image of our Creator, we are, by nature, creative beings. We have an eye for detail. We are not mere collectors of data, nor are we mere appliers of lessons. We gather stories and use them to make sense of the world. Eugene Peterson wrote, "Story is the most adequate way we have of accounting for our lives, noticing the obscure details that turn out to be pivotal, appreciating the subtle accents of color and form and scent that give texture to our actions and feelings, giving coherence to our meetings and relationships in work and family, finding our precise place in the neighborhood and in history."[6] Stories are how we learn about our lives, engaging the whole person with complicated, nuanced truth.

Stories give texture. People don't connect to vague concepts in the same way we connect to specific details. For example, if I said, "I lost someone I was very close to, and I'm terribly sad," most people could relate, but to what? To being sad? To feeling grief? To losing someone they loved? The vague statement would provide a general sense of relatability. But look at how the power of detail works in the way C. S. Lewis described his own grief:

No one ever told me that grief felt so like fear. I am not afraid, but the sensation is like being afraid. The same fluttering in the stomach, the same restlessness, the yawning. I keep on swallowing. At other times it feels like being mildly drunk, or concussed. There is a sort of invisible blanket between the world and me. I find it hard to take in what anyone says. Or perhaps, hard to want to take it in. It is so uninteresting. Yet I want the others to be about me. I dread the moments when the house is empty. If only they would talk to one another and not to me.[7]

Do you see how Lewis's specificity deepens our connection to the sentiment of his grief? He doesn't just tell us he's sad; he tells us how his particular sorrow is affecting his physiology. That is how we all experience grief—physiologically. We lose our appetites. We don't know how to act around others. We feel numb in our heads. Lewis also tells us how his grief is affecting him relationally. He feels a separation from the rest of the world—a lonesome sorrow. He doesn't want an empty house, but he doesn't want to have to talk to people either.

We don't share the same lost loved one as Lewis or the same physiology, friends, or house, but the details he gives spin us forward into the specificities of our own. How does that work? He doesn't just tell us how he feels; he tells us a story—a sad story. And it helps us.

Why are we so drawn to sad stories, like the one Doré tells? Sorrow, grief, anger, futility, frustration, and distress are complicated yet universal realities, and to talk about them in any substantive manner is to do so by way of story. These emotions are not data points; they're tales of heartache and woe, and they come for all of us. So we lean in when sad stories are told because they prepare us for what's coming. They teach us about pain and suffering when we're not necessarily going through those trials

Something Utterly Heartbroken 11

personally in that moment. They allow us to feel the feelings of grief and loss without the personal anxiety that accompanies them when that sorrow is uniquely our own. They remind us that we are not alone in our pain. It is a sign of emotional maturity to be able to feel competing emotions—like hope and sorrow—at the same time, and sad stories give us practice. They help us develop empathy and compassion. They tell us that these sorrows we experience, which can leave us feeling so isolated, are, in fact, well-traveled roads.

Sad stories also teach us how to deal with the problem of evil in the world. G. K. Chesterton said of fairy tales that they "do not give the child the idea of the evil or the ugly; that is in the child already, because it is in the world already. Fairy tales do not give the child his first idea of the bogey. What fairy tales give the child is his first clear idea of the possible defeat of the bogey."[8] The same is true of sad stories. They remind us not just that this world can wound us, but that wounds can heal. They remind us to hope.

They also remind us to lament. Lament is sorrow joined to prayer, directed pain about which we ask, "How long, O Lord?" We often tell our saddest stories as a form of protest, as a way of saying, "Look at what beauty came from this wreck of a life, what faith was born from this spiral of despair, what hope rose up in this darkest night, what rescue crested the hill just when it seemed all was lost." So much beauty is born out of suffering. We make some sense of brokenness and pain by looking at the beauty they produce.

This is where much of the world's art is born—from struggle and sorrow. An artist looks for a story to tell, a message to convey, a point of connection between them and some unknown viewer. What do we as people have in common? Art does not necessarily start a new conversation, but it picks up one that is already under way. What are we interested in discussing? For one thing, the wonder and struggle of being alive in this world as we experience it.

12 Van Gogh Has a Broken Heart

Much of the world's great art includes these stories of wonder and struggle in some way. What makes them beautiful is how they remind us we're not alone. All art comes from somewhere. It comes from someone who is in the process of living the one life they've been given. The more we can understand the specifics of their individual experience, the more we will understand why they created what they did and why the world has responded to it in the way we have.

A Book of Stories

This book tells the stories of the lives, works, and experiences of some of the world's great artists, and also some you've likely never heard of. Some of the stories are inspirational; others are complicated. Some celebrate wisdom and the profound transcendence of art; others lament the outcomes of self-absorption, pride, and the complex forces that can lead a person to ruin. Some you might relate to more than others, based on your own life experiences. Others may upset any admiration you may have held for a particular artist as you learn about their darker side—a natural hazard when it comes to meeting your heroes.

I hope these chapters will help you develop a deeper understanding of the human experience. I hope they will help make you fearless when it comes to loving art. I want these stories to undermine the intimidation and distance people can sometimes feel when walking into a museum, as though there's some academic or cultural knowledge you must possess before you could ever hope to appreciate what you see there. Perish the thought. It is a legitimate form of art criticism to stand in front of a painting and say, "I like this one," and of another, "This one, not so much."

Every artist I've written about in this book and in my previous volume, *Rembrandt Is in the Wind: Learning to Love Art through the Eyes of Faith*, I found by looking at art in museums,

in books, and online. Following my art teacher's advice, if I liked a particular work, I might read a little about the painting or the artist—an exercise in curiosity that has invariably introduced me to more art and other artists. That process of discovery continues to delight me to this day. There are artists I will discover next year I'm unaware of now—artists who will teach me things I don't yet know, inspire me with the joy of discovering new beauty, challenge me to reconsider areas in my own mind and heart where I am nearsighted or wrong and don't yet know it, show me more of the goodness of Christ, and connect me to other people who share an appreciation for the same beauties that stir me. I love knowing all of this is coming if I will just keep looking. I invite you to do the same.

As these stories remind you that wonderful and terrible things happen in this world, remember also that beauty is everywhere.

CHAPTER 2

OWNING *MONA LISA*

Leonardo's Masterpiece and the Desire
to Possess More Than Life Can Give

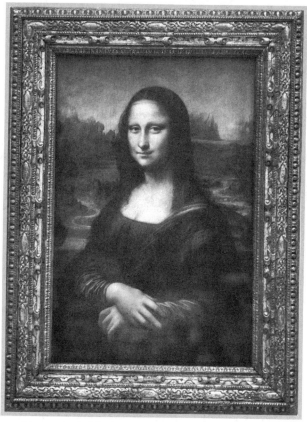

Leonardo da Vinci, *Mona Lisa*, ca. 1503–1506, oil on
poplar panel, 77 cm × 53 cm, Louvre, Paris.
agcreativelab / stock.adobe.com

Every generation throws a hero up the pop charts.

Paul Simon, "The Boy in the Bubble"

September 5, 1911. Pablo Picasso and his friend Guillaume Apollinaire tried to look as natural as they could, lugging a heavy bag down a steep flight of apartment stairs to the sidewalk in their little neighborhood in Paris. Out on the cobblestone street, they saw the Seine glistening in the glow of the streetlamps and moonlight. The two plodded in her direction.

Just act casual. Be careful with the suitcase.

Had the statues been from anywhere else, perhaps their anxiety wouldn't be running so hot. Maybe they wouldn't even be out there after midnight as they were. But Pablo and Guillaume hadn't exactly kept these statues a secret from their friends, and most of their friends happened to be anarchists whose motto was, "The enemy is whoever impedes us from living."[1] Trusting friends like those to keep their shady dealings a secret seemed a fragile hope. And even if they did, anyone who took hold of one of the two statues would see stamped on the bottom, "PROPERTY OF THE MUSÉE DU LOUVRE." This was not the night to be found with plunder from the Louvre—not after what had just happened. No, these statues needed to go into the river.

A few years earlier, Picasso and Apollinaire had acquired the two third-century BC Iberian sculptures from Apollinaire's secretary, Joseph Géry Pieret, a poet and small-time art thief. Apollinaire hired Pieret to be his secretary and let him stay in his apartment. Occasionally Pieret, as he was about to leave, would say, "I am going to the Louvre: can I bring you anything you need?"[2]

Owning *Mona Lisa* 17

He was only half-joking. In 1907, he went into the famed Paris museum, "a young man with time to kill and no money to spend," he would later recount.[3] He noticed there weren't enough guards to watch over every room. He also noticed many of the galleries' statues were small enough to conceal under his coat. That year, he walked out with several items, including two Iberian statues, one that Pieret sold to Picasso, who kept his in a cupboard when he wasn't using it as a model for his art, and the other that Pieret displayed on a shelf in Apollinaire's living room.

Museums have long been custodians of timeless treasure, designed to simultaneously grant access to and safeguard the world's most noteworthy bits of history and enduring works of art. But the institution of museums didn't mean the anarchists of Paris had to respect the system. Who said these things should belong to the masses? Why couldn't they own some of them? What difference did it make if a statue was in a gallery in the Louvre or on a shelf in a poet's apartment? For the past couple of years, Picasso and Apollinaire didn't think much about the implications of possessing these two relics, but suddenly the marble busts had become like millstones around their necks, and they needed to be free of them.

They stood on the bridge in the dark, looking around to make sure there were no witnesses. When all was clear, the two men lifted the suitcase onto the stone rail, and just as they were about to shove it over into the black water below, Picasso slumped his shoulders and pulled the bag back onto the bridge, crestfallen.

"We can't do this," he said. "*I* can't do this."

Apollinaire looked relieved. "I can't either. I'll see that they get returned."

About a week later, Picasso sat in an interview room in a Paris police station. Across the table sat an investigator. "Did you steal *La Joconde*?"

"No," Picasso insisted.

18 Van Gogh Has a Broken Heart

The investigator studied his suspect. "Do you know who took her?"

"No," he answered again.

"Stay where we can find you, understood?"

"Understood," Picasso replied as he picked up his hat and coat and made his way to the door, trying to hide his trembling at the realization that the police suspected him of stealing *La Joconde*, otherwise known to the English-speaking world as *Mona Lisa*.

The Heist

Famous for her enigmatic expression of confidence and feminine charm, *Mona Lisa* represents the pinnacle of late fifteenth-century Florentine portraiture: "The half-figure is turned two-thirds towards the viewer, a balustrade with pillars connects the foreground with the landscape in the background."[4] Leonardo da Vinci (April 15, 1452–May 2, 1519) painted his oil-on-poplar-panel painting of Lisa del Giocondo, wife of a wealthy silk merchant in Florence,[5] between 1503 and 1506. He continued working on the portrait until 1517, when he sold the panel to the king of France.

Leonardo is best known for his paintings, but he was a true Italian Renaissance polymath who applied his skill and curiosity about the world, not only as a painter, but as a drawer, engineer, scientist, theorist, sculptor, and architect as well. He left a trove of notebooks filled with sketches of human anatomy, botany, astronomy, cartography, and even concepts for a flying machine. But *Mona Lisa* stands out today as not only his best-known work but also, as John Lichfield said, "the most visited, the most written about, the most sung about, the most parodied work of art in the world."[6]

How did Pablo Picasso come to be a prime suspect in *Mona Lisa*'s disappearance? On the morning of August 21, 1911, a man

Owning *Mona Lisa* 19

dressed in the white smock of a museum employee entered the Louvre through an unlocked service door. He walked into the Salon Carré—a grand gallery of dozens of Renaissance masterworks—lifted the *Mona Lisa* from the wall, went into a nearby stairwell to remove the painting from its frame, hid the panel under his smock, walked out the same door through which he had entered, and took it home to his apartment nearby.[7]

The theft happened on a Monday, when the museum was closed for cleaning.[8] *Mona Lisa's* absence wasn't noticed until the following morning when a wealthy museum patron named Louis Béroud arrived to study *La Joconde*. When he walked into her gallery, he found nothing but the four iron pegs that fastened the painting to the wall. Figuring staff had removed it for cleaning or that it was being photographed, he asked the security guards when they might expect it back. The guards did a quick search of the museum. *Mona Lisa* was nowhere to be found.

Security at the Louvre was notoriously lax. They employed just 150 guards to work in shifts, watching over 250,000 artifacts. Not long before *Mona Lisa* disappeared, a reporter hid in a sarcophagus to prove how easy it would be to simply walk out with priceless works if one wanted to. While other museums in Paris were tightening security measures by bolting paintings to the walls, many works in the Louvre, including *Mona Lisa*, could simply be lifted off their hooks.

When *Mona Lisa* was confirmed to be missing, museum security called the police and locked the doors. Detectives arrived and began to question the detained staff and visitors. They concluded that the painting had been missing for at least twenty-six hours before anyone noticed. She could be anywhere. Border guards were put on alert and ordered to check all vehicles leaving France. Typically, ransom demands in cases like this come within the first forty-eight hours, but two days came and went without a word.

When the museum opened the following week, tourists flocked to see the bare wall where the painting had once hung—as though the bare wall was, in itself, a compelling site to visit, history in the making. Franz Kafka was among the curious crowd, calling the theft a "mark of shame" for the Louvre.[9] The iron pegs protruding from the wall prompted museum guests to ask a simple question: "How could this happen?" One visitor left a bouquet of flowers on the floor beneath the pegs.

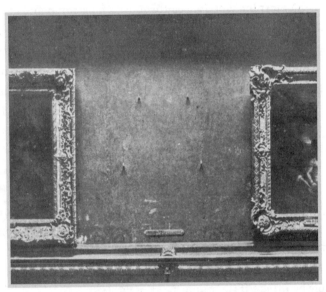

Wall pegs where *Mona Lisa* was stolen.
Chronicle/Alamy Stock Photo

The *Paris-Journal* offered 50,000 francs for *La Jaconde*'s return. Dozens of tips poured in, along with no shortage of conspiracy theories and hoaxes. Nothing much came of any of them. But with these tips came a few other offers to help the police recover additional works that had been stolen from the Louvre. One particularly intriguing letter that came into the journal's office read as follows:

Owning *Mona Lisa* 21

Monsieur,

On the 7th of May, 1911, I stole a Phoenician statuette from one of the galleries of the Louvre. I am holding this at your disposition, in return for the sum of _____ francs. Trusting that you will respect my confidence, I shall be glad to meet you at [such and such a place] between ___ and ___ o'clock.[10]

A museum curator and reporter accepted the thief's invitation and described meeting "a young man, aged somewhere between twenty and twenty-five, very well-mannered . . . whose face and look and behavior bespoke at once a kind heart and a certain lack of scruple."[11] This was none other than Picasso's friend Joseph Géry Pieret.

Pieret produced the sculpture he wrote about in his ransom letter, and a curator from the museum confirmed that the stamp on the bottom was indeed from the Louvre. Pieret said stealing these items from the Louvre had proven to be a rather reliable source of income for him, but with all the attention *Mona Lisa* had brought, he feared his revenue stream had run dry. Maybe there could be a new stream—ransom money. Perhaps the search for *Mona Lisa* would raise interest in the return of other pieces from the Louvre that were presently in the wind.[12] Pieret went on to tell them about other objects he had taken and where they might be, offering to return them for a fee.

The *Paris-Journal* took the statue Pieret had brought and wrote a story about its return. In the article, they described other items he had confessed to stealing, including the Iberian statue in Picasso's cupboard. This detail caught the police's attention. Pieret said, "I put the statue under my arm, pulled up the collar of my overcoat with my left hand, and calmly walked out, asking my way of the guard as I left. . . . I sold the statue to a Parisian painter friend of mine. He gave me a little money—fifty francs, I think, which I lost the same night in a billiard parlor."[13]

22 Van Gogh Has a Broken Heart

The police wanted the identity of this painter. If he was friends with this thief, maybe they were part of a circle of confidence men who worked together to exploit the Louvre's weak security. And if this painter was so cavalier that he would buy a statue clearly marked as belonging to the museum, maybe he had the nerve to walk out with a Leonardo da Vinci under his arm.

When Picasso and Apollinaire read the article, Picasso recognized himself as the Parisian painter. And the sculpture in question was in a cabinet in his apartment. Realizing their possession of items from the Louvre might make them prime suspects in the *Mona Lisa* case, and that being caught with stolen historical artifacts could mean deportation or prison, they put their statues in a suitcase and rushed down to the Seine River to dispose of the evidence.

But being the true artist that he was, Picasso couldn't bring himself to see art destroyed or lost, so he and Apollinaire agreed to turn over their sculptures to the *Paris-Journal* on the condition of anonymity. Apollinaire set up a meeting with the journal's poetry editor, Andre Salmon, a friend and fellow dabbler in anarchy. Salmon promised he wouldn't reveal their identities, but when the police came by demanding that he give them up or be implicated as a co-conspirator himself, he pointed the finger at Apollinaire.

Two days later, Apollinaire was arrested. He maintained his innocence in the *Mona Lisa* case but gave up both Pieret and Picasso to the police.[14] Apollinaire was put in jail to await trial for dealing in stolen art. Soon afterward, Picasso was questioned. The newspaper *Le Martin* reported about the "arrest made in connection with the recent restitution of the Phoenician statuettes stolen from the Louvre in 1907. The name of the person arrested is Guillaume Kostrowsky, known in literature and art as Guillaume Apollinaire. What exactly are the charges against him? Both the Public Prosecutor and the police are making a considerable mystery of the affair."[15]

"In the end," Ian Shank of *Artsy* wrote, "the trial played out more as farce than finale. Apollinaire confessed to everything: harboring Pieret, possessing stolen art, conspiring to conceal evidence. Picasso—ordinarily at pains to project male bravado—wept openly in court, hysterically alleging at one point that he had never even met Apollinaire."[16] Like Simon Peter during the trial of Jesus, Picasso denied knowing his friend, later lamenting, "I saw Guillaume's expression change. The blood ebbed from his face. I am still ashamed."[17]

The judge who heard the case questioned Picasso and Apollinaire and determined they did in fact know each other and were both in possession of art stolen from the Louvre, but concluded they had nothing to do with the disappearance of *Mona Lisa*.

The Return of *La Joconde*

Though the case against Picasso and Apollinaire was thrown out, a cloud of suspicion hung over them as weeks turned into months and months turned into years with no sign of *La Joconde*. But that all changed two years later when an Italian art dealer in Florence named Alfredo Geri received a letter in response to an ad he had placed in a Paris newspaper offering to buy old works of art.

The letter, signed "Leonardo," said the *Mona Lisa* was for sale, but only on the condition that she remain in Italy.[18] She was Italian, after all. The return address was a post office box in Paris. Geri wrote back, arranging to meet at his gallery in Florence. After settling on a date, the mysterious Leonardo said he wanted half a million lira for her return.[19] Jennifer Rosenberg wrote, "With some quick, clear thinking, Geri agreed to the price but said the director of the Uffizi would want to see the painting before agreeing to hang it in the museum. Leonardo then suggested they meet in his hotel room the next day."[20]

24 Van Gogh Has a Broken Heart

They met as planned, and Leonardo produced *Mona Lisa*, which he had kept hidden under a false floor in a trunk for two years. Geri asked if he could take her to the Uffizi Gallery in Florence for authentication. The thief began to protest, but Geri, having already agreed to Leonardo's price, praised him for his sense of taste, his patriotism, and his willingness to trust Geri with so great a treasure. Flattered, Leonardo let Geri walk out with the painting. As soon as he was far enough away from Leonardo's apartment, Geri called the police. Moments later, there was a knock on Leonardo's door. He opened up, only to find two officers, who then arrested him. In the police report, the officers noted that he was "quite astonished" to see them.[21]

The painting was confirmed to be authentic.

Leonardo, whose real name was Vincenzo Peruggia, believed that since *Mona Lisa* was an Italian painting by an Italian artist, she belonged in Italy. That's why he stole her, he claimed. He mistakenly believed Napoleon stole her from Italy and brought her to Paris, though in truth she had been in France since 1516, when Leonardo da Vinci sold her to King Francis I. After the French Revolution, the painting was placed in the Louvre.[22] The only disrespectful thing Napoleon did to *Mona Lisa* was take her from the Louvre for a time so he could display her in his bedroom.[23]

Peruggia was an aspiring artist and glass cutter from Italy. He worked for a company that made glass cases used to deter theft for paintings in the Louvre. During his time at the museum, his French coworkers made fun of his Italian heritage, calling him "Macaroni." Little did anyone know that, after the theft, when the police came to his apartment as part of their due diligence in questioning anyone with access to the museum, *Mona Lisa* was in the room, wrapped in a blanket and hidden in a trunk.

Historically, legal penalties for art theft have often been light in cases where no one gets hurt, making it a reasonable gamble

Owning *Mona Lisa* 25

for daring criminals and patriotic idealists alike. Peruggia was sentenced to seven months in prison.

People from both Italy and France debated whether *Mona Lisa* should remain in Italy, but the Italian government issued the following statement: "The *Mona Lisa* will be delivered to the French Ambassador with a solemnity worthy of Leonardo da Vinci and a spirit of happiness worthy of Mona Lisa's smile. Although the masterpiece is dear to all Italians as one of the best productions of the genius of their race, we will willingly return it to its foster country . . . as a pledge of friendship and brotherhood between the two great Latin nations."[24]

Mona Lisa stayed in Italy for a few weeks before coming back to France. She was exhibited in the Uffizi Gallery and returned to the Louvre on January 4, 1914. When she arrived in Paris, she was the most famous painting in the world.

Fame and Mania

The aftermath of the 1911 theft of *Mona Lisa* is a fascinating study. No fewer than 120,000 people came to see her during the first two days after her return. To be sure, before she was stolen, *Mona Lisa* was considered a great work. Sixteenth-century commentator and painter Giorgio Vasari praised her realism, mystery, and romance. But neither he nor any of his contemporaries elevated her to the status she now holds. Before the theft, she lived in a gallery alongside other great paintings by masters like Titian and Raphael, but she wasn't regarded as the flagship of the fleet in the Salon Carré, much less the Louvre. In fact, Terence McArdle noted, "When *The Washington Post* first reported the theft and appraised the painting's value at $5 million, the paper mistakenly ran a picture of the *Monna Vanna*, a nude charcoal sketch that some believe Leonardo made in preparation to paint the *Mona Lisa*."[25]

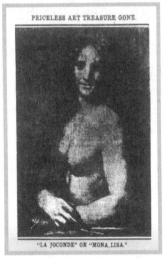

Page 3 of the *Washington Post* from August 23, 1911, mistakenly showing *Monna Vanna* instead of *Mona Lisa*.
Public domain

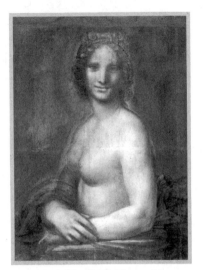

Leonardo da Vinci, *Monna Vanna*, ca. 1515, gouache and black chalk on paper, 72 cm x 54 cm, Musée Condé, Chantilly.
Heritage Image Partnership Ltd. / Alamy Stock Photo

Mona Lisa didn't come to be regarded as the pinnacle of the Italian Renaissance until she was stolen and recovered. After her return, she was on the cover of every newspaper around the world. Noah Charney, professor of art history and author of *The Thefts of the Mona Lisa*, said, "If a different one of Leonardo's works had been stolen, then that would have been the most famous work in the world—not the *Mona Lisa*. There was nothing that really distinguished it per se, other than it was a very good work by a very famous artist—that's until it was stolen. The theft is what really skyrocketed its appeal and made it a household name."[26]

It was *Mona Lisa*'s sudden absence, not her four centuries of prior availability, that made her the cultural icon she is today. Her return to public life marked the times when people began giving up vacation days and booking flights to travel halfway around the world just to see her. Art critic Robert Hughes said of the crowds

Owning *Mona Lisa* 27

that came to the Louvre, "People came not to look at the painting, but to say that they'd seen it. . . . The painting made the leap from artwork to icon of mass consumption."[27]

Even Adolf Hitler wanted to own her. During World War II, the French people and the Monuments Men—a group of Allied soldiers charged with protecting Europe's art from the Nazis, popularized by their eponymous movie based on Lynn Nicholas's book *The Rape of Europa*—knew Hitler would want to capture *Mona Lisa* as part of his plan to establish Germany as the cultural center of the world. Late one night, soldiers smuggled her out of the Louvre on an ambulance stretcher and loaded her into a truck.[28] The driver whisked her away to safety, moving her from village to village all over France for the next six years to keep her out of der Führer's reach.

After the war, people's obsession with *Mona Lisa* only grew. In the early 1950s, one man cut her with a razor and tried to steal her, claiming he was in love with her. In 1956, another visitor threw a rock at her, breaking the glass case the museum had installed, dislodging a fleck of paint from her left elbow. In 1974, when *Mona Lisa* was on display in Japan, a woman tried to spray her with red paint as a protest against the museum's inadequate accessibility for people with special needs.

The mania and fame surrounding *Mona Lisa* became a subject for commentary by pop artists. Was she to be taken seriously as a work of art, or was she just a symbol of pop culture? Was she revered because she was a true masterwork, or was she just famous for being famous? When *Mona Lisa* toured the United States in 1963, pop artist Andy Warhol joked, "Why don't they have someone copy it and send the copy, no one would know the difference."[29] Taking his own suggestion, Warhol created multiple serigraphs of *Mona Lisa* and arranged them together in what columnist Ben Davis described as a "silkscreen indifferently repeating the famed Leonardo in washed out monochrome gray and black."[30] Warhol called the piece *30 Are Better Than One.*

Owning *Mona Lisa*

Today, the eight million people who travel to Paris every year to see *Mona Lisa* crowd into a gallery built just for her and look at her through a pane of bulletproof glass.[31] She now sits apart, not just from the eager tourists with their iPhones held aloft, but also from the rest of the collection in the Louvre. Part of what makes her so famous is her unattainability—she cannot be owned. But this hasn't stopped people from dreaming of what it would be like to possess her. Peruggia walked out with her under his arm. He claimed he did it out of patriotism, but with his next breath, he said he would like half a million lira for her return, making his claim of selfless devotion to Mother Italy dubious at best. He wrote of his desire for wealth in a letter to his father two months after he took her: "I will make my fortune and it will arrive in one shot."[32]

Why would anyone want to possess the *Mona Lisa*? Why do people steal priceless art? Before the internet, it was much easier to leverage art as currency in the black market, but technology has complicated the crime. If someone stole *Mona Lisa* today, it would be in every news outlet and social media feed within minutes. Anthony Amore, director of security for the Isabella Stewart Gardner Museum, said, "Art thievery is a short-sighted crime. Thieves are certain they're going to make loads of money. Then it hits the press and they realize this is going to get them in trouble."[33] This is why so many priceless stolen works are slow to resurface, if they resurface at all—thieves realize they'll likely get caught, whether they try to sell them or return them to claim the reward.

No one can own *Mona Lisa*. Article 451–55 of the French "Heritage Code" governing national treasures stipulates, "Collections held in museums that belong to public bodies are considered public property and cannot be otherwise."[34] Still,

there is something in us that makes the thought of owning *Mona Lisa* compelling. The desire to possess the unattainable is a thread that runs through *Mona Lisa*'s story—from the thief's desire for money, to his (perhaps feigned) wish for Italy to own the painting that originated there, to the Louvre's desire to have its stolen works back, to the desire of people around the world to reclaim something they didn't realize was important to them until it was gone, to the photographs the throngs of tourists take and the refrigerator magnets they buy in the gift shop before they leave the Louvre.

It is this desire for the unattainable that made *Mona Lisa* the most famous painting in the world. And this is the same compulsion that makes the fifty-year-old man abandon his family for a young trophy wife, motivates the financier to set a goal of becoming a millionaire by the time he turns thirty, or drives the anxious mother to try to preemptively ensure her children will succeed and reflect well on her as they grow up. We want to possess what is not meant to be owned—security, control of the future, unencumbered use of the best the world has to offer. And if we can't have those, we'll try to obtain things that give the appearance of them. We think we can prove something about our worth to ourselves or to others when we pull up not in just any car but in a Porsche.

Why do we want what we cannot have? And what does this pursuit cost? Ecclesiastes 5 tells the story of a man who tried to add value to his life by owning what could not be kept. Verses 13–15 read, "There is a grievous evil that I have seen under the sun: riches were kept by their owner to his hurt, and those riches were lost in a bad venture. And he is father of a son, but he has nothing in his hand. As he came from his mother's womb he shall go again, naked as he came, and shall take nothing for his toil that he may carry away in his hand."

When the man in Ecclesiastes possessed his wealth, it did

30 Van Gogh Has a Broken Heart

him no good. When he lost it, it was unrecoverable. When the next generation needed it, he had nothing to offer. Old Testament scholar Derek Kidner says of the man's wealth, "Now it has spoilt their lives twice over, first in the getting, then in the losing. . . . [The author] is mainly pointing out what happens, not what ought to happen, in a world we can neither dictate to nor take root in."[35]

The person who tries to add value to their existence through acquiring things will meet the unavoidable reality that we take from this world the same as what we brought into it—in terms of possessions, nothing. Yet when we encounter objects or desire status that we think can add to our worth, something in us, to borrow a phrase from songwriter Jason Isbell, wants to "try to chase it down, try to make the whole thing mine."[36] There is something in the human condition that leads us to believe that possessing external things regarded as precious and desired by the world will somehow add to our intrinsic value, even when it costs us dearly.

In what ways do we ask of life more than it can give?

For two years, Vincenzo Peruggia hid the most famous painting in the world in a compartment under a false bottom in a trunk in his living room. Did she haunt him? Did he hear her like the madman in Edgar Allan Poe's "The Tell-Tale Heart," who said of the victim he dismembered and buried under his floorboards, "Now, I say, there came to my ears a low, dull, quick sound, such as a watch makes when enveloped in cotton. I knew that sound well, too. It was the beating of the old man's heart. It increased my fury, as the beating of a drum stimulates the soldier into courage."[37]

Though Peruggia held *Mona Lisa* for a time, did he ever really own her? Could anyone really own her? And as she lay wrapped in blankets, hidden away there in his apartment, did he ever get a good night's sleep?

CHAPTER 3

NOW LET YOUR SERVANT GO IN PEACE

Rembrandt's *Simeon in the Temple* and the Power of Suffering

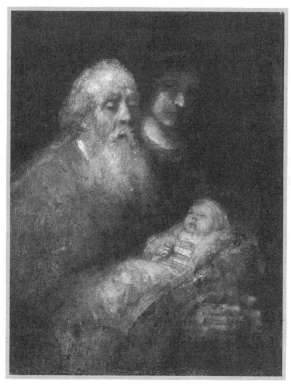

Rembrandt van Rijn, *Simeon in the Temple*, 1669, oil on canvas, 98.5 cm × 79.5 cm, Nationalmuseum, Stockholm.
© Swedish National Art Museum / Bridgeman Images

The Son of God . . . suffered unto the death, not that men might not suffer, but that their suffering might be like his.

George MacDonald, *Consuming Fire*

March 1669. An old man stands in a church holding his infant granddaughter in his arms. His young daughter looks on from a pew in the front row as he stands in as godfather at his granddaughter's baptism. These two girls are all that are left of Rembrandt's family.

The minister dips his hand into the baptismal font and prays:

> Almighty and eternal God, you, who has according to your severe judgment punished the unbelieving and unrepentant world with the flood, and has according to your great mercy saved and protected believing Noah and his family—we beseech you, that you would be pleased by your infinite mercy, to graciously look upon this child, and incorporate her by your Holy Spirit into your Son Jesus Christ, that she may be buried with him into his death, and be raised with him in newness of life.

The old painter thinks about the severity of both judgment and mercy. He thinks about his son Titus, the boy who lived, and he thinks about his other children—the two sons and two daughters he buried. He remembers his wife, Saskia, dead now for twenty-seven years, and Hendrickje, his companion for the second half of his days. He remembers the swagger, defiance, and ignorance of his youth.

The minister continues:

> May she daily cleave unto Christ in true faith, firm hope, and ardent love; that she may, with a comfortable sense of your favor, leave this life, which is nothing but a continual death, and at the last day, appear without terror before the judgment seat of Christ your Son, through Jesus Christ our Lord, who with you and the Holy Spirit, one only God, lives and reigns forever. Amen.

After his prayer, the minister reminds Rembrandt and the others gathered what this ceremony means: "Since then baptism has come in the place of circumcision, Titia is baptized as an heir of the kingdom of God. Take comfort in that. Go in peace."[1] Rembrandt bows his head, mutters a quiet "Amen," hands Titia back to her mother, takes Cornelia's hand, and shuffles home to work on a painting not unlike the scene he's leaving—a picture of an old man holding an infant in a church.

Humbled by the Greatness of His Own Creation (1606–1634)

Rembrandt was born on July 15, 1606, in Leiden, the Netherlands —the second youngest of six. His father was part owner of a mill along the Rhine River, from which came his family name "van Rijn." They were a well-to-do family, which granted him access to a life of privilege. He entered the University of Leiden in May 1620 at the age of thirteen to learn a viable trade, but his interest in art was already firmly established. All he really wanted to do was draw and paint. With his parents' support, young Rembrandt left the university before the year was done and began studying under the painter Jacob van Swanenburg, where he apprenticed for three years.

After his time in van Swanenburg's studio, Rembrandt moved

to Amsterdam, where he studied under the well-known Pieter Lastman, returning to Leiden at the age of nineteen. When he came home, he "turned eagerly to the work which satisfied him so well that he was wholly indifferent to the usual pleasures of youth."[2] He set up shop as a portrait artist, and soon people came from all over the area to sit for portraits.

At twenty-two, Rembrandt began taking on students. That year, he painted *The Artist in His Studio* (1628). The young artist stands at a distance, back straight, brushes in hand, regarding his expansive canvas. We do not know if he is surveying a finished masterpiece or contemplating the possibilities of his blank canvas. In the portrait, he presents not his work, but himself. He isn't painting; he's thinking. He wants the viewer to appreciate that his craft is as much an intellectual exercise as it is a physical act. One biographer said, "It appears to be a depiction of an artist humbled by the greatness of his own creation."[3] It was a bold painting, full of the pretend confidence of youth. As far as Rembrandt was concerned, the entire world belonged to him. It was his to regard, to capture, and to master, and that's just what he had a mind to do.

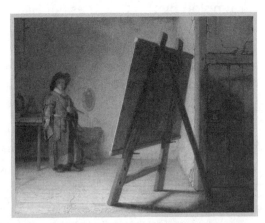

Rembrandt van Rijn, *The Artist in His Studio*, 1628, oil on panel, 24.8 cm × 31.7 cm, Museum of Fine Arts, Boston, MA.
Photograph © 2023 Museum of Fine Arts, Boston. All rights reserved. / Zoe Oliver Sherman Collection / Bridgeman Images

Before long, art collectors and dignitaries from other parts of Europe began to learn of Rembrandt's talent. In 1630, the English ambassador to the Netherlands, Sir Robert Kerr, was so impressed by Rembrandt's work that he bought a couple of the twenty-four-year-old's paintings for King Charles I of England. The following year, Rembrandt returned to Amsterdam. The challenge of proving himself in that prominent city that was quickly becoming a global center of commerce and culture drew him back. To prove himself there, he would have to earn the respect and notoriety reserved for the established masters known around the world. Rembrandt knew the only way to do this was to rival their greatness.

He moved into the home of his friend Hendrick van Uylenburgh, an art dealer. He set up a room in van Uylenburgh's studio and got to work. During his first few years in Amsterdam, Rembrandt completed some of his best-known canvases, like *Simeon's Song of Praise* (1631), *The Philosopher in Meditation* (1632), *The Storm on the Sea of Galilee* (1633), *The Descent from the Cross* (1634), and *The Anatomy Lesson of Dr. Nicolaes Tulp* (1632).

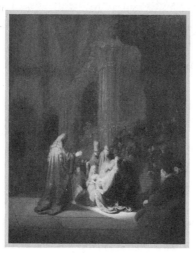

Rembrandt van Rijn, *Simeon's Song of Praise*, 1631, oil on panel, 61 cm × 48 cm, Mauritshuis, The Hague.
Herman Pijpers / CC BY 2.0

36 Van Gogh Has a Broken Heart

When Dr. Tulp commissioned Rembrandt to paint him with his students, Rembrandt saw an opportunity. Where many artists would have arranged the professor and his class as a group seated facing the viewer, Rembrandt took the composition into the classroom. Here he would demonstrate his skill not only in portraiture but also in the illustration of anatomical precision. Rembrandt focused on the cadaver with its tendons exposed. *The Anatomy Lesson of Dr. Nicolaes Tulp* became the talk of the town, and the social elites all wanted versions of their own. Anyone with a high view of their position in the community wanted a portrait of themselves to display in their home. Portraits didn't so much convey the person's likeness as they did their status. For those concerned about such things, Rembrandt could provide something more valuable than money itself—prestige. Before long, he had more commissions than he could manage.

As the money flowed in, it also flowed out. Rembrandt was notoriously terrible with his finances. He began collecting items of luxury and curiosity from around the world—everything from coral and minerals to weaponry, fine dishes, furniture, precious stones, and paintings by Titian, Raphael, and van Eyck, among others. Rembrandt historian Helga Kuenzel wrote, "His artistic imagination was constantly fired by these beautiful possessions, which furnished him with renewed inspiration."[4] These assets, he justified, were an essential part of his rise to prominence.

The arc of Rembrandt's fame can be traced in his signature. His early pieces in Leiden were signed "Rembrant Harmenszoon van Rijn, fecit," which meant "Rembrant, the son of Harmen, who lives by the Rhine, made this."[5] Sometimes he would simply use the monogram RHL—Rembrant, Harmen's son, from Leiden. In either case, he took care to specify which Rembrant he was. But when his renown began to spread in Amsterdam, he added a *d* to his name and dropped everything else: *Rembrandt*. This was a calculated move. If he wanted to be counted among Italian

masters like Michelangelo, Raphael, and Titian, he would name himself as they did—by first name only.

From time to time, as Rembrandt worked in his friend's studio, Hendrick van Uylenburgh's cousin Saskia would come around. She was the orphaned daughter of a wealthy art dealer.[6] Rembrandt asked her to sit for a portrait because he had not yet painted many women. In that portrait, she gives the painter a self-confident, flirtatious look from under the wide brim of her pretty hat. The two formed a bond, and Rembrandt began courting her. In 1634, the two were married.

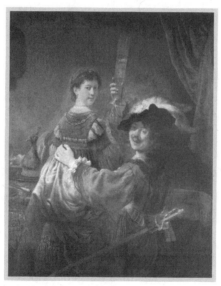

Rembrandt van Rijn, *Rembrandt and Saskia in the Scene of the Prodigal Son in the Tavern*, ca. 1635, oil on canvas, 161 cm × 131 cm, Gemäldegalerie Alte Meister, Dresden.
Public domain

Rembrandt loved Saskia, and she loved him. He painted her often, and his compositions told the story of their devotion to one another. The year after they married, Rembrandt painted *Rembrandt and Saskia in the Scene of the Prodigal Son in the*

38 Van Gogh Has a Broken Heart

Tavern, in which he used himself and his wife as the models. Saskia sits on the prodigal's knee, looking over her shoulder at the viewer. She wears a dignified, sober expression. Rembrandt's bleary eyes betray his smiling intoxication as he raises a large glass of half-drunk wine. A peacock, a symbol of luxury and pride, sits on the table before them. Here he was, a thirty-five-year-old painter in his prime. The money was flowing. His peers respected him, his students revered him, and his wife adored him. He was like the prodigal in the far country before the money ran out—wealthy, free, desired, and dismissive to the possibility of losing it all.

These were arguably the happiest years of his life.

She Looks Away (1635–1642)

In the spring of 1635, Saskia became pregnant. With Rembrandt's career and marriage in place, they now would build a family. On December 15, they welcomed their first child, a son named Rumbartus, into the world. The boy struggled to thrive and died two months later. Though it wasn't uncommon in those days to lose children in infancy, it was still every bit as painful as it is now. This was their first real taste of sorrow as a couple.

Rembrandt and Saskia kept collecting and spending. Saskia's family grew concerned that Rembrandt was going to blow through her trust, so they filed a legal complaint that she and Rembrandt were squandering her inheritance. Rembrandt argued his case, and the van Uylenburghs' complaint failed in the courts, but on a personal level it put distance between the couple and Saskia's family. She was becoming a prodigal too.

In 1638, Rembrandt and Saskia had a second child—a daughter, Cornelia. She lived just three weeks. The following year, using his commissions and Saskia's inheritance,[7] the couple bought a big house in Amsterdam, known today as "The Rembrandt

House." There he opened a studio and took on more pupils. Helga Kuenzel wrote, "Numerous students now flocked to Rembrandt's studio, but in fact the painter had been taking pupils since he was twenty and must have been an outstandingly good teacher, because he knew how to develop the individual talents of each student without oppressing or stifling him with his own genius."[8]

In those days, students tried to emulate their masters. Rembrandt's pupils were no exception. They worked to replicate Rembrandt's contrast of light and shadow, a technique developed in the early 1600s called *chiaroscuro*. During this time, painters of note like Ferdinand Bol and Govaert Flinck worked out of Rembrandt's studio. They studied the master's craft and were paid to create copies of his more popular pieces. Rembrandt biographer Christopher White wrote, "From 1637 onwards there are numerous references in inventories and sales of such copies in collections on the market. One collection . . . contained one original and no less than six copies after Rembrandt, clearly listed as such."[9] Rembrandt's students were so skilled at imitating him that many paintings that came out of his studio were later wrongfully attributed to the master, either by honest mistake or shady opportunism. German art historian Wilhelm von Bode quipped, "Rembrandt painted about 700 pictures in his lifetime. Of these, 3,000 are still in existence."[10]

In 1640, two years after Cornelia's death, Rembrandt and Saskia had a third child, another daughter they also named Cornelia. Like her sister and brother before, this child also died after just a few weeks. That same year, Rembrandt's mother died. His father had died before he left Leiden, and now with his mother gone, he was a thirty-five-year-old orphan. Though his sorrows were beginning to mount, if Saskia was all he could have in this world, she would be enough.

In September of the following year, Saskia gave birth to a fourth child, a son they named Titus. The days turned into weeks

and the weeks into months as Titus grew bigger and stronger. To their great joy, they were given a child who would live—a testament and heir to their love.

By the time Titus was born, Saskia's body had endured great travail. This fourth labor and delivery drained her of her strength, and in May 1642, Saskia fell ill. Sensing she might not recover, she drew up a will stating that Rembrandt would receive her entire estate upon her death, provided he never remarry. Ten days later, Saskia died, taking with her their life of youthful exuberance and leaving Rembrandt alone with their nine-month-old son.

Rembrandt mourned Saskia's passing by painting one final, intimate portrait of his beloved. She is elegant, bathed in light, again wearing a wide-brimmed hat. But in this final pose, she looks away. She will never set her eyes on him again.

Rembrandt van Rijn, *Portrait of Saskia van Uylenburgh*, ca. 1633–1634, oil on oak panel, 99.5 cm × 78.8 cm, Gemäldegalerie Alte Meister, Dresden.
Public domain

Geertje Dircx (1643–1656)

When Saskia became ill, Rembrandt hired a widow, Geertje Dircx, to nanny for Titus and help keep the house.[11] After Saskia died, the two became intimate, and Geertje read Rembrandt's advances as a path to marriage, which she wanted because she had no other family. But Rembrandt had no intention of remarrying because he would have to forfeit Saskia's inheritance, likely including his house.[12] Geertje insisted that if Rembrandt had no intentions of marriage, his sexual advances were a crime against her honor. Still, he refused to marry, and she became a woman scorned.

Rembrandt's years with Geertje were unhappy from the start and filled with trouble. In 1646, Geertje left Rembrandt's house and sued him for refusing to marry her, stating that he seduced her under the false pretense of marriage. On October 23, 1649, the Court of Commissioners of Marital Affairs in Amsterdam found that although Rembrandt made no promise to marry Geertje, he did indeed seduce her, and he was ordered to pay her 200 guilders per year in alimony for the rest of her life.

Though the court ultimately found in Geertje's favor, she refused to sign the settlement because she felt she was entitled to more. She sold some of Saskia's jewelry and kept the money, which enraged the painter. Biographer Charles Mee said Rembrandt reached out to Geertje's brother, who had been given power of attorney over Geertje, and used him to "collect testimony from neighbors against her, so that she could be sent away to an insane asylum."[13]

With this testimony, Rembrandt countersued her for not agreeing to the settlement and had her put in prison. Geertje was institutionalized for five years, and when the possibility of her release came up, Rembrandt hired a private investigator to collect further evidence against her to make sure she remained locked away.[14] Geertje was released from prison in her early

42 Van Gogh Has a Broken Heart

forties, having spent the bulk of her thirties either in jail or in the asylum. She died the following year, in 1656, destitute and alone.

Henri Nouwen wrote, "This Rembrandt is hard to face. It is not so difficult to sympathize with a lustful character who indulges in the hedonistic pleasures of the world, then repents, returns home, and becomes a very spiritual person. But appreciating a man with deep resentments, wasting much of his precious time in rather petty court cases and constantly alienating people by his arrogant behavior, is much harder to do."[15]

Through all this, Rembrandt kept painting, and his professional reputation only grew. The Amsterdam city journal called him "one of the most celebrated painters of this century."[16] Amid the swirl of loss, grief, lawsuits, bitterness, and scheming, Rembrandt had reached the professional summit he longed for when he moved from Leiden to Amsterdam. He had become a household name.

Rembrandt, Hendrickje, Titus, and Cornelia (1657–1662)

After Geertje left, Rembrandt hired a new young housekeeper and nanny named Hendrickje Stoffels, who began appearing in several of his compositions. Rembrandt soon fell in love with Hendrickje. The two lived together as common-law husband and wife for many years, though they never married. Hendrickje was with Rembrandt during his legal battle with Geertje.

While Geertje sat in the asylum, Rembrandt and Hendrickje made a new life for themselves. In the early 1650s, Hendrickje bore Rembrandt a son who died in infancy, but in 1654, she gave birth to a daughter they named Cornelia. The child thrived, and once again Rembrandt and Titus had a family. They would try to rebuild what was lost.

Though Rembrandt had the reputation of wealth, his financial world was in disarray. The year before Cornelia was born,

Rembrandt received a bill for multiple back payments on his house. He borrowed enough to repay those charges by moving debt to other lenders. His legal fees, spending habits, unchecked borrowing, and poor business acumen were catching up to him, and in 1656, when he was fifty years old, his new creditors began to demand repayment as well. Early the following year, he auctioned off some of his art supplies to whittle down his debts. This barely made a dent, so he held an additional two auctions later that year, but nothing seemed to close the gap. To right his reputation, Rembrandt agreed to surrender his assets to repay his creditors. Through a further series of auctions, he sold off much of his art collection and personal property.

His paintings continued to sell, but he was in deep. Fearing his lenders would strip him of everything he had, Rembrandt devised a plan to shelter what little he might preserve by giving it all to Titus. He drew up legal papers that named his teenage son as the owner of most of his possessions, including the house. Then he had Titus make a will leaving every item he owned, "including those he might have inherited from his late mother" and "any he might yet come into possession of now and again," to Rembrandt.[17]

With the house in Titus's name, along with many other possessions, Rembrandt declared bankruptcy before the high court of Holland. Bankruptcy meant he would have to liquidate his goods at auction and disburse the proceeds to his creditors, which they would then have to receive as satisfaction for his debts. A list of 363 items, including paintings, sculptures, stage props, weapons, furniture, books, prints, and musical instruments, were inventoried and sold,[18] but the proceeds didn't cover his debts, and his creditors were not happy with his gamesmanship.

Fearing what would happen to him if something were to happen to Titus, Rembrandt changed a couple of details in his son's will. First, instead of everything going to Rembrandt, it would now all pass on to Cornelia. Second, the will stated, "The

aforementioned father shall control and administer the property left behind, at his discretion and desire . . . and may, in case of need, dip into, take, and use the principal sum."[19] Rembrandt scholar Charles Mee said, "Rembrandt finally found the key: to possess his property, but not to own it. To be able to dip into it whenever he wanted, to take it, to use it, to sell it, but to have it forever not his own, forever beyond the reach of his creditors."[20]

Rembrandt's shell game proved to be only partially legal, and his creditors soon found a way to go after the house. In 1658, he sold his home in the center of Amsterdam and moved to a rental away from the heart of town, in the community of the Jordaan, "one of the poorer neighborhoods of Amsterdam, filled with the houses of the lower middle classes, of artisans, and small shopkeepers."[21]

When Rembrandt, Hendrickje, Titus, and Cornelia moved into their new rental, they took a long look at what would need to happen if they were to have any peace moving forward. In 1660, Hendrickje and Titus took control over Rembrandt's financial and business affairs, essentially incorporating him so he was no longer an artist but a cottage industry. Hendrickje and Titus ran the business and hired Rembrandt as an "advisor," an arrangement structured to provide room and board in exchange for advice and art, thus making his work the legal property of the firm so it could not be seized. They also acquired works by other artists and hung their shingle as art dealers. It wasn't until 1661 that Rembrandt was finally able to pay off his debts. Under this new arrangement, Rembrandt finally found some peace.

Self-Portrait with Two Circles (1663–1669)

The Black Plague had been making its way through Asia, Africa, and Europe since the early 1300s, surging and waning but never dying off completely. It would claim tens of thousands of lives,

Now Let Your Servant Go in Peace 45

wither away, and come back in a different strain. Contracting the plague was a miserable way to die; it covered the body in sores and infected the respiratory system so the victim would lie in bed, racked with pain, drowning as their lungs filled with fluid.

In 1663, the plague hit Amsterdam. One-tenth of the population, an estimated 10,000 people, died during its first surge. Another 24,000 were lost during its second. Hendrickje was one of them. Her death plunged Rembrandt into a depth of compounded distress. He was grieving not only the loss of his companion and friend, but all the sorrows that came before—Saskia, his children with her (Rumbartus and the two Cornelias), and the loss of his fortune. Perhaps even the cruel outcomes of his affair with Geertje. We don't know if Rembrandt ever truly repented of his treatment of her, but going through his life carrying this character flaw that would allow him to so mistreat and diminish another human being must have caused some kind of pain—the unhappiness that comes with practicing wretchedness.

When Hendrickje died, Rembrandt's output slowed—an outcome of grief that complicated his already fragile financial stability. But his works in this period were particularly focused and poignant. Helga Kuenzel wrote that this "sorrow seemed to open for him new realms of the spirit, this time the ultimate, deepest regions. . . . In these last years Rembrandt gave himself up entirely to artistic visions and with his wisdom he acknowledged only one aim—to portray the higher life, the hidden spiritual existence."[22]

Among these works is his *Self-Portrait with Two Circles* (1665). With brushes and maulstick in hand, the aging artist wears a fur-lined robe with a red shirt underneath, along with the white cap that appears in his later self-portraits. X-rays of the painting show that he altered the composition significantly from what he first put on the canvas. Originally, his body was turned more to the right and his brush hand was raised, painting a canvas. But at some point, he lowered his hand, stopped his work, and turned

to face the watching world. Rembrandt said, "Life etches itself onto our faces as we grow older, showing our violence, excesses, or kindnesses." In *Self-Portrait with Two Circles*, he looks at the viewer with a "searingly direct gaze and austere mood."[23] He stands like a monument. Two circles on the wall behind him call to mind a map of the world—his now empty—or perhaps they represent, as some scholars speculate, the spheres of theory and skill, necessary complements to the genius of any artist.[24] His hand on his hip conveys defiance, as if to say that, in light of all he has lost, he has not lost his vocation. Here stands a painter.

Rembrandt van Rijn, *Self-Portrait with Two Circles*, 1669, oil on canvas, 114.3 cm × 94 cm, Kenwood House, London.
Public domain

Titus took over the family business. Work and busyness created a practical and logistical distance between Rembrandt and his son. Titus served as the keeper of his father's affairs and

maintained the home, but as he stepped into his twenties, he began to explore what a life of his own might look like. In 1668, Titus married a woman named Magdalena van Loo, the daughter of Jan and Anna, a couple who had been friends with Rembrandt and Saskia many years before. Magdalena's father had since died, and so Titus agreed to begin their marriage in the van Loo home so Anna would not have to live alone, leaving Rembrandt with Cornelia.

Soon after the wedding, Magdalena became pregnant. When she was three months along, Titus succumbed to the same plague that took Hendrickje five years earlier. He died on September 4, 1668. Rembrandt had no money to buy a grave for his son, so Titus was laid to rest in a rented plot with the plan to move his remains to the van Loo family grave later. But that never happened. Magdalena died in October of the following year.

Before she died, on March 22, 1669, she gave birth to a baby girl, named Titia after her father. Magdelena asked Rembrandt to stand in as the child's godfather at her baptism. Rembrandt received Magdalena's invitation as a great honor. This fragile baby was all that was left of his son Titus. And she was all that remained of Saskia. She held his heart.

On October 4, 1669, seven months after Titia's baptism, Rembrandt died. He was sixty-three. A notary came to catalog his possessions. He owned very little. Aside from his paintings, the notary made a list of fifty-five items,[25] including "painting equipment, a bed with blankets, some clothes, a few handkerchiefs, caps, and a Bible."[26] Like his son, he was buried in a rented grave. The location remains unknown.

The Two Simeons

Simeon in the Temple (1669) was Rembrandt's final painting. Luke's gospel tells the story of an old man, possibly a cleric, whom

48 Van Gogh Has a Broken Heart

the Lord had promised would not die until he had seen the coming Messiah.[27] Simeon went to the temple every day to wait. Then one day, Mary and Joseph arrived with their child and the poor man's offering of two pigeons, answering the call of their ancient faith to redeem their firstborn son.[28] As the couple took their boy to the place where he would be redeemed, Simeon saw them and knew in his spirit that this child was the Messiah.

All his life, Simeon hoped he would catch a glimpse of the Christ, but God had something better in mind. Simeon got to *hold* him. He took the boy in his arms and sang a song of praise:

> O Lord, my God! Father of all blessing and honor and praise, you have been so good to your servant. I hold in my arms your salvation, which you have prepared in the presence of a dark but watching world. He will be the light by which the Gentiles will see you and come to know you, and the light by which your people Israel will again see the glory of how you have loved them with a love that has not let them go. O great and glorious King, Shepherd of my soul, Captain of my guard, I have kept my post. I have not turned my eyes from the horizon because you have promised that your Messiah would come on my watch. I have seen him. I have held him. Now let your servant go in peace. Honorably retire your watchman, O great and glorious King, and bring me home.[29]

Simeon in the Temple was found, unfinished, in Rembrandt's studio the day after he died. It didn't have the third person in the background yet—presumably Mary or Anna the prophetess; it was simply an old man holding an infant, as Rembrandt had done at Titia's baptism.

Rembrandt was drawn to this story; he had sketched and painted it many times. In 1631, he had painted *Simeon's Song of*

Now Let Your Servant Go in Peace 49

Praise, a crisp, ornate scene with the temple itself as a character in the story, "a vast vaulted building peopled with chance spectators."[30] Rembrandt's composition captures "an extraordinary event taking place amidst the normal bustle of existence."[31] A beacon of light shines down from heaven on the central characters, illuminating everyone except Jesus. Light does not fall on him but rather emanates from him. Simeon holds the Christ as he gazes up to heaven. Joseph kneels with his birds. Another attendant in the temple looks on, hands raised in praise. Nearly two dozen other figures line the background.

Rembrandt painted *Simeon's Song of Praise* when he was twenty-five, the year he moved to Amsterdam, before he married Saskia. He was a newly arrived prodigal in the big city, flush with cash, establishing the expectation of greatness, showing what he was capable of. In this painting, the young painter was flexing, kissing his artistic bicep, and winking at the viewers. If at twenty-five he could already do this, just imagine where he'd be at thirty-five.

His final painting of Simeon couldn't be more different. This one has no reference to the temple at all, just an old man holding the Christ. Gone are the crowds looking on. Gone are the columns, filigree, and architecture. Gone is the brilliant beam of light. The crisp brushwork of a steady young hand has given way to the shaky, mottled impressions of the master's touch. All we see is an old man and his Lord. Simeon's hands are pressed together in prayer. A gentle light emanates from above, bathing them both, and only them, as though they are the only two people in the world—this baby at the beginning of life and the old man near his end, holding at last the peace that has eluded him.

The third figure is draped in shadow as a way of highlighting just how intimate this moment is between Simeon and the Messiah. At sixty-three, Rembrandt isn't concerned with impressing his audience. He is content to deliver warmth over

Van Gogh Has a Broken Heart

detail, individuals over a crowd, and simplicity over grandeur. He presents a man ready to take his leave, satisfied that his life has led him to this moment he had longed for all those years.

Practicing Our Faith

People often speak of Christianity as a practice—we *practice our faith*. We shouldn't dismiss the use of the word *practice* as merely a synonym for *do* or *believe*. To be a "practicing Christian" means we practice our faith in the same way a pitcher might practice his curveball or a cellist might practice a certain piece of music. There is an art to the Christian life, and any artist will tell you learning a craft takes practice.

Rembrandt must have made some terrible art when he was young—ugly stick figures only his mother could have loved. He didn't go from stick figures to the ornate *Simeon's Song of Praise* without practice. He had to learn what makes for good composition. He had to study light, shadow, the weight of lines, vanishing point, and human form. He had to drill on fundamentals until they were second nature. This is a good analogy for living the Christian life. A child can embrace the simplest board-book basics of the gospel and offer stick-figure prayers, but living the Christian life is an art we spend our entire lives learning. And suffering is one of our teachers.

Louis Évely wrote, "A tortured heart committed to the Father is the most living image of the Redeemer."[32] To suffer well is not to have our faith shattered but rather to have it strengthened because, through it, the object of our confidence becomes clearer and more focused. The blessing of suffering is that it strips away any pretense of not needing God or others. It frees us from "this exhausting comedy"[33] of having to pretend that we're fine on our own.

When we face trials of many kinds,[34] the goal of life as it pertains to suffering is not to leverage our pain to move us from

Now Let Your Servant Go in Peace 51

rudimentary prayers for help to elaborate masterpieces of eloquence. The goal of suffering well is to move us not only beyond the stick figures, but also from a place of pride to one of intimacy and familiarity with our Lord. It is to move us not from crude to eloquent, but from unfamiliar to intimate. This is why we practice spiritual disciplines.

I have to believe that the contrast of Rembrandt's two paintings of Simeon is most certainly a commentary on his own life. Fame, money, sex, love, art, and time threw him headlong into suffering, and the suffering changed him. In his earlier painting, the twenty-five-year-old did not know the sorrow he would face. When he imagined the scene of Jesus being presented in the temple, he saw an opportunity to show us what he could do. He saw the ornate beauty of the building, the faces of those looking on, the trick with the light. There is much bravado in that image, but little intimacy.

I wonder about the later painting of Simeon holding the Christ. The older artist has suffered. He has buried a wife and children. He's gone through bankruptcy. He has risen to fame and seen it all come crashing down. He has been humbled by life. Rembrandt's body of work bears witness to a religious man and a student of Scripture. I wonder, as wave after wave of suffering crashed upon the shores of his heart, did he distance himself from God as he aged, or did those waves round his rough edges? When I think about the suffering I've witnessed in others over the years, as well as in my own life, I see how it will either harden people or break them, tempering the swagger of youth, softening their hearts toward the mercy of God, and emptying them of the cocksure certainty that they are fine on their own.

When I look at the old painter's reimagining of the scene, to my eye he doesn't seem to want to show us the spectacle of the temple when Simeon held Jesus, or what he can do with it as a painter. After a life filled with suffering and sorrow, he just seems to want to hold Jesus.

CHAPTER 4

THE ALLEGORY OF PAINTING

Artemisia Gentileschi and Inhabiting a Discipline in an Unjust World

Artemisia Gentileschi, *Self-Portrait as the Allegory of Painting*, 1638–1639, oil on canvas, 98.6 cm × 75.2 cm, London. Royal Collection Trust / © His Majesty King Charles III, 2023 / Bridgeman Images

> And now, I'll show Your Most Illustrious
> Lordship what a woman can do!
>
> **Artemisia Gentileschi**

Thumbscrews were a medieval torture device designed to obtain a confession during an interrogation. They were typically comprised of three vertical bolts holding two horizontal metal bars—sometimes flat, sometimes spiked—that could be pressed together with the turning of a wingnut on the threaded middle bolt. The interrogator would place his subject's thumbs between the two bars and slowly turn the screw. At first the pressure would inflict agonizing pain, but soon it would rupture the flesh and eventually crush bone. The pain the device caused proved incredibly reliable in persuading people to confess their guilt. It was also a very effective way to coerce false confessions from the innocent. Only those of a fierce constitution and clear conscience could withstand the pain.

The transcript from the trial of Agostino Tassi, dated Monday, May 12, 1612, read in part:

> The defendant said, "I say this, that everything the summoned woman said and put down on paper is a lie and is not the truth at all."
>
> The summoned woman then replied, "I say this, that everything I have said is truth, and were it not truth, I would not have said it."
>
> And the summoned woman was asked whether she

was prepared to confirm her aforesaid testimony and deposition, as well as everything contained in it, even under torture. She answered, "Yes sir, I am ready to confirm my testimony even under torture and whatever is necessary."

Then the judge said, "If the truth indeed appears to be as the summoned woman testified in her examination, she should not hesitate to confirm everything, even under the said torture of thumbscrews."

She answered, "I have told the truth and I always will, because it is true and I am here to confirm it."

Then the judge ordered that the prison guard put on the thumbscrews and her hands before her breasts, and while the guard tightened the screws, the woman began to say, "It is true, it is true, it is true, it is true," repeating the above words over and over, and then saying, "This is the ring you gave me, and these are your promises."

Asked whether what she had testified in her examination and had just now confirmed in his presence was and is true, and whether she wished to sanction and confirm it under the said torture, she answered, "It is true, it is true, it is true, everything that I said."

The defendant said, "It is not true. You are lying through your teeth."

The summoned woman answered, "It is true, it is true, it is true."

Since both of them stood by their statements, the judge ordered the thumbscrews be untied and removed from her hands . . . and then the judge dismissed the summoned woman.[1]

The summoned woman, Artemisia Gentileschi, was eighteen years old.

Orazio and Susanna

Artemisia Gentileschi was born in Rome on July 8, 1593, to her mother, Prudenzia di Ottaviano Montoni, and father, Orazio Gentileschi. Orazio was a mannerist painter, with a style that emphasized exaggerated positions and asymmetrical composition, as opposed to the more balanced and harmonious approach of the high Renaissance work that came before. He was born in Pisa in 1563 but moved to Rome around 1576. In his late thirties, around 1600, he befriended the younger Italian Baroque artist Caravaggio, and the two painters caroused the city together until Caravaggio had to flee to Naples in 1606.

Orazio lived and painted in Rome until 1621, when he moved to Genoa, and then to Paris in 1624, and eventually to London in 1626, where he became a court painter for King Charles I until Orazio died around 1639. During his time in Rome, he ran a studio out of his home. When his wife, Prudenzia, died giving birth in 1605, his twelve-year-old daughter, Artemisia, began studying art under her father, along with her brothers, mixing colors, preparing canvases, and learning technique.[2] She quickly emerged as the most talented of the siblings, and by the time she was sixteen, she was "giving drawing lessons to apprentices, and was fulfilling commissions for portraits and religious themes."[3] She was learning how to be a working artist.

During this period, when she was just seventeen, she painted one of her earliest and most celebrated surviving works, *Susanna and the Elders* (1610). "Susanna and the Elders" is a story from the deuterocanonical *Book of Susanna* in the additions to Daniel in the Roman Catholic Apocrypha. In it, two older men spy on a young married woman as she bathes and then demand favors from her or else they will destroy her reputation. She says to them, "I am completely trapped. For if I do this, it will mean death for me; if I do not, I cannot escape your hands. I choose not to

The Allegory of Painting **57**

do it; I will fall into your hands, rather than sin in the sight of the Lord."[4]

Then she screams for help. The men flee but later claim to have caught her in the act of adultery, an offense punishable by death. Her life is at the mercy of the court. During her trial, a young man named Daniel notes inconsistencies in the two men's testimonies and proves her innocence by exposing their lies.

In Susanna's facial expression and body language, Artemisia captures the young woman's anguish over how she is being treated. She had come to simply bathe and now has to ward off the unwanted advances of men who possess the power and position to destroy her life if she doesn't acquiesce. She didn't ask for this encounter, nor does she have much control over it, except to choose which painful road she will walk as a result of their actions. Give in, and her life and reputation will be destroyed. Resist, and her life and reputation will be destroyed.

Artemisia sets Susanna's exposed skin against the pale stone on which she sits—both surfaces at their most elemental, one vulnerable and warm and the other hard and cold. Artemisia does not eroticize her subject by presenting Susanna in a suggestive pose. Susanna is fending off her would-be seducers, twisting away from them, contorting her neck. This was a significant departure from many depictions of this scene done by male painters, who often presented Susanna as a seductress.

Art historian Mary Garrard said, "Presenting Susanna as seductive makes her responsible for the Elders' action, which was the legal and social crime of cuckolding her husband. The appearance of her inviting their attention wipes out the issue. And it keeps all three men, the Elders and Joachim [Susanna's husband], on the same side—as joint venturers in the tricky business of balancing their sexual appetites with their desire to maintain patriarchal control of their women."[5] Artemisia offers no indication that Susanna is complicit in this moment. She is entirely a victim.

Susanna appears to be roughly the same age as Artemisia when she painted it, and they bear some physical resemblance. In describing Artemisia's choice to present Susanna with features similar to her own, Elissa Weichbrodt, author and art professor at Covenant College, told me in an interview, "This painting is smart because what Artemisia is doing is using a biblical story that was very popular at that time in such a way that it would spread the message of both her own moral virtue and skill simultaneously for an audience that was likely to be skeptical about both, and in so doing, make her commercially viable."[6]

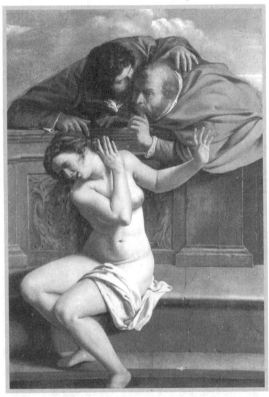

Artemisia Gentileschi, *Susanna and the Elders*, 1610, oil on canvas, 170 cm × 119 cm, Schloss Weißenstein, Pommersfelden, Bavaria.
incamerastock / Alamy Stock Photo

But depicting Susanna in Artemisia's own likeness was also a risk. Art historian Sheila Barker said, "That physical resemblance encouraged a potentially scandalous connection between the artist and the nude figure she had painted, and viewers must have wondered if they were seeing a nude self-portrait of the pretty young daughter of Orazio Gentileschi in the guise of a blameless Biblical heroine. The identification was further encouraged by the proximity of Artemisia's signature to Susanna's pale legs, appearing like an inscription in the stone on which her pale body rests."[7]

Artemisia's *Susanna* simultaneously proclaimed her moral virtue and skill while subjecting her physical and personal worth to the imaginations of men who did not recognize the dignity of women. Living as a working artist in that world was Artemisia's great dilemma. Barker said, "Work as a history painter required a knowledge of the world and the affairs of great men."[8] Artemisia had to expose herself to the injustices and misogyny that went with her field of discipline, and even if she found some success among other artists, she would still have to adhere to a standard of decorum and resolve most men never had to think about.

Artemisia's talent and family trade telegraphed the real possibility of becoming a successful painter. She had the skill, resources, connections, and God-given talent. The problem was that the access she had was to a world in which very few women operated. To navigate it, she would have to be both cautious and clever. And even then, she would still suffer.

Truth and Consequence

As an art student, Artemisia studied the human body and was good at rendering people, but she hadn't yet been trained in how to set the figure into space. This limitation is seen in *Susanna and the Elders* in the way Susanna sits on a bench in front of

60 Van Gogh Has a Broken Heart

a wall—a choice that accommodated Artemisia's artistic limitations. Though most painters at that time set "Susanna and the Elders" in a garden, at seventeen years old, Artemisia didn't know how to set her figures in a place of depth. It wasn't until the mid-1630s that Artemisia began painting landscaped backgrounds.[9] To help her learn this skill, her father hired a young colleague, Agostino Tassi, to teach his daughter how to draw in perspective.

Tassi and Orazio collaborated on each other's work; Orazio painted figures into Tassi's landscapes, and Tassi helped Orazio with his backgrounds. The fact that Orazio ran a studio out of his home meant people came and went all the time. Because Tassi worked with Orazio and mentored his daughter, he was afforded regular access to their house. On May 6, 1611, Tassi went to the Gentileschi home and sexually assaulted his student Artemisia. According to Sheila Barker, details of the assault "and the complicated relationship that ensued over the following months between the victim and her aggressor can be reconstructed from the various testimonies gathered in the course of the criminal trial brought by Orazio."[10]

In those days, when a man assaulted another man's daughter in this way, particularly if they were both from respected families in the community, restitution often meant the offender would have to marry his victim to safeguard her family's name. When Orazio learned of Tassi's crime, he demanded that Tassi marry Artemisia. Tassi agreed. In his proposal, he told Artemisia, "Give me your hand and I promise to marry you as soon as I am out of the mess that I am in. I warn you that when I take you as a wife I want no foolishness."[11]

Artemisia spent the next ten months engaged to Tassi, an arrangement he used as an excuse to continue taking advantage of her under the promise that they would soon be married. But Tassi and Orazio had a falling out over money, and Tassi backed

The Allegory of Painting 61

out of the engagement. When he did, Orazio brought criminal charges against Tassi for violating his daughter and sullying the Gentileschi family's good name.[12]

In the three-hundred-page transcript of that trial, Artemisia gives a lengthy, graphic description of the attack in her own words. She told her version of what happened with clarity, composure, and consistency. Tassi denied everything, insisting she was lying, leaving the court in a quandary over who to believe. So the judge asked the eighteen-year-old young woman—not the thirty-four-year-old man—if she would submit to torture to verify the truth of her testimony. She agreed, and as the guard tightened the thumbscrews, she did not change her story. Rather, she kept insisting, "It is true, it is true, it is true."

Tassi was found guilty and sentenced to five years' exile from Rome—a sentence no one seemed dedicated to enforcing. Instead, it was the Gentileschi name that took the hit. Artemisia experienced the reality that "even the smallest transgressions of the spatial and social boundaries of the private sphere could be devastating for a woman's standing, especially if she was unmarried."[13] Neighbors talked about how she would stand looking out the window of her home, as though she wanted the attention of men. This, coupled with her work as a painter, which involved familiarity with the affairs of men, led neighbors to "besmirch Artemisia's name with malicious slander,"[14] which diminished her chances of securing patronage as an artist in Rome. And if Artemisia's name took on a bad reputation, Orazio's would too. So Artemisia's father arranged for her to marry a Florentine painter named Pierantonio Stiattesi, and in 1613 she moved to Florence and began working as a painter for the Medici Court, a wealthy banking dynasty in Italy.[15]

In Florence, she painted several of her best-known works—the violent *Judith Slaying Holofernes* (1614–1620) and *Judith and Her Maidservant* (1613–1614), both depicting Judith and her

62 Van Gogh Has a Broken Heart

maidservant beheading Holofernes; and *Jael and Sisera* (1620), from the book of Judges, the scene in which Jael drives a tent peg through the temple of the sleeping general. These paintings have often given the impression that Artemisia's work focused on the grotesque, though the majority of her other paintings aren't violent.

Between 1613 and 1618, Artemisia and Pierantonio had five children. Giovanni Battista, their first; Agnola, their second; and Lisabella, their fifth, each survived less than a year. Their third child, Cristofano, died at the age of five. Only Prudentia, their fourth, survived into adulthood.[16]

The seven years Artemisia spent in Florence were tumultuous. She "underwent financial challenges, the deaths of three children, the wreckage of her adulterous affair with a younger man named Francesco Maria Maringhi, frequent displacements of her household and workshop, continuous legal trouble over her debts with servants and shopkeepers, and even accusations of theft."[17] But her work as an artist thrived. She won the patronage of the Grand Duke of Tuscany and became friendly with many of the social elite, including the playwright Michelangelo Buonarroti the Younger (nephew of Michelangelo, the Italian master) and Galileo Galilei.

Financial pressure forced Artemisia out of Florence. A court record from 1619 suggests Artemisia and Pierantonio were no longer living together at this point.[18] She moved back to Rome in 1620 and tried to rebuild her career, but a developing rift between her and her father aggravated her deteriorating marriage. Orazio still owed Artemisia's husband five hundred Florentine scudi as part of a promised dowry—roughly three years' wages. His delay in paying the dowry exacerbated Artemisia and her husband's financial troubles, but when they tried to escape the debt by fleeing Florence, creditors seized her property and supplies and informed her father of what they had done.

The Allegory of Painting **63**

Ashamed and embarrassed, Orazio refused to pay the remainder of the dowry. Pierantonio sued Orazio for payment, and Artemisia found herself in an unexpected legal battle with her father.[19] It took her some time to reconcile with Orazio and make good on her unfinished commissions in Florence before she could gain much traction as a working artist in Rome.

Artemisia caught the eye of "one of the most ardent art collectors in Rome, Cardinal Montalto."[20] He saw her painting of Hercules, commissioned by the Grand Duke of Tuscany, and commissioned a copy of his own. Artemisia used her time in Rome to demonstrate her versatility as an artist. She learned new techniques and showed that she could imitate the styles of other celebrated painters. Rome was a competitive market, and she recognized the value in being able to move among styles to accommodate the preferences of her patrons.

Along with portrait work, Artemisia received multiple commissions of religious scenes by members of Spanish nobility, including the Spanish ambassador to the pope.[21] There she painted *Mary Magdalene in Ecstasy* (1623–1625) and *Judith and Her Maidservant with the Head of Holofernes* (1624–1627).

In 1626, she left Rome for Venice, where she stayed four years. Historians speculate she made this move to expand her reach as an artist.[22] There she saw the large-scale canvases of Tintoretto and Veronese, which were filled with multiple characters and complex scenes that she would imitate in her later works. Always a student, she studied Tintoretto's use of paint, learning how to apply it more loosely and with greater expression.[23] In Venice, her reputation as an artist was at an all-time high. She received a lucrative commission from King Philip IV of Spain for *Hercules and Omphale* (1628), which was probably destroyed in a fire in the 1700s.[24]

In 1630, Artemisia moved to Naples when she was invited to join the court of the Spanish viceroy, the Duke of Alcalá. At this

64 Van Gogh Has a Broken Heart

point in her career, she was working on commissions for the daughter of King Philip IV and an altarpiece of *Annunciation* (ca. 1630) for the national church—San Girolamo dei Genovesi—of the Genoese residents in Naples. In Naples, Artemisia worked closely with her patrons, delivering work tailored specifically to their desires. Her commissions were profitable, and the placement of her work was prestigious.

But Naples was both violent and expensive. The life of a single mother was a difficult existence, so Artemisia made the decision to leave. She reached out to a former connection in the Medici Court to arrange a way back to Florence. That appeal led nowhere, but in 1638, she was sent to London "as part of a soft diplomatic campaign to coax Charles I into lending support to the Catholic cause in England."[25] The timing of her move to London allowed Artemisia to be with her father during his last months. He died in February 1639, and Artemisia stayed in London for another year after his death to fulfill her commissions there before moving back to Naples, where she remained until her own death. Historians speculate that she died in 1656 from the plague that swept through Naples, claiming nearly 200,000 lives—half the city's population.[26]

Little is known about Artemisia's later years in Naples, except that she continued painting. In a letter to one of her mentors, Don Antonio Ruffo, she reveals not only that she was still painting, but also that she was still struggling to be treated with equity and dignity. In her letter to Ruffo, dated 1649, she described how one potential patron stole her compositional designs: "I have made a solemn vow never to send my drawings because people have cheated me. In particular, just today I found . . . that, having done a drawing of souls in Purgatory for the Bishop of St. Gata, he, in order to spend less, commissioned another painter to do the painting using my work. If I were a man, I can't imagine it would have turned out this way."[27]

Navigating the Limits of the System

Artemisia had a thematic style. All but three of her existing paintings—*Portrait of a Gonfaloniere* (1622), *The Sleeping Christ Child* (1630–1632), and *Saint Januarius in the Amphitheatre at Pozzuoli* (1635–1637)—feature women as the dominant subjects. Most of her compositions deal with issues of misogyny, and several of her best-known works depict women committing acts of violence against abusive men.

Some scholars, and the broader public imagination, have read her paintings, particularly her more graphic works like *Judith Slaying Holofernes* (1614–1620), as commentary on her experience of sexual violence and a kind of vengeance against her abusers. On its surface, it would seem to make sense that this was her intent, since she was a woman who was continually subjected to mistreatment, inequity, and abuse in a male-dominated culture, working in a male-dominated industry. But for us to imagine all this, we must place a lot of our present-day assumptions on her as she lived and worked in her moment.

Regardless of the rightness of the values we hold as most sacred today, we must remember that the generations before functioned by different sets of values. I am not at all making a judgment about the limits or strengths of the values most prized by our culture today, but the lens through which we see the world is not the same lens through which people in the 1600s saw the world, just as the lens will undoubtedly be different three hundred years from now. From our present-day perspective, we can easily imagine that Artemisia's body of work was meant as a commentary on the injustices committed against her, an expression of her deep pain, resolution to be an agent of change, and perhaps some sort of retaliation. But was it?

Professor Weichbrodt said, "My hesitancy with the interpretation that she is taking revenge on her abusers with those

compositions is that it assumes seventeenth-century artists are painting as a form of personal expression and catharsis when culturally that's not going to be the case. They're painting on commission. They're painting to sell their work and to gain an audience to get patrons." While these early paintings certainly convey feminine defiance against unscrupulous men, art historian Griselda Pollock argues that the near-constant mention of her assault by scholars and critics only succeeds in limiting Gentileschi's image.[28] Her world, life, and art were richer, deeper, and much more complicated than that.

Artemisia Gentileschi, *Judith Slaying Holofernes*, 1614–1620, oil on canvas, 158.8 cm × 125.5 cm, Museo di Capodimonte, Naples.
Raffaello Bencini / Bridgeman Images

When we as twenty-first-century Western people engage with art, we bring twenty-first-century Western ideas to our interpretation. We can't help but apply our assumptions about

what's happening in a painting based on how we instinctively trace a narrative. We could look at Artemisia's work and think her intended narrative thread is about the plight of a woman living in a man's world, which is certainly part of her story. But we must be careful not to romanticize her work to make it fit our own cultural moment. It is one thing to draw conclusions about the impact of her art over time, and quite another to assign intent to her body of work that may not represent how she thought about it.

Weichbrodt said, "I don't think she's a girl-power feminism icon. She's an icon in the sense that she's an example of a woman who's navigating a world that's not built for her. I do think there is a story of tenacity in Artemisia, a kind of commitment to a recognition of the limits that are put on her because she is a woman, experiences that make her say, 'I'm going to negotiate that. I'm going to figure out the path I want to carve out for myself, given these restrictions.' But she never rises above them. She's always working in the midst of them. She manages to operate within the world she inhabits."

When we talk about Artemisia today, we must understand that we do so as we navigate a system of our own, with its own set of rules, presumptions, and biases. If we come to an artist like Artemisia with a narrative already in mind and insert her into it, we dishonor her actual experience—a luxury afforded to us now that wasn't hers then. Weichbrodt said, "We want our heroes to be simple so we can use them. We don't actually want them to be human. One of the hardest things for me when it comes to Artemisia is her paintings, which seem to just reiterate male sexual desire, like her painting of a woman playing a lute with her dress falling off her shoulder. If you need Artemisia to be your raw feminist icon in every single thing she does, she is going to disappoint you." Artemisia was a human being living in a community that functioned in a particular way, and she had to

A Working Artist

If we want to honor Artemisia for who she was, how should we see her? One way is to see her as a working painter. Along with painting being her craft, it was her work, her industry. Talent alone wasn't enough to launch a career as a painter. To establish herself as a business, Artemisia had to think and act entrepreneurially, devising ideas to get patrons to look her way. She rose to the occasion, often in unconventional ways, using her femininity as an asset. For example, to attract the attention of a wealthy silk merchant—Alessandro Covoni, a member of the court of the Grand Duke of Florence—she purchased materials from him on credit to make a dress for herself and to furnish her studio. This purchase served as a personal and professional introduction. When she later intentionally fell behind in her repayment, she went to him to discuss the matter in person, wearing the dress she had created from his silk. She asked if he would be willing to receive payment in kind in the form of portraits for him and his family.[29]

During her years in Rome, Artemisia spent much of her time painting portraits, explaining to a friend that portraits "served only as a means of acquiring the good graces of those who might give [the painter] more worthy kinds of commission."[30] Portraiture was the working artist's bread and butter. They served as advertisements; if one wealthy person visited the home of another and saw the homeowner's portrait on the wall, they might want one for themselves and ask who painted it. If they saw a portrait of someone else, out of courtesy, they would ask who it was. In a shrewd act of self-promotion, Artemisia volunteered to sit for portraits by other painters. Then when a possible patron

The Allegory of Painting **69**

would inquire about one of these portraits, they would discover they were looking at a beautiful artist who would happily paint a portrait of them.

A brief look at Artemisia's body of work gives insight into the life of a commission painter. Though she painted for nearly fifty years, there are only fifty-seven or so paintings in existence attributed to her—an average of 1.2 per year over the course of her career. Seventeen of those paintings were completed during her first twelve years, before the age of twenty-seven—some while painting as a young woman in her father's studio, and the rest when she served as a court painter in Florence. Another fifteen were completed after she turned forty-five, leaving only twenty-five existing works from between the ages of twenty-seven and forty-five—an average of just 1.4 paintings per year during what was presumably her most prolific era as a professional artist—her years in Rome, Venice, and Naples.

Why so few paintings? One reason Artemisia didn't leave behind a larger body of work is that the majority of what she made, like that of most of her contemporaries, was work made for hire. The days of art motivated by self-expression had not yet arrived. Most working artists were creating work that was funded, commissioned, and defined by paying customers—individuals, courts, businesses, and churches—in much the same way people hire studio musicians or graphic designers today (usually artists at heart) to create for specific needs and purposes.

Though her signature in some of her work is clear—like the etched-in-stone declaration of her authorship of *Susanna and the Elders* (1610) when she was sixteen—many of her later attributed works, like *Esther before Ahasuerus*, are not signed. Because commission work was often intended for personal use and focused more on the subject matter than the painter, many works from Artemisia's era don't bear the artist's signature. As Artemisia spent her life working in her studio, she had to have known that

70 Van Gogh Has a Broken Heart

many of the unsigned works she produced would lose their attribution. People would look at her portraits and ask, "Who is that?" before they would wonder, *Who painted that?*

Artemisia's existing body of around fifty-seven paintings probably represents only a fraction of all she created. More likely, the work she created in her studio day in and day out consisted mostly of portraits, religious and mythological murals, and privately commissioned pieces, many of which have since been disassociated with her name, lost, or destroyed.

The Allegory of Painting

During her time in London, when Artemisia was forty-five years old, she painted *Self-Portrait as the Allegory of Painting* (ca. 1638–1639), a play on Caravaggio's painting of Narcissus, in which Narcissus fell in love with his own reflection—a legend that the fifteenth-century Italian philosopher Leon Battista Alberti later speculated led to the invention of painting.[31] At first blush, Artemisia's *Self-Portrait as the Allegory of Painting* looks like little more than a picture of a middle-aged woman painting. But the title and compositional details tell us this is no ordinary self-portrait. She produced something utterly unique, something no male painter could have done.

In terms of history, an allegory is the personification of an inanimate discipline. Almost all allegories were depicted as female, *Scultura, Architettura*, and *Poesia*, along with the three disciplines of the classical liberal arts trivium (grammar, dialectic, and rhetoric) and quadrivium (arithmetic, geometry, music, and astrology). For example, the allegory for justice is a blindfolded woman holding a scale; liberty is a radiant woman holding a torch in one hand and a declaration of independence in the other.

One reason allegories were feminine was to avoid confusion.

The Allegory of Painting 71

If the allegories were masculine, people would wonder if they were looking at an actual historical figure. Elissa Weichbrodt said, "You would have a woman be the allegory of the discipline of history because everybody knew there were no female historians. But if you had a man be the allegory of philosophy, people would say, 'Oh, is that Socrates?'"[32]

Pittura (painting, picture) is the name for the allegorical representation of painting. Pittura "made her first appearance in Italian art sometime in the first half of the sixteenth century, along with the equally new female personifications of sculpture and architecture."[33] According to Cesare Ripa's standard *Iconologia* from 1593,[34] painting is depicted as a woman because the discipline is a container for meaning and a womb out of which beauty is born. Along with her femininity, other characteristics of the allegory of painting include a gold chain around her neck with a pendant of a theater mask to indicate she's telling a story. Her mouth is bound or sewn shut because painting is a silent act. Her hair is disheveled to symbolize the "divine frenzy of the artistic temperament."[35] She wears *drappo cangiante*, garments that change colors, which allude to the painter's skill.

Weichbrodt said, "If you were a male painter in the seventeenth century and you wanted to show that you were a really good painter, you might show yourself in the company of the allegory of painting, a self-portrait with the allegory on the wall beside you." Or, as Nicolas Poussin did in 1650, compose an image in which a woman, Pittura, holds forth a portrait bearing your image.

As Artemisia entered the latter part of her career, she painted a version of the allegory of painting, presenting herself as Pittura. She inhabited the discipline. Her life was a story told in secret of a skilled craftsperson, a model of the artistic temperament, a container of meaning, a womb out of which beauty was born. She was the vessel men had to represent as something outside

of themselves. Mary Garrard wrote, "The fact is, no man could have painted this particular image because by tradition the art of painting was symbolized by an allegorical female figure, and thus only a woman could identify herself with the personification. By joining the types of the artist portrait and the allegory of painting, Gentileschi managed to unite in a single image two themes that male artists had been obliged to treat separately."[36] As a woman, Artemisia didn't need to show herself in the presence of the allegory; she was Pittura.

But Artemisia's Pittura broke with convention. In Artemisia's *Self-Portrait as the Allegory of Painting*, Pittura is not a demure, composed figure holding forth a finished work. She is bent over a canvas the viewer can't see. Hanging over her iridescent dress is a gold chain with a pendant depicting the traditional theater mask, but without the word *imitation*. She isn't imitating anything; she is in the act of creating. Rather than sewn shut, her lips are slightly open, as if she's speaking, bearing witness to what she's making with her life. She is a presence. She fills the room, "activating that whole space with that dynamic diagonal and the foreshortening of her arms that pushes her out into our space."[37] She is making a bold statement. She is not just an artist; she is an artist at work. She is the container of meaning attributed to the discipline.

As a vessel for the beauty of creation, what did Artemisia carry? She carried the instinct of a prodigy and the skill of a devoted practitioner of her craft. She carried the tenacity of an entrepreneurial mind and the savvy of a businesswoman. She carried a mind thoughtful about the arc and power of a well-told story.

But what else? What secrets? What complexities? What tenacity? What fragility? What fire?

Did she carry the knowledge that men wondered if they were looking at a self-portrait of her body when they looked at her

The Allegory of Painting 73

paintings that included the nude female form? Did she bear the exhaustion that came during her most prolific years in Florence when she produced many of her best-known works while sharing her body with five babies growing in her womb? Did she harbor unspeakable grief when three of those children died in infancy and another before the age of five? Did she maintain a vigilant fear as she moved from town to town with her remaining young daughter by her side, aware of what the men around her might do to her precious child, carried in, born from, and raised alongside her own body, if given the opportunity?

Did she navigate resentment when potential patrons hired less expensive painters to copy her concept drawings so they could have her mind without having to pay her commission? Did she carry the wounds of estrangement from her father because he had a falling out with her husband over a dowry her father promised as part of an arrangement the two men made to protect her father's good name after a colleague he invited into his home assaulted her? Did she carry the knowledge that her first answer to any of these questions might not be believed?

If asked whether these things were true, would she need to take the stand in a court of law for the world to believe her? Would the judge have to instruct the bailiff to lash on the thumbscrews to verify the truth of it all? Or would it be enough for her to simply say yes?

CHAPTER 5

KEEP THEM TOGETHER

Joseph Mallord William Turner and the Evolution of an Inner Life

J. M. W. Turner, *Rain, Steam and Speed—The Great Western Railway*, 1844, oil on canvas, 91 cm × 121.8 cm, National Gallery, London.
Bridgeman Images

The work of Joseph Mallord William Turner represents a unique phenomenon in the history of painting: the successive achievement of two diametrically opposed styles of expression, implying a radical transformation of the sense of perception, the first style based on the continuation of an esthetic past, the second providing an example of a vision whose revolutionary power would be revealed in time to come.

Jean Selz, *Turner*

Early one morning in 1830, a train crept through the Italian countryside. The passengers sat amused as they watched one "good-tempered, funny, little, elderly man continually popping his head out of the window to sketch whatever strikes his fancy."[1] One fellow traveler said he "became quite angry because the conductor would not wait for him whilst he took a sunrise view of Macerata. 'Damn the fellow!' says he. 'He has no feeling.' His good temper, however, carries him through all his troubles. . . . Probably you may know something of him. The name on his trunk is JMW Turner."[2]

Joseph Mallord William Turner never went anywhere without a sketchbook. He drew in them constantly. On trains, he sketched the passing landscapes. At the coast, he drew the ships coming in. Even at dinners, he would often be found in the corner of the room, capturing the moment. Over the course of his life, he filled hundreds of these little journals. They were his place to practice, experiment, test new techniques, jot down his thoughts, plan his paintings, and study what he wanted to master.[3]

Turner was a very secretive person. His sketchbooks were visual diaries, meant to be kept private. He preferred to keep his artistic approach and technique shrouded in mystery. He didn't want to be known. In Turner's day, England favored the classical decorum that would come to mark the Victorian sensibilities—modesty, composure, moral sensitivity, and tasteful presentation. It was the age of men retiring to the parlor with their pipes as the women in their pristine dresses took tea in the drawing room. Whatever was shown to the world was polished and complete.

This approach carried over into the world of art. Jean Selz wrote, "Enduring traditions have never deprived the English of being daring individuals, but in painting, before Turner and long after, we find in England none of those movements that revolutionized the conceptions of artistic creation in France, Germany, Scandinavia, and prerevolutionary Russia."[4] Artists in England during Turner's era didn't show unfinished work; it was considered bad form. This suited Turner. His sketchbooks, which were only made public after his death as part of his bequest, were an entirely private affair.

As with his art, Turner was also secretive about his personal life. He had a mistress, Sarah Danby, with whom he had one daughter, possibly two, but he never married. He avoided anything he felt would tie him down and keep him from his work.[5] Historian Eric Shanes said, "Things were only of any importance if they assisted his painting. We need to be aware of this from the very beginning. It is useless to look for much of a life beyond painting, for it barely existed."[6] Turner kept his inner life in sketchbooks tucked in a coat pocket over his heart.[7]

When we look at Turner's early work, we see an artist with an obviously trained eye for detail and a fondness for design, order, and classical composition. As a child, he was drawn to architecture—especially to old castles and churches. He studied the geometry, scale, and perspective of buildings and landscapes

78 Van Gogh Has a Broken Heart

so he could impress people with drawings of elaborate structures rising up from the viewer's field of vision. The first half of Turner's body of work majors on this sort of compositional precision and detail.

But when we look at the second half of his work, it would be easy to imagine that this artist, "who cares little for [precision and detail] and sees the world only through an approximate vision of its forms, is a different painter."[8] In Turner's later compositions, his precise line work is all but gone. In its place are expanses of color and light in which the viewer's imagination must assemble much of the subject of the composition. It is as though his later sparse approach to painting was a revolt against the precision of his earlier work.

Art historian Lawrence Gowing wrote, "There is a special reason for looking at Turner. We are aware that in his painting something singular and incomparable happened. It astounded and bewildered his contemporaries, and it is still not altogether comprehensible today. In the pictures that Turner showed—and concealed—in the last two decades of his life a change was evidently taking place of a kind that is disturbing to an artist's public."[9]

What changed? This is an important question, because Turner gives us a visual example of the evolution of the inner life. When he was young, Turner painted one way. But something changed inside of him that made its way into his later art—an undeniable transformation, a kind of deconstruction, and, perhaps because of his secretive nature, something of a riddle. What do we do with that?

The First Half (1775–1819)

J. M. W. Turner was born on April 23, 1775, in London's Covent Garden neighborhood, north of the Thames and west of the

Houses of Parliament. His mother battled manic depression and fits of rage. She was in and out of hospitals until she was eventually institutionalized in an asylum in 1800.[10] Turner's father, William, was a local barber. Barbershops in London were like taverns, where people would gather to gossip and read the paper, which Turner's father would pin up on the wall each morning. William noticed his son's artistic talent early and proudly supported him by allowing him to display and sell his drawings in his shop window.[11]

Turner had a knack for perspective, the geometry of design that allows an artist to create a sense of three-dimensional depth on a two-dimensional plane. Turner was not particularly good at drawing people, so he stuck mainly to his castles and landscapes, subject matter that required sound perspective and rewarded those who could master it. He loved scenes inspired by literature, mythology, English novels, and Scripture, though "Turner had no particular interest in any part of the Bible but the Apocalypse."[12]

At fourteen, Turner enrolled in the Royal Academy of Arts and had his first works chosen for display the following year.[13] His first commissions were illustrations for travel guides and calendars—subject matter that paired nicely with his affection for buildings and landscapes.

In his early twenties, Turner worked exclusively in pencil and watercolor, "to which he devoted himself with unflagging application,"[14] but in 1796, he tried his hand at oil, producing *Fishermen at Sea*. One critic praised the painting as "the work of an original mind." Another said, "He seems to have a special vision of nature, and the exceptional character of his perceptions includes a skill such that this artist succeeds in rendering the transparency and the movements of the sea with a perfection not generally seen in paintings."[15] When Turner turned from watercolor to oil to paint the sea, he learned that he had a talent for drawing not just what was fixed—castles and bridges—but also for what was in motion.

J. M. W. Turner, *Fishermen at Sea*, 1796, oil on canvas, 91.44 cm × 122.24 cm, Tate Gallery, London.
Artefact / Alamy Stock Photo

By most accounts, there was nothing especially attractive about Turner as a person. The Romantic painter Eugene Delacroix said, "He looked like an English farmer, with his black, rather vulgar clothes, heavy shoes, and hard, cold expression."[16] Another friend said, "He always had the indescribable charm of the sailor both in appearance and manners; his large grey eyes were those of a man long accustomed to looking straight at the face of nature through fair and foul weather alike."[17]

What Turner lacked in outward appearance he made up for in confidence.[18] He was extremely self-assured in his abilities, but he was also sensitive to criticism.[19] He believed he was a great painter. He also believed painting was a demanding craft. Even when criticism was aimed at other painters, "Turner could not bear to hear the work of a contemporary disparaged without making the best possible defense and emphasizing the difficulty of painting at all."[20]

Though he wanted critics to respect his craft, he still regarded

painting as a competition. He wanted to be known as the best in the world. His goal as a young artist was to achieve greater technical ability than his peers, which was one of the reasons he worked so hard at refining his mastery of perspective. Mastering the fundamentals determined whether a finished painting would look true to life.

For Turner, to look at another painter's work was to scrutinize it. Turner scholar Graham Reynolds said, "Turner's immediate reaction in front of a painting by another master was, 'I can do better, or at least as well.'"[21] Edward Villiers Rippingille, one of Turner's competitors, said, "Turner boasted he could outwork and kill any painter alive."[22] He was even critical of Rembrandt. In one of his sketchbooks, he described one of the Dutch master's paintings as "miserably drawn and poor in expression."[23]

Ten years after Turner enrolled in the Royal Academy, he was admitted as an associate member and soon after became a full member. To be a full member of the Royal Academy meant he would never again have to defend his vocation as an artist, nor prove his abilities. The accolade alone told everyone everything they needed to know about his qualifications and talent as a painter. He cherished this honor and in 1807 became the academy's teacher of perspective.[24] He remained focused on his own architectural drawings, always seeking greater complexity. He was meticulous. His paintings during this era were popular and well received.[25] His reputation grew, and soon he had as many commissions as he could handle.

Turner's father supported his art production by purchasing supplies, maintaining his studio, and managing his business. Turner had good business sense. In a bold display of self-assuredness, he built a gallery in a room next to his studio and hosted one-man shows of his own work—uncommon in London at that time. People came from all around, hoping to go home with a genuine Turner. Though he was willing to sell,

82 Van Gogh Has a Broken Heart

he gave nothing away. One friend noted Turner would "do nothing without cash and anything for it. He is almost the only man of genius I ever knew who is sordid in these matters."[26] During these early years, Turner earned a comfortable wage.[27]

Once Turner became financially independent, he began taking fewer commissions so he could focus on large-scale oil paintings.[28] A few of his paintings during this period—*The Battle of Trafalgar* (1805–1808), *The Festival of the Opening of the Vintage at Mâcon, France* (1803), and *The Shipwreck* (1805)— each commanded top dollar. Buyers became collectors seeking original J. M. W. Turner paintings, in the same way one might seek to acquire a Constable or Rembrandt painting.

As he gained commercial success and name recognition, Turner remained a mystery, closely guarding his private life. His confidence in his own brilliance, the swagger of hosting his own one-man shows, and his professional esteem in academic circles presented him as a man many would have assumed they knew something about. But in the breast pocket of his coat, always, was his sketchbook, filled with ideas, experiments, subjects, and thoughts known only to him.[29]

He was not like one of his castles—fixed and unchanging. He was studying the world, thinking about it, pushing back against it, testing new ideas, trying to figure it out and navigate it with greater clarity and insight. He was a person in process and a riddle. We all are.

The Second Half (1819–1851)

In 1818, at the midpoint of his career, Turner took an assignment to paint Italian scenes for a tourism book. To fulfill the commission, he traveled to Venice. He wanted to study the great Italian painters and experience the Italian light that Sir Thomas Lawrence described as "the atmosphere that wraps everything in

Keep Them Together 83

its own milky sweetness."[30] In his sketchbooks, Turner noted the colors of the hills and groves, "the ground reddish green-grey and apt to purple, the sea quite blue under the sun a warm vapor."[31]

He went to Italy looking for light. What he discovered was that light and color were one. Light *was* color.[32] Italy was to him like Vincent van Gogh's discovery of Provence or Paul Gauguin's arrival in Tahiti;[33] it changed the way he saw the world and revolutionized the way he approached the role and use of color in his art.[34]

Regarding this transformation, Martin R. F. Butlin and Mary Chamot wrote, "While Turner's earlier paintings and drawings show the most accurate observation of architectural and natural detail, in his later work this precision is sacrificed to general effects of colour and light with the barest indication of mass."[35] Selz added, "In all the paintings done in his first period, color was visibly secondary to drawing. Without color, the picture undoubtedly would not have attained its poetic density. But the drawing alone contained the basic subject of the painting. The situation, however, changes completely with the second period."[36] These later works look like they could have been painted by one of the great Impressionists, though the dawn of Impressionism wouldn't occur for another fifty years.

Turner's early use of color was melancholic and existed to serve his line work.[37] But after Venice, this painter who had built his career around the use of line and detail to demonstrate his mastery became enthralled with how color worked on the senses. He didn't suddenly start using bolder and more vibrant hues. His palette never ventured far from the blues, greens, and a dominant gold he had been relying on for years.[38] Rather, he began experimenting with fields of color as the leading element in his compositions. Where he had once used line to establish definition, Turner now looked to color to create harmony.[39]

Turner's later paintings, which he initially kept secret, had no

line work in them at all. Selz wrote, "There is no trace of drawing in these watercolors, which he carefully refrained from exhibiting, as if the time had not yet come to confess his discovery of an impalpable world that was nothing but shapes colored with light, and, in most cases very pale, masses. Here Turner was the obvious precursor of Impressionism.... He was now beginning to look only at the colors of objects.... No painter before had given color such resolute autonomy."[40]

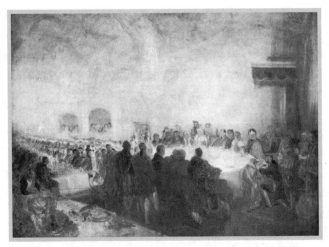

J. M. W. Turner, *George IV at the Provost's Banquet in the Parliament House, Edinburgh*, 1822, oil on mahogany, 68.6 cm × 91.8 cm, Tate Gallery, London.
Stefano Ravera / Alamy Stock Photo

In 1822, Turner revealed the early stages of his transformation in his painting *George IV at the Provost's Banquet in the Parliament House, Edinburgh*. It shows the struggle for dominance between the detailed perspective in his early work and the primacy of color fields in the latter. Jean Selz wrote concerning this painting, "Was he perhaps beginning to discover that color needs freedom? This question found an answer in another canvas, painted the following year [1823], *The Bay of Baiae, with Apollo and the Sybil*....

The details to which Turner had previously devoted himself are completely absent from this painting. He has now set off on a road of a poetic conception of color which was to reach fruition several years later."[41] By 1829, the transformation was mostly complete. *Ulysses Deriding Polyphemus* "is a work in which the light from an extravagant sun seems to cause the explosion of the entire composition with its ancient sailboats and wild crags—a canvas Tuner could not have painted before his return to Italy."[42]

J. M. W. Turner, *Ulysses Deriding Polyphemus*,
1829, oil on canvas, 132.7 cm × 203 cm,
National Gallery, London.
Bridgeman Images

Fortunately for Turner, his transformation took place when his confidence was at an all-time high. He didn't seem to be trying to fix a problem. He was experimenting with something new. Critics didn't appreciate his new approach.[43] They saw it as a foil to his earlier work, like when Bob Dylan went electric. The United Kingdom's *Morning Herald* wrote, "Here is a canvas in which truth, nature, and feeling are sacrificed to melodramatic effect. . . . *Ulysses Deriding Polyphemus* can be regarded

86 Van Gogh Has a Broken Heart

as an example of color in delirium."[44] Another critic who visited Turner's gallery said he was "disgusted with what he found there; views on the Thames, crude blotches, nothing could be more vicious."[45] They didn't realize they were seeing the evolution not just of Turner's art but of landscape painting in general. Lawrence Gowing wrote, "It is evident that both the kind of reality and the order of imagination that painting had traditionally offered were changing in Turner's hands."[46]

Where traditional painters sought to master the math of a composition, Turner now focused on the mood. The result of this change was that his work began to take on what one critic described as a "certain deliberate slowness."[47] Turner's submissions for the Royal Academy also slowed during this period. Before Venice he would typically submit four or five paintings per year, but after Venice, that output dipped to one or two, and sometimes none.[48] All the while, his mind was turning over the world he wanted to capture in color.

The Varnishing Days

In 1829, Turner's most faithful supporter, champion, and business manager—his father—died. William's was the final voice Turner felt obliged to answer. With that voice gone, he channeled his grief into his new form of expression. Jean Selz wrote, "Now free of all filial bonds . . . Turner entered upon the most important period of his work."[49]

Throughout Turner's career, people viewed him as a recluse—a reputation he found unfair. He wasn't an ascetic; he was private. He didn't make himself available to others as a matter of principle. He generally painted alone to keep his technique a secret.[50] He never talked about his private life. So the reputation was understandable. But he didn't like it and sought to change it. Turner scholar Anthony Bailey said, "To overturn

the central assumption about his character—that he was a mystifying recluse—Turner for a short period once a year came forth and performed as an artist before his colleagues. The hedgehog turned briefly into a peacock."[51]

The days when the "peacock" emerged were known as the "varnishing days." The varnishing days were a festival-like time leading up to the Royal Academy's annual exhibition, when artists were allowed to add finishing touches to the works they planned to show. Graham Reynolds wrote, "Artists would paint in full view of everyone. A chance to show off skill and technique, and outperform other painters, like a contest of sorts."[52] These few days became a time for artists to show not only their work but also themselves as artists at work. Turner would send his paintings to the Academy for exhibition unfinished and use the three varnishing days to complete them.

Turner "was generally one of the first to arrive, coming down to the Academy before breakfast and continuing his labor as long as daylight lasted; strange and wonderful was the transformation he at times affected in his works on the walls."[53] He would spit on his canvases and rub colored powder over the picture, putting on quite a show.[54] One time, when Turner was working on his gray seascape *Helvoetsluys*, C. R. Leslie recounted:

> Turner put a round daub of red lead, somewhat bigger than a shilling, on his grey sea [and] went away without saying a word. The intensity of the red lead, made more vivid by the coolness of his picture, caused even the vermillion and [paintings next to it to] look weak. I came into the room just as Turner left it. "He has been here," said Constable, "and fired a gun." . . . The great man did not come again into the room for a day and a half, and then, in the last moments that were allowed for painting, he glazed the scarlet seal he had put on his picture and shaped it into a buoy.[55]

88 Van Gogh Has a Broken Heart

On another occasion, one attendee wrote this:

> In one part of the mysterious proceedings, Turner, who worked almost entirely with his palette knife, was observed to be rolling and spreading a lump of half-transparent stuff over his picture, the size of a finger in length and thickness. . . . After it was finished Turner gathered up his tools, then, with his face still turned to the wall and at the same distance from it went sidling off without speaking to anybody. At which Maclise remarked, "There, that's masterly, he does not stop to look at his work, he *knows* it is done and he is off."[56]

Even Turner's public performance was draped in mystery—he showed what he could do but offered little of who he was.

Keep Them Together

In his last three decades, Turner produced a substantial body of work focused on his preoccupation with color. Though his later work became more disorganized, fragmented, and impressionistic, he won over many of his critics as they not only warmed to his new style but also began to admit that his work marked a shift in English painting.[57] What he had initiated was undeniable, and it proved to be nothing less than the break between the classical age and modern art.[58] Andrew Wilton, senior research fellow at the Tate Gallery in London, said that by the time Turner died, "landscape painting had replaced aristocratic portraiture as the archetypal British art-form."[59]

This shift in style and preference, of course, matches the story of art, literature, music, architecture, language, style of dress, and countless other expressions of social and cultural moments. Every generation tries to zero in on what best reflects

their interests and most clearly differentiates them from previous generations. Few things in the world are afforded unchanging carryover from generation to generation. Turner happened to be the tip of the spear for this revolution in British art.

As Turner reached his seventies, his health began to fail and his production slowed.[60] He became lonely in his old age—surrendering to the reclusive reputation he so wanted to shed.[61] During this era, he made one last visit to the varnishing days. When a colleague asked where he had been, Turner replied, "You must not ask me that."[62] He split his time between an apartment in London and a room on the coast he rented from a woman named Mrs. Booth. Ian Shank wrote, "By the time of his death in 1851, Joseph Mallord William Turner had been living under an alias in a Chelsea hovel in London for at least five years. Few knew his whereabouts, not even the housekeeper of his official residence at 47 Queen Anne Street. Local tradesmen knew him as Admiral Booth."[63] When Mrs. Booth's husband died, she and Turner became intimate, and he spent most of his time at her place by the sea, still sketching. Always sketching.

Turner despised his own limitations, which became more pronounced as each year passed. The idea of mortality seemed especially bothersome. When his doctor told him he was dying, Turner said, "So I am to become a nonentity then?"[64] His final painting, *The Visit to the Tomb* (1850)—a breathtaking swan song—was "a fitting illustration of Turner's lifelong preoccupation with the frustration of human plans."[65] For any artist, there comes a point when all the work, discipline, discovery, and failure that go into the cultivation of a craft end. The last song is written. The last painting is finished. The last meal is prepared.

Turner died on December 19, 1851. The doctor at his bedside said, "Just before 9:00 a.m., the sun burst forth and shone directly on him with brilliancy that he loved to gaze on. . . .

J. M. W. Turner, *The Visit to the Tomb*, 1850, oil on canvas, 121.9 cm × 91.4 cm, Tate Gallery, London.
Smith Archive / Alamy Stock Photo

He died without a groan."[66] He was buried in London's famed St. Paul's Cathedral, an honor about which Ian Shank said, "Even by the standards of nineteenth-century London, the circumstances surrounding the man's final days were peculiar. More so given the fact that Turner was, at the end of his life, Britain's most accomplished and widely known artist."[67]

Turner gave all the art still in his possession—more than three hundred canvases and about two thousand watercolors and drawings—to England in a bequest to be enjoyed by the people. This was more than a gesture of generosity; it was a matter of personal conviction. Turner lived a life singularly focused on art. He was always drawing, looking, and working—filling his sketchbooks and hiding them away. In his mind, he wasn't working on a castle here or a seascape there; he was creating a body of work that held together. There was no clear line separating the man from what he had made. The nineteenth-century English art critic John Ruskin said, "There were few things he hated more

than hearing people gush about particular drawings. He knew it merely meant they would not see the others."[68]

Turner didn't give much instruction concerning his body of work except to say, "Keep them together. What is the use of them but together?"[69] And he meant it. Turner gave all of his finished paintings to the National Gallery on the condition that a separate facility be built to exhibit them.[70] Most of his work remains housed in museums around England today. The Tate Britain has the largest collection, with more than three hundred finished and unfinished oil paintings—split almost down the middle between styles—and thousands of drawings, watercolors, and notes from his collection of more than three hundred sketchbooks.

Deconstruction and Perspective

How should we respond when the comfort of a consistent voice yields to the disorienting strangeness of a new expression? What do we do when a musician, writer, or mentor experiences a shift in their view of the world that moves them to a place we no longer recognize? When Bob Dylan picked up an electric guitar, many in his fan base from the 1960s didn't know what to do with him. One of my favorite songwriters—a masterful storyteller and brilliant lyricist—recently turned his attention to political and social issues, and now I struggle to listen, not necessarily because I disagree with him, but because what I loved most about his storytelling was its subtlety. Should we expect those we admire, or even ourselves, to hold the same perspectives and beliefs in our later years that we embraced when we were young? On what basis should our views of the world change?

J. M. W. Turner didn't give the world many ways to know him outside of his art. But the transformation that took place at the midpoint of his career was so mysterious that Jean Selz said, "It is not a logical evolution in Turner's work; his first style cannot in

any way be regarded as the first experimental, tentative stage in his future development."[71]

When you compare *The Decline of the Carthaginian Empire* (1817) with *Rough Sea with Wreckage* (ca. 1840–1845), they look like they came from completely different painters. Graham Reynolds wrote, "What is most remarkable is the facility with which Turner turned from one mode of expression to another without losing his confidence."[72] At no point did Turner telegraph that he was going through an identity crisis. He just changed.

J. M. W. Turner, *The Decline of the Carthaginian Empire*, 1817, oil on canvas, 170.2 cm × 238.8 cm, Tate Gallery, London.
Photo © Tate

I keep thinking about Turner's sketchbooks. Though he did eventually share them with the public upon his death, they are as cryptic as he was. The notes are terse, almost like they were written in code. What he chose to write down meant vastly more to him than any outsider could hope to decipher. His notes were thought triggers more than fleshed-out ideas.

I suspect Turner's artistic evolution was not a mystery to

him. The young painter drilled on the fundamentals of design and perspective. He mastered the technical realities of geometry, without which his work would look wrong to a viewer, but with it, the structure goes unnoticed. Who looks at a painting and says, "Wow, they really got the geometry right on this one?" The whole point of mastering perspective is so no one thinks about perspective.

The older painter forsook the line work and detail he had once leaned on, not because he wanted to move away from the sound geometry of perspective, but because he had so mastered it that he trusted it would carry over into his new approach, even if the lines were taken away.

I can't think about Turner without thinking about the phenomenon of deconstruction. Deconstruction is the process of examining one's faith, asking, "What do I really believe?" It often comes in response to trauma or a crisis of faith. Many deconstruct when the dogma they accepted as reliable for years proves to be problematic. This is where we do well to ask, *What along the way should fall into the category of immutable, fundamental truths that have nothing to do with age or perspective, and what ideas or convictions are up for grabs?* Though Turner "deconstructed," if you will, he did not abandon the fundamental truths of perspective.

Deconstruction, for some, is a quest for truth. We ask, *What lines must stay? What dogmas, when removed, have no impact on the integrity of the truth? Where has good doctrine been used in evil ways?* For others, it can be little more than an unexamined rejection of a belief system—a pain-driven leap from conviction to cynicism. Therapist and author Dan Allender said, "When people attempt to move out of dogmatism, tragically what often seems to be the protective barrier is a form of cynicism. . . . And sometimes cynicism becomes something of a necessary period to ask the hard question: What do I actually believe, what is it that I

would allow my own heart to say yes to?"[73] Though cynicism may be part of the deconstruction process, it would be a tragedy if all the process produced was a cynic.

We do not know the hurt Turner carried. We don't know much about his sorrows or his joys. But I have to believe his artistic transformation was somehow connected to his pain. He was looking for something—chasing a vision of a new world. Lawrence Gowing wrote, "In Turner's first pictures, imagination and reality seem like opposite alternatives."[74] But his later works presented endless possibilities of imagination without sacrificing the reality of perspectival truth.

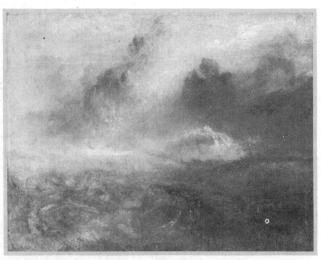

J. M. W. Turner, *Rough Sea with Wreckage*, 1840–1845, oil on canvas, 92.1 cm × 122.6 cm, Tate Gallery, London.
Photo © Tate

Turner wanted his body of work kept together; he wanted his artistic life to be preserved as a single thing. His early work was not a phase to leave behind. His later work was not the only word on who he was as an artist. He wasn't just the painter who painted *The Decline of the Carthaginian Empire* (1817). Nor was he just

the painter who composed *Rough Sea with Wreckage* (ca. 1840–1845). He was the artist who produced both, and though they represent different eras of his creative journey, they are both part of his creative journey—each speaking into the other.

So it is with us. The paintings, the poems, the songs, the journals, and the sketchbooks tell the story. Keep them together.

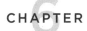

CHAPTER 6

A SORT OF DELIGHTFUL HORROR

The Hudson River School, the Beautiful, and the Sublime

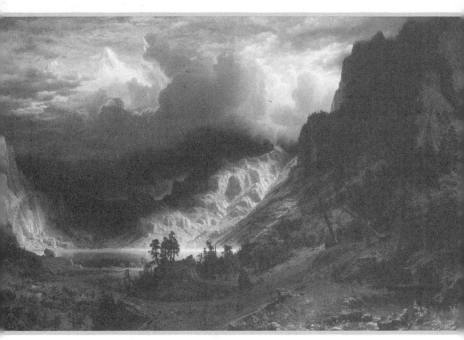

Albert Bierstadt, *A Storm in the Rocky Mountains, Mt. Rosalie*, 1866, oil on canvas, 210.8 cm × 361.3 cm, Brooklyn Museum, Brooklyn, New York.
Public domain

The passion caused by the great and the sublime in *nature*, when those causes operate most powerfully, is astonishment: and astonishment is that state of the soul in which all its motions are suspended, with some degree of horror.

Edmund Burke, *A Philosophical Inquiry into the Origin of Our Ideas of the Sublime and the Beautiful*

When the eighteenth-century English poet Thomas Gray visited the French Alps for the first time, he said that everywhere he looked he saw "not a precipice, not a torrent, not a cliff, but [a place that] is pregnant with religion and poetry. There are certain scenes that would awe an atheist into belief, without the help of other argument. One need not have a very fantastic imagination to see spirits there at noon-day: you have Death perpetually before your eyes, only so far removed, as to compose the mind without frighting it."[1]

The places we aim to call home can take our breath away. They can reduce us to tears. They can beckon us in like a siren song. They can stir in us a hunger for the divine. And they can kill us. Such is the glory of God. Such is the nature of his handiwork.

In the mid-1800s, a German-born American painter named Albert Bierstadt traveled into the front range of the Rocky Mountains as part of an expedition looking for a wagon route to the West. After three hundred miles in the prairie lands of Nebraska following the South Platte River, the group saw the snowcapped peaks of the eastern edge of the Rockies come into view, which the leader of the expedition described as "an exquisite marine ghost, almost evanescent in its faint azure."[2]

The expedition made their way to Denver City, where William N. Byers, editor of the *Rocky Mountain News*, joined up with them and took Bierstadt on a private excursion toward Idaho Springs, where the two men followed Chicago Creek through a dense forest that emerged into a beautiful meadow. Byers rode out of Bierstadt's line of sight so he could see the artist's immediate reaction to the valley:

> [Bierstadt] said nothing, but his face was a picture of intense life and excitement. Taking in the view for a moment, he slid off his mule, glanced quickly to see where the jack was that carried his paint outfit, walked sideways to it and began fumbling at the lash-ropes, all the time keeping his eyes on the scene up the valley. . . . As he went to work he said, "I must get a study in colours; it will take me fifteen minutes!" He said nothing more. . . . Bierstadt worked as though inspired. Nothing was said by either of us. At length the sketch was finished to his satisfaction. The glorious scene was fading as he packed up his traps. He asked: "There, was I more than fifteen minutes?" I answered: "Yes, you were at work forty-five minutes by the watch!"[3]

Details from this sketch and others on that journey were incorporated into one of Bierstadt's most notable paintings, *A Storm in the Rocky Mountains, Mt. Rosalie* (1866), an enormous panorama showing the awesome and fearsome reality of the interior lands of the great mountain range that cut the continent in half. Bierstadt's job was to capture images like this to show his fellow immigrants from Europe what awaited them if they should want to make this land their home—both the beautiful and the sublime.

What is "the sublime"? John Updike said, "The very word, from Latin meaning 'under the lintel,'—i.e., as high as one can go

100 Van Gogh Has a Broken Heart

in a constructed opening, just under the upper limit—is a roomy and aspiring one, 'sublimation' having precise senses in chemistry and psychiatry related to the vaporization of solids and the taming of instinctual desires."[4] The sublime refers to qualities of places, forces, and experiences that are distinguished by their ability to transform, overpower, and overwhelm.

The Beautiful and the Sublime

In art there has always been a fascination with the natural world. One of the purposes of landscape painting has been to show the connection between people and the land, either by saying of places that have already been civilized, "Here are your cities, pastures, and ports," or by saying of the untouched places, "Here is the great unexplored wild that lies beyond what you have been able to subdue."

In the early nineteenth century, as countless Europeans continued to arrive in waves on the East Coast of North America, landscape painters "were to become a significant, if unaware, element in the creation of the cultural character of that national identity."[5] As equal parts explorers and artists, they were tasked with going out into the heart of the forests, plains, and mountains; capturing what they saw; and returning with images that said, "This is the land of the brave. This is what our new nation must tame."

Many of these artists came to be known as the Hudson River School—"an identifying group title given to a number of mainly landscape painters working in the United States of America in the early and middle years of the nineteenth century."[6] The Hudson River School—which included Asher Brown Durand, Thomas Cole, Frederick Edwin Church, Thomas Moran, and Albert Bierstadt, among many others—got its name because the earliest members' work took place in and around the Hudson

A Sort of Delightful Horror 101

River in the Catskills of New York. But as Hudson River School scholar Trewin Copplestone wrote, "They did not all paint with any direct or exclusive connection with the Hudson River and its environs, did not all have precisely the same interest, nor were they all known to one another. In addition, there is no general agreement on who should or could be included as members of the 'School.'"[7]

What bound them together was not any certain style that was immediately identifiable, a shared artistic philosophy, or even a bond of community and friendship, but rather this shared assignment—to paint the unexplored world that would become the United States of America.

The Hudson River School painters were heavily influenced by and borrowed liberally from the English Romantic painter Joseph Mallord William Turner's imagery of foreboding seas, ominous clouds, and vast landscapes. It is hard to overstate the impact Turner had on the art world in the mid- to late 1800s. He was, at the time, "the greatest figure of the Romantic painting movement and his exploration of light, atmosphere, and color is recognized as having been an essential influence in the development of Impressionism later on."[8] His influence wasn't merely relegated to his technique but included his subject matter as well—landscapes. As mentioned in the last chapter, by the year of J. M. W. Turner's death, "more than half the population of England and Wales lived in urban areas, and landscape painting had long replaced aristocratic portraiture as the archetypal British art-form."[9]

Across the sea, the Hudson River School painters understood that their job was to show the sublime terrain of America to her new immigrants in order to evoke a response. And so they did, often with panoramas so large the viewer felt like they were actually standing in the paintings. John Updike noted that their canvases "were show business, and until photography gradually relieved the painter of reportorial duties, news from afar."[10]

102 Van Gogh Has a Broken Heart

Before the time of the Hudson River School, much of the more popular landscape painting was relegated to the *picturesque*, "that particular quality which makes objects chiefly pleasing in painting."[11] This wouldn't work in America. The New World needed artists who would be ruthlessly truthful about what these immigrants would have to overcome in order to transfer to these shores some semblance of their European way of life. They needed artists who would show them America's glory, artists who would venture beyond the picturesque and beautiful into the sublime.

Beauty is a subset of the sublime, but the sublime is always greater than mere beauty. Summarizing the view of nineteenth-century philosopher Edmund Burke, who devoted significant time to differentiating the two, Andrew Wilton and T. J. Barringer wrote, "Burke's contention was that we apprehend beauty as a function of 'generation'—our desire to reproduce our species; we define it in terms of physical attraction. In a male-dominated society, then, beauty is governed by what men find desirable in women: smoothness, gentleness, softness and so on."[12] Burke wrote, "By beauty [as distinguished from the sublime], I mean that quality, or those qualities in bodies by which they cause love, or some passion similar to it. . . . I likewise distinguish love, by which I mean that satisfaction which arises to the mind upon contemplating anything beautiful, from desire, which is an energy of the mind that hurries us on to the possession of certain objects."[13] When we admire something for beauty alone, we admire what is pleasing, pleasurable, and desirable, and often our instinct will be to attempt to possess it.

The sublime, on the other hand, cannot be possessed. It is, by nature, greater than us. Burke wrote, "The passions . . . which are conversant about the self-preservation of the individual, turn chiefly on *pain* and *danger*, and they are the most powerful of all the passions. Whatever is fitted in any sort to excite the idea of pain or danger, that is to say, whatever is in any sort terrible, or is

A Sort of Delightful Horror 103

conversant with terrible objects, or operates in a manner analogous to terror, is a source of the *sublime*; that is, it is productive of the strongest emotion which the mind is capable of feeling."[14]

Whatever makes us feel small in the universe, question our ultimate significance, experience existential helplessness, or fear the magnificent power of nature belongs to the sublime. Burke described encountering the sublime as "a sort of delightful horror; a sort of tranquility tinged with terror."[15] We may choose to step into the sublime for a time. We may, for example, pack for a hike to the floor of the Grand Canyon, but before we do, we had better prepare, study topographical maps, and listen to the warnings about the dangers of falling, getting lost, or running out of water so we can come back up once we've made it to the bottom. And when the hike is over, we'll return for the latitudes of home, relieved not only that we experienced such beauty in nature but that we survived it. And when we look back over the pictures we took, they will fail to illustrate what we actually beheld or convey what we experienced.

Part of what we experienced may in fact feel a little like sorrow, or soul-level pain. Eighteenth-century German philosopher Immanuel Kant said we often respond to the sublime with "a feeling of displeasure, arising from the inadequacy of imagination in the aesthetic estimation of magnitude."[16] In other words, we are pained that we cannot describe or even comprehend the wonder we're beholding, and we're aware that this is because there is something in us that is unable to behold the glory in full. Yet at the same time, we are overwhelmed because there is also something in us that suspects we were made to exist in such splendor. This response of pain joined to passion, this holy discontent joined to astonishment, is the power of the sublime. When we encounter the sublime, we don't just see a thing; we see part of our own experience through it. The power resides not in the thing we're beholding, but in our response.

104 Van Gogh Has a Broken Heart

A Storm in the Rocky Mountains

The Hudson River School painters were an unapologetically imaginative lot. To convey a sense of the sublime to their viewers, they incorporated elements of the grandeur they saw in nature into their work so that their paintings themselves would overwhelm anyone who stood before them. They did this through compositional choices, scale, methods of display, and often a requirement that people purchase tickets to see the work. We interact differently with experiences that cost us something; we tend to bring higher expectations and deeper engagement to those things into which we've invested something of ourselves.

The Hudson River School painters didn't view their assignment as an obligation to capture exact reproductions of the places they saw but instead to create amalgamations and impressions that would convey the scope and sublimity. Their work didn't need to be geographically factual as long as it was thoroughly true to nature. Few were better at this than Albert Bierstadt.

Bierstadt was born in Solingen, Germany, in 1830. His family emigrated to Massachusetts when he was two, where his father worked as a barrel maker. Though Albert's father wanted his son to pursue a practical vocation, the young man's natural artistic talent became apparent early, and at the age of twenty, without any formal training, Albert held his first art show in Boston. Soon after, he returned to Germany to study art in Düsseldorf under the tutelage of engraver and painter Karl Lessing.[17]

Bierstadt returned to America in 1857 and in 1859 traveled west with a government expedition led by Colonel Frederick Lander, whose mission was to plot an overland wagon route to the West. The grandeur of the Rocky Mountains moved Bierstadt. He was one of the only Hudson River School painters to venture west of the Appalachians—a territory ceded to him by most other painters because of his immense talent and tenacity as an

explorer.[18] Trewin Copplestone wrote, "In this wild and dangerous land he suffered for his passionate curiosity and was once almost killed by Indians and on another occasion nearly starved to death through his devotion to the solitary sketches he liked to make in isolated mountainous and tree-covered locations."[19]

Many regarded Bierstadt as J. M. W. Turner's most natural successor, as both were commercially minded and aware of the value of theater and presentation with regard to both their work and their person.[20] Bierstadt was a showman. He insisted that his paintings be hung low and dramatically lit, often framed by drapes so there was no noticeable edge to the scene. Turner pioneered this approach. Wilton said Turner "was making the aesthetic point that such works require to be hung so that the spectator can 'enter' them, allowing the eye to explore the recession and penetrate the perspective of the view, rather than looking up at them as though they were altarpieces. Landscape was no longer contemplated from afar, but participated in as an immediate experience."[21]

One of Bierstadt's most celebrated and massive paintings, *A Storm in the Rocky Mountains, Mt. Rosalie*, measuring almost 7 feet by 12 feet, captures the subtlety, grandeur, theater, and skill of his approach. The Brooklyn Museum, where the painting is on display, noted that the massive canvas "thrilled audiences at a moment when the North American continent was under rapid development. Bierstadt's display for profit of theatrically lit large canvases like this one was a forerunner of today's movies."[22]

There's a little bit of everything in *A Storm in the Rocky Mountains, Mt. Rosalie*—charcoal clouds and blue skies, craggy peaks and grassy meadows, rays of sun and sheets of rain, an ancient forest and a glassy lake. John Updike described the painting as "a furry black storm cloud [that] seems to be devouring a lower slope of the mountains even as sunlight beats upon the rocks."[23]

106 Van Gogh Has a Broken Heart

Whereas many paintings use the contrast of chiaroscuro to draw the eye to the light, Bierstadt's *A Storm in the Rocky Mountains, Mt. Rosalie* seems to draw the eye into the darkness—the titular storm—as though that's the drama. But with the hindsight of history, we know the storm is not the drama because there in the bottom left, likely to be overlooked on first viewing, is a small encampment of Native American tepees with Indians on horseback. And therein lies the real drama. There are people there.

Updike continued his description:

> Beyond a high boil of clouds a snow-covered peak measures a scale of breadth and height in which the tiny Indian horsemen and tinier tepees in a flat valley are reduced to the stature of microbes. The canvas overwhelms us with its towering vision and passionate detail; and yet there is something corrupt, something calculating and extreme in Bierstadt, a heightening of the already very high, an imposition of geological melodrama that closes the chapter on exploration which began with Cole's and Durand's attempt to apply European proficiency to a landscape where men still scarcely figured.[24]

But men were there. And women. And children. And more than the height of the mountains or the darkness of the storm or the extremes of the terrain, the sublime is found in their presence and the viewer's response concerning what to do with them.

Discovery That Leads to Destruction

Albert Bierstadt described the American West as being like the Garden of Eden—astonishing, pristine, and untouched.[25] Andrew Wilton made the haunting observation that the act of painting it "suggests that the possibility of its destruction was inherent in its

A Sort of Delightful Horror 107

discovery, just as had been the case in the East."[26] For Bierstadt to paint the Western expanse and show it to his fellow immigrants who had come here to settle a new world was to light the end of a very long fuse—one that would smolder for quite some time but eventually ignite a charge that would blow apart scenes like this one.

No one understood this relationship between discovery and destruction better than the indigenous people in Bierstadt's scene—the people who inhabited the land the incoming Europeans intended to own. Colonization would inevitably make the traditional Native American way of life impossible, since it would be incompatible with the European idea that land could and should be owned. For the native people, their stories, and their way of life, the results would be catastrophic. George Catlin, who studied Native American culture in the mid-1800s, made the sober observation that the impact of European expansion meant most Native Americans would "end their days in poverty and wretchedness, without the power of rising above it . . . surrendering their lands and their fair hunting grounds to the enjoyment of their enemies, and their bones to be dug up and strewed about the fields, or to be labelled in our Museums."[27]

For the native people in Bierstadt's painting, land was to be stewarded and lived on but not privately owned. Talia Boyd of the Grand Canyon Trust wrote, "From a Native perspective one cannot 'own' land, yet one may live with the land. Our regenerative relationships to land are based on generations of deep interconnectedness that have been taught through our cosmologies, ceremonies, and languages. Native peoples acknowledge that these on-going connections require responsibilities to the natural world."[28]

Most Europeans had little personal experience with the Native American people or their culture and tended to see them as "evocative emblems of the natural world."[29] Though everything

108 Van Gogh Has a Broken Heart

about the native people's appearance, clothing, settlements, and customs appeared primitive to the European eye, their way of life complemented the land. They were in harmony with their environment. The European objective was to conform the wilderness to accommodate their own preferences, comforts, and customs—to tame the sublime for the purpose of colonization. This was what they knew, and what we're accustomed to informs how we negotiate the future.

For the native people, the life they knew was less about comfort or property rights and more about how to live as stewards of the only world they had ever known. For them this was a spiritual existence—people communing with their creator on the creator's terms, surviving among the essential elements of plant, animal, land, fire, and water. Albert Bierstadt captured the native people's connection to the land in *A Storm in the Rocky Mountains, Mt. Rosalie* without truly understanding what he had done. Though he might have imagined that he was showing a primitive way of life, what he captured was, in fact, a sophistication that had been developed over hundreds of years. They inhabited the sublime.

You Cannot See My Face

For the Hudson River School painters, their work was spiritual too. Much of their motivation to come to this land in the first place was driven by religious ideas of freedom. The God who authored creation seemed to be lurking in the shadows and crags of this wilderness unfolding before them, and in his name, they told themselves, they would settle it. In his *Essay on American Scenery*, from 1835, early Hudson River School painter Thomas Cole wrote, "Prophets of old retired into the solitudes of nature to wait the inspiration of heaven. It was on Mount Horeb that Elijah witnessed the mighty wind, the earthquake, and the fire; and heard the 'still small voice'—that voice is YET heard among

A Sort of Delightful Horror 109

the mountains! St. John preached in the desert; the wilderness is YET a fitting place to speak of God."[30] Add to that list Abraham under the desert stars of Ur, David in the cave of Adullam, and Moses in the cleft of the rock on Mount Sinai.

Moses's entire life could be distilled into a single, complicated purpose—to lead God's people to a new world, bringing them out of slavery and into the land the Lord swore to their forefathers as an everlasting covenant. From the day Pharaoh's daughter found Moses in a basket among the reeds and raised him as one of Egypt's princes, his entire life had been leading toward this exodus through the Red Sea and across the wilderness of Sinai to this new world, the land flowing with milk and honey.

After the ten plagues, the parting of the sea, bread raining down from heaven, and water flowing from a rock, the people of Israel came into the wilderness, where the Lord took Moses high up onto a mountain and wrote by his own hand the law that was to govern the people—ten commandments to show them how to live and worship rightly.

While Moses was up on that mountain in his conference with God, the people were down below making a golden calf to worship, turning the God of all creation into a brute beast, profaning the sublime. The Lord's wrath burned against the people, and Moses pleaded with God to restrain his fury and not bring disaster upon them. He said, "Remember Abraham, Isaac, and Israel, your servants, to whom you swore by your own self, and said to them, 'I will multiply your offspring as the stars of heaven, and all this land that I have promised I will give to your offspring, and they shall inherit it forever.'"[31]

Then Moses went down from the mountain with the tablets and saw the people holding a carnival for their new golden god. Now it was *his* anger that burned against *them*. He threw down the tablets inscribed by the finger of God and took their golden calf and burned it in the fire. He ground its remains into powder

and scattered the powder in the people's water and made them drink it.[32]

Then Moses went into the tent of meeting and pleaded again with the Lord to deliver his people from a destruction he knew they had earned. He said, "If I have found favor in your sight, please show me now your ways, that I may know you in order to find favor in your sight. Consider too that this nation is your people."[33] And the Lord said to Moses, "My presence will go with you, and I will give you rest."[34]

But Moses wanted proof that he had found favor with God— something beyond words alone. So he asked for a sign to prove that they "are distinct, I and your people, from every other people on the face of the earth."[35]

The Lord asked Moses what he had in mind.

"Show me your glory," Moses said.

The Lord said he would show his goodness to Moses, but "you cannot see my face, for man shall not see me and live. . . . Behold, there is a place by me where you shall stand on the rock, and while my glory passes by I will put you in a cleft of the rock, and I will cover you with my hand until I have passed by. Then I will take away my hand, and you shall see my back, but my face shall not be seen."[36]

When the Lord hid Moses in the cleft of the rock, shielded his eyes, and allowed him to see only a glimpse of his back as he passed by, Moses fell to the ground in awestruck worship with his face in the dirt.[37] When Moses eventually regained enough composure to rise to his feet, refractions of that glory now radiated from his countenance with such overwhelming splendor that when the people down below saw him after he descended the mountain of the Lord, they were afraid to come anywhere near him. When Moses called Aaron and the other leaders to him and saw their terror, he covered his face with a veil so they would not be afraid.[38] Such was the glory of God.

A Sort of Delightful Horror 111

People have all kinds of ideas about what God is like—a distant old man in the sky, a concierge for all manner of spiritual and material blessings, a morality cop, a perpetually unhappy parent, a friend who just wants us to be happy—but if we take Moses's encounter with God at face value,[39] we must conclude that one of his qualities is that his glory alone has the power to destroy us where we stand. He embodies the sublime. The God of our wilderness, the Lord of our wanderings, the King of our deliverance, the Commander of our suffering, goes before us as a pillar of cloud by day, under whose refuge we find relief from the burning sun, and a pillar of fire by night, who illuminates our way. Yet God's people were instructed to maintain a certain distance from him so as not to be consumed. This is the nature of God—his glory is too wondrous to behold.

To this glory all creation bears witness. Land and spirituality are connected. The natural world is a reflection of its maker. It brings together the diversity and splendor of creation—the dense forests, roaring waterfalls, cantilevered precipices, and winding rivers that run onward and upward to some undiscovered ford—with the transcendence and immanence of the one who made it.

Albert Bierstadt and the other Hudson River School painters were interpreters of the new world, trying to translate what they saw and understood into the vernacular of the civilized. Their showmanship depended on an audience that could be astonished by scenes of the American wilderness—captured by the unease of the unfamiliar, interested in what should be avoided and what should be subdued. But the native people who lived there inhabited all the wonder and danger that came with it as heirs to the sublime. Their customs, their dress, their tepees, their diet, their traditions, their agricultural and hunting practices, and their approach to the changing seasons were not primitive, but sophisticated. They were elegantly suited to the land and attuned to their communal needs as a people. Their approach was minimal

112 Van Gogh Has a Broken Heart

because the land was abundant. It was portable because the seasons changed. It was durable because the weather demanded it. They were not trying to subdue the sublime, but to live within its limits—and the limits were extreme.

When Albert Bierstadt slid off his saddle that day, eyes transfixed on the valley that had suddenly opened up before him, and reached for his paint box, he was beholding a world that was new to him but known to those who had made that valley home. Both understood that this was not a tame world, and both had some sense that there was a creator behind it. They weren't just beholding rock formations; they were beholding handiwork. What he saw spoke to the nature of this world—a dangerous world, a world where we will have trouble.[40] And it spoke to the nature of the one who made it—magnificent and dangerous, overwhelming and vast, beautiful and sublime.

Oh, to call such a place home. It is a fearful thing to fall into the hands of the living God.[41]

CHAPTER 7

THE YELLOW HOUSE

Vincent van Gogh, Paul Gauguin, and the Sacred Work of Stewarding Another's Pain

Vincent van Gogh, *The Yellow House*, 1888, oil on canvas, 76 cm × 94 cm, Van Gogh Museum, Amsterdam.
Public domain

> Oh, if I could have worked without this accursed
> disease—what things I might have done.

**Vincent van Gogh, letter from Vincent van Gogh
to Theo van Gogh, Saint-Rémy, 2 May 1890**

In the late 1990s, a special Vincent van Gogh exhibit came through my city. When it comes to art museums, I prefer to go alone. I'm the guy moving around each room in a methodical way that makes sense only to me. I read the tombstones—a macabre term for the label on the wall featuring the artwork's title, artist, date, medium, and sometimes more—beside the works that interest me and skip the others as though they weren't even there. I keep track of where the docents are and sidle up far too close to the paintings when no one is looking. I trip the alarms with my nose three inches from Rembrandt's *Head of Christ*, hands clasped innocently behind my back. I'm in my own world, and while I may love you very much, you will probably pick up a note of irritation if you try to talk to me while I'm taking in a Vermeer. He and I are busy, and please don't take this the wrong way, but you're interrupting.

All of this to say, I went to the van Gogh exhibit alone.

I remember it was a collection of a few van Goghs and a great many works by later painters he inspired, arranged on temporary walls that guided us through something of a narrative. We entered by the coat check and spent the next hour learning about van Gogh's brilliance and influence, about his vision and output, and about his enthusiasm and depression.

The show was meant to give us a sense of the genius and suffering that went into the creation of some of the world's most celebrated paintings by perhaps the world's most beloved painter.

Then we exited through the gift shop, which, along with a few posters and postcards commemorating the select works in the exhibit, was largely comprised of tchotchkes making light of Vincent's episode with his severed ear. You could buy an enamel lapel pin or an eraser in the shape of an ear, or a thermal coffee mug bearing Vincent's portrait with a note beside it that explained, "When you pour in a hot beverage, Vincent's ear magically vanishes before your very eyes. Easy van come—easy van Gogh." It broke my heart. It still does.

That gift shop grieved me in the same way as when I read in Scripture about Simon the leper, the woman caught in adultery, or the doubly vexed Zacchaeus, the diminutive tax collector—people identified by the worst things about them. For some, our most humiliating moments happen for all to see, and the legends of our collapses go before us, casting shade and setting expectations for those we've yet to meet. But for most of us, our greatest disappointments and deepest shames are closely guarded secrets known only to a few, if anyone. Why do we hide our failures and limits? Sure, we do it to avoid embarrassment, but what if the real reason we protect those parts of ourselves is not that they're shameful, but that they're sacred?

What if what happened to Vincent's ear isn't really all that funny? What happened there—undoubtedly one of the lowest points in an already tortured soul's life—helps us see not just his shame but also the hope that surrounds it. It shows us that, in the end, we are not our worst moments or our biggest failures. It teaches us the sacred work of stewarding another's pain. And it bids us, "Be gentle. This is a hard world."

The Night Café

When the train pulled into the Arles station at five o'clock in the morning on October 23, 1888, a man in a black suit stepped out onto the platform. He let his eyes adjust, took his suitcase from the porter, and studied the map on the wall by the ticket window. One block south, then a quick left to the square one block over. The address he was looking for, 2 Place Lamartine, was on the northeast corner.

The two-story house was shuttered, and all was quiet in the square except for a faint din of activity coming from around the corner. Following the sound, the man saw light spilling onto the street from the Café de la Gare, known to the locals as Café de Nuit, the Night Café. Night cafés in France were twenty-four-hour establishments where "the 'night prowlers' can take refuge when they don't have the price of a lodging, or if they're too drunk to be admitted."[1]

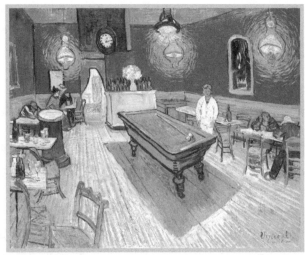

Vincent van Gogh, *The Night Café*, 1888, oil on canvas, 72.4 cm × 92.1 cm, Yale University Art Gallery, New Haven, CT.
Public domain

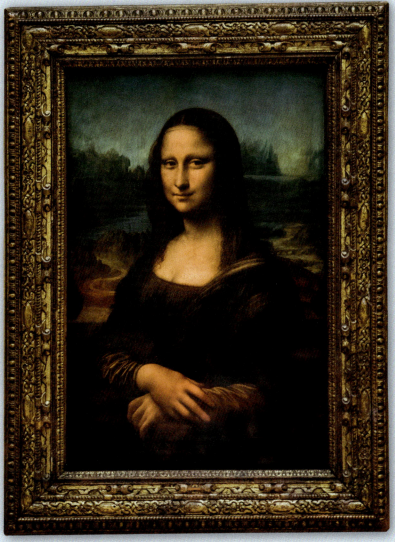

Leonardo da Vinci, *Mona Lisa*, ca. 1503–1506,
oil on poplar panel, 77 cm × 53 cm, Louvre, Paris.
agcreativelab / stock.adobe.com

Paintings by Rembrandt van Rijn

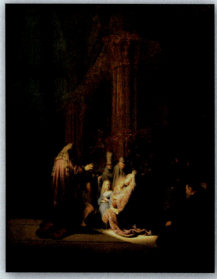

Rembrandt van Rijn, *Simeon's Song of Praise*, 1631, oil on panel, 61 cm × 48 cm, Mauritshuis, The Hague.
Herman Pijpers / CC BY 2.0

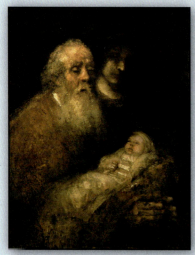

Rembrandt van Rijn, *Simeon in the Temple*, 1669, oil on canvas, 98.5 cm × 79.5 cm, Nationalmuseum, Stockholm.
Public domain

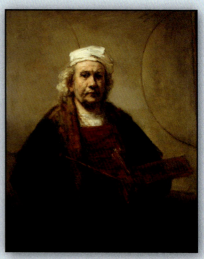

Rembrandt van Rijn, *Self-Portrait with Two Circles*, 1669, oil on canvas, 114.3 cm × 94 cm, Kenwood House, London.
© Swedish National Art Museum / Bridgeman Images

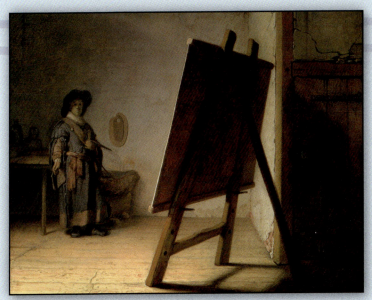

Rembrandt van Rijn, *The Artist in His Studio*, 1628, oil on panel, 24.8 cm × 31.7 cm, Museum of Fine Arts, Boston, MA.

Photograph © 2023 Museum of Fine Arts, Boston. All rights reserved. / Zoe Oliver Sherman Collection / Bridgeman Images

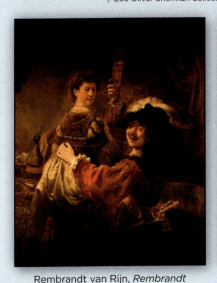

Rembrandt van Rijn, *Rembrandt and Saskia in the Scene of the Prodigal Son in the Tavern*, ca. 1635, oil on canvas, 161 cm × 131 cm, Gemäldegalerie Alte Meister, Dresden.

Staatliche Kunstsammlungen Dresden / © Staatliche Kunstsammlungen Dresden / Bridgeman Images

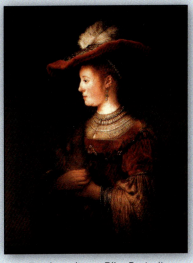

Rembrandt van Rijn, *Portrait of Saskia van Uylenburgh*, ca. 1633–1634, oil on oak panel, 99.5 cm × 78.8 cm, Gemäldegalerie Alte Meister, Dresden.

Public domain

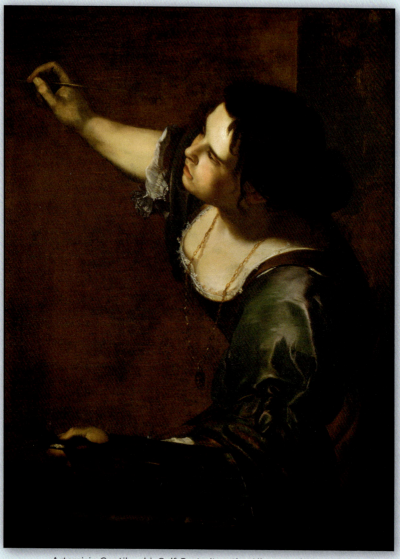

Artemisia Gentileschi, *Self-Portrait as the Allegory of Painting*, 1638–1639, oil on canvas, 98.6 cm × 75.2 cm, London.
Royal Collection Trust / © His Majesty King Charles III, 2023 / Bridgeman Images

Artemisia Gentileschi, *Susanna and the Elders*, 1610, oil on canvas, 170 cm × 119 cm, Schloss Weißenstein, Pommersfelden, Bavaria.
incamerastock / Alamy Stock Photo

Artemisia Gentileschi, *Judith Slaying Holofernes*, 1614–1620, oil on canvas, 158.8 cm × 125.5 cm, Museo di Capodimonte, Naples.
Raffaello Bencini / Bridgeman Images

Paintings by Joseph Mallord William Turner

J. M. W. Turner, *Rain, Steam and Speed—The Great Western Railway*, 1844, oil on canvas, 91 cm × 121.8 cm, National Gallery, London.
Bridgeman Images

J. M. W. Turner, *Fishermen at Sea*, 1796, oil on canvas, 91.44 cm × 122.24 cm, Tate Gallery, London.
Artefact / Alamy Stock Photo

J. M. W. Turner, *George IV at the Provost's Banquet in the Parliament House, Edinburgh*, 1822, oil on mahogany, 60.6 cm × 91.8 cm, Tate Gallery, London.
Stefano Ravera / Alamy Stock Photo

J. M. W. Turner, *Ulysses Deriding Polyphemus*, 1829, oil on canvas, 132.7 cm × 203 cm, National Gallery, London.
Bridgeman Images

J. M. W. Turner, *The Visit to the Tomb*, 1850, oil on canvas, 121.9 cm × 91.4 cm, Tate Gallery, London.
Bridgeman Images

J. M. W. Turner, *The Decline of the Carthaginian Empire*, 1817, oil on canvas, 170.2 cm × 238.8 cm, Tate Gallery, London.
Photo © Tate

J. M. W. Turner, *Rough Sea with Wreckage*, 1840–1845, oil on canvas, 92.1 cm × 122.6 cm, Tate Gallery, London.
Photo © Tate

Albert Bierstadt, *A Storm in the Rocky Mountains, Mt. Rosalie*, 1866, oil on canvas, 210.8 cm × 361.3 cm, Brooklyn Museum, Brooklyn, New York.
Public domain

Vincent van Gogh, *Le pont de Trinquetaille*, 1888, oil on canvas, 65 cm x 81 cm, private collection.
Bridgeman Images

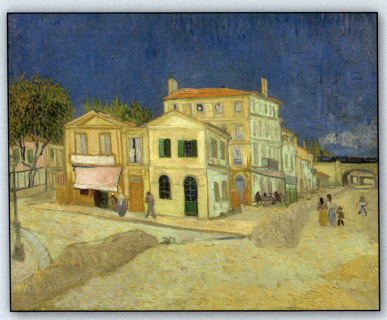

Vincent van Gogh, *The Yellow House*, 1888, oil on canvas,
76 cm × 94 cm, Van Gogh Museum, Amsterdam.
Public domain

Vincent van Gogh, *The Night Café*, 1888, oil on canvas,
72.4 cm × 92.1 cm, Yale University Art Gallery, New Haven, CT.
Public domain

Paul Gauguin, *Self-Portrait with Portrait of Émile Bernard (Les misérables)*, 1888, oil on canvas, 45 cm × 55 cm, Van Gogh Museum, Amsterdam.

Van Gogh Museum, Amsterdam (Vincent van Gogh Foundation)

Vincent van Gogh, *Self-Portrait Dedicated to Paul Gauguin*, 1888, oil on canvas, 51.5 cm x 50.3 cm, Harvard Art Museum, Boston, MA.

© President and Fellows of Harvard College

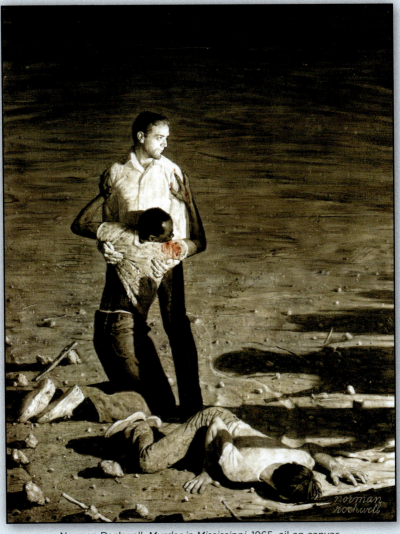

Norman Rockwell, *Murder in Mississippi*, 1965, oil on canvas, 134.5 cm x 106.5 cm, Norman Rockwell Museum, Stockbridge, MA.
Artwork Courtesy of the Norman Rockwell Family Agency

Norman Rockwell, *Breaking Home Ties*, 1954,
oil on canvas, 112 cm x 112 cm, private collection.
Artwork Courtesy of the Norman Rockwell Family Agency

Norman Rockwell, *Golden Rule*, 1961, oil on canvas,
113.5 cm x 100.5 cm, Norman Rockwell Museum, Stockbridge, MA.
Artwork Courtesy of the Norman Rockwell Family Agency

Norman Rockwell, *The Problem We All Live With*, 1963, oil on canvas,
91 cm × 150 cm, Norman Rockwell Museum, Stockbridge, MA.
Artwork Courtesy of the Norman Rockwell Family Agency

Jimmy Abegg, *Obscured by Clouds*, 1954, oil on canvas,
112 cm × 112 cm, private collection.
Courtesy of Jimmy Abegg and Ben Pearson

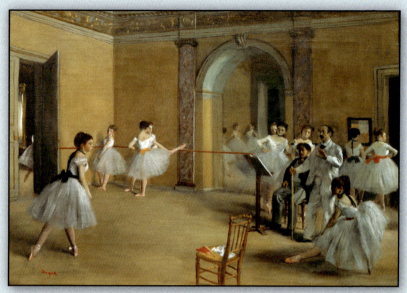

Edgar Degas, *The Dance Foyer at the Opera on the rue Le Peletier*, 1872, oil on canvas, 32 cm × 46 cm, Musée d'Orsay, Paris.
Public domain

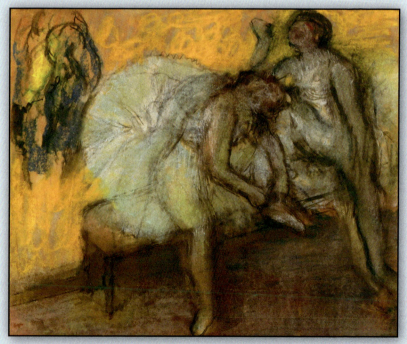

Edgar Degas, *Two Dancers Resting*, 1910, pastel on paper, 78 cm × 96 cm, Musée d'Orsay, Paris.
carlo-trash / Alamy Stock Photo

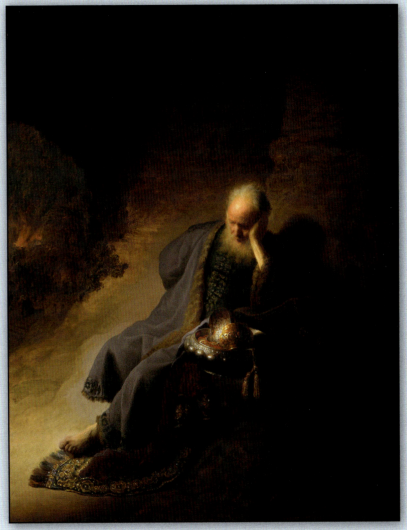

Rembrandt van Rijn, *Jeremiah Lamenting the Destruction of Jerusalem*, 1630, oil on panel, 58 cm × 47 cm, Rijksmuseum, Amsterdam.

Rijksmuseum, Amsterdam

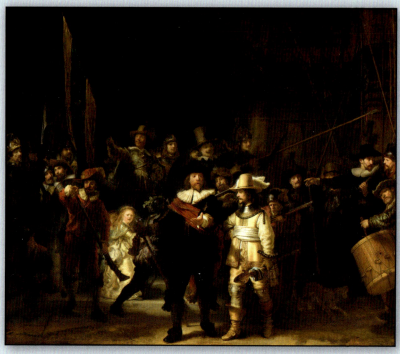

Rembrandt van Rijn, *The Night Watch*, 1642, oil on canvas, 363 cm × 437 cm, Rijksmuseum, Amsterdam.

Rijksmuseum, Amsterdam

Leonardo da Vinci, *The Last Supper*, 1498, tempera on plaster, 460 cm × 880 cm, Santa Maria delle Grazie, Milan. The area at the bottom by the feet of Christ was cut away to make room for a door that has since been bricked in.

Public domain

The outer walls of the Café de Nuit were lined with marble-topped tables. In the back was a simple, well-stocked bar, and in the center of the room, a large green billiard table. A few customers sat slumped over their drinks, waiting for daylight. The proprietor, a tidy man in a white suit named Joseph-Michel Ginoux, emerged from the back, took one look at his new arrival, and said, "And you must be Monsieur Gauguin. Welcome."

The man looked at him curiously.

Ginoux said, "Your host showed me your picture—the one you sent. He said I might find you in need of refreshment. What can I get you?"

The sun wouldn't be up for another couple of hours,[2] so Paul Gauguin settled down at a table. At first light, he paid Ginoux, thanked him, and went around the corner to find the house just as his host had described it—butter yellow with green shutters, which were now open. Gauguin knocked and waited. The quick patter of footsteps came down the stairs like the sound of a man running. An excited but anxious Vincent van Gogh opened the door.

Martin Gayford wrote, "Gauguin's arrival was, it was safe to say, among the most exhilarating but also the most anxious moments of Vincent's life. No sooner had he signed the lease for the Yellow House, almost six months before, than Vincent had started to evolve a plan. He didn't want to live in the house alone; he desperately yearned for company. Right from the start, Gauguin had come to mind as the ideal companion."[3]

Paul Gauguin's arrival was more than a visit from a friend. The two barely knew each other. His presence—which took a lot of persistence and cajoling on Vincent's part, and which had been delayed several times for a variety of reasons that made Vincent wonder if Gauguin really wanted to come at all—represented a crucial step toward Vincent's dream of an artist colony in the south of France. Vincent appreciated the colonies in northern France and Brittany—communities meant to encourage and

118 Van Gogh Has a Broken Heart

inspire—but he had never known a place quite as beautiful as southern France, and especially Arles. Julius Meier-Graefe wrote, "The beauty here was overwhelming, and he slunk about like a Protestant in a cathedral during High Mass. What had he, from the north, to do with this riot of color?"[4] Vincent was convinced that Arles would draw things out of his fellow artists that would remain untapped anywhere else.

Neither Vincent van Gogh nor Paul Gauguin were considered successful artists at this point, but both had, through different though similar circumstances, committed themselves to painting as a vocation. After working as a missionary and an art dealer, Vincent tried his hand at painting at the age of twenty-seven. He was immediately taken by the sensuality and mystery of what the infinite combinations of color and composition could produce. His letters were filled with so much enthusiasm, curiosity, reverence, and zeal for the craft of painting that it would be hard to imagine him doing anything else.

As for Gauguin, the Yellow House was more of a strategic move for someone with limited options. As a young man, Gauguin served in the French military as a pilot's assistant in the merchant marine. After five years of service, he moved to Paris and took a job as a stockbroker. In 1873, at the age of twenty-five, he married a Danish woman from Copenhagen named Mette Sophie Gad, with whom he had five children.

While working as a stockbroker, Gauguin took up painting. He met Camille Pissarro, and through their friendship got to know other Impressionists around town. In 1877, he moved his family into an apartment with a studio that was close to where several other artists lived. His paintings improved, and in 1881, he submitted some of his canvases for an Impressionist exhibition. Critics dismissed his work as lacking maturity, which he didn't mind since he had only recently come to the craft. He would keep practicing.

The following year, the stock market crashed, which not

only impacted his primary job in finance but also led to a sharp decline in art sales as people became more cautious with their spending. With both of his potential income streams—finance and art—now dry and him needing to find a way to support his family, the Gauguins moved to Denmark to be near Mette's relatives. Gauguin became a tarpaulin salesman, which proved to be a disaster because he didn't speak the language and Danes weren't interested in tarps from a Frenchman. Mette became the family's primary earner by, ironically, teaching Danes to speak her husband's language.

Gauguin's professional struggles, combined with his desire to paint, fractured his marriage, and in 1885, Mette urged Gauguin to move back to Paris. She and the children would stay in Copenhagen. Gauguin struggled to make his way back into the artistic community and lived in poverty that first year, producing only a few works. The following year, he moved to an artist colony in Brittany on the Atlantic coast and found unexpected success and admiration among the young artists who gathered there in the summer. Coastal life suited him; it was affordable and ran at a slow pace. He resumed his painting and took up fencing and boxing—sports in which he became quite proficient.

In 1887, Gauguin moved across the Atlantic to Panama, and then to the Caribbean island of Martinique—a French colony. While the idea of island living appealed to Gauguin, the intense heat, dysentery, marsh fever, and leaky hut he called home soon motivated him to return to France. While in Martinique, Gauguin painted close to twenty paintings. Back in France, he showed them at a gallery, where they were seen by Vincent and Theo van Gogh. Theo purchased three of them to display in his art dealership, Goupil & Cie, bringing visibility not only to the paintings but to the painter as well.

Gauguin's relationship with Goupil & Cie was instrumental in his decision to join Vincent in Arles. Once Vincent was

120 Van Gogh Has a Broken Heart

convinced Paul Gauguin would be the perfect partner for his brotherhood of painters in the south, he pleaded with Theo to make Gauguin an offer he couldn't refuse—free board and lodging in exchange for pictures for as long as he lived in the Yellow House. This gave Gauguin a place to live and guaranteed that his work would be seen and purchased by art dealers and collectors. The only catch was that he had to live with Vincent.

Two Self-Portraits

Paul Gauguin met Vincent in Paris through his relationship with Theo.[5] They got to know each other through their correspondence. For Gauguin, this was a way to develop and refine his philosophy and approach to art; for van Gogh, it was an opportunity to exchange letters with a painter he truly admired. In their relationship, Gauguin was the one trying to figure out how to earn a living as a painter. His use for Vincent never really strayed far from that goal. Vincent, however, was trying to figure out how to truly live as a painter. He wasn't primarily interested in how Gauguin's influence might elevate his notoriety or success; he wanted Gauguin's friendship and inspiration.

These differences made for a potentially volatile chemistry long before Gauguin's train pulled into the station. They made Gauguin dodgy in his commitment and left Vincent anxious about his arrival. What if Gauguin hated Arles? What if he found the pastoral countryside uninspiring? What if he felt like he had been deceived and came to resent Vincent?

Prior to Gauguin's arrival, he and Vincent exchanged pictures of themselves; this was how Giroux was able to recognize Gauguin. Each man created a new self-portrait especially for this occasion, and they seemed to have agreed to tie their portraits to literature as a way of revealing to one another a bit more of their personalities and passions. Martin Gayford wrote:

Those self-portraits were not simply evidence of how the two men actually looked or who they actually were. One was a forty-year-old Frenchman with an estranged family and a background in finance trading, the other a thirty-five-year-old Dutchman who had tried his hand at various tasks. Both had come to painting relatively late in life. But the pictures were indices of how Gauguin and van Gogh imagined themselves. Each had presented his image in character, as a figure from literature. One thing they had in common was an intense fantasy life in which their own real lives merged with their reading.[6]

Paul Gauguin, *Self-Portrait with Portrait of Émile Bernard (Les misérables)*, 1888, oil on canvas, 45 cm × 55 cm, Van Gogh Museum, Amsterdam.
Van Gogh Museum, Amsterdam (Vincent van Gogh Foundation)

Gauguin painted himself as Jean Valjean from *Les Misérables*, presenting himself as an outcast, martyr, hero, and leader of a band of rebels—possibly a nod to the Impressionists. To Vincent he wrote of his portrait:

It is the face of an outlaw, ill-clad and powerful like Jean Valjean—with an inner nobility and gentleness. The face is flushed, the eyes accented by the surrounding colors of a furnace-fire. This is to represent the volcanic flames that animate the soul of the artist. . . . The girlish background, with its childlike flowers, is there to attest to our artistic purity. As for this Jean Valjean whom society has oppressed—cast out—. . . is he not equally a symbol of the contemporary Impressionist painter? In endowing him with my features I offer you as well as an image of myself a portrait of all the wretched victims of society.[7]

Vincent van Gogh, *Self-Portrait Dedicated to Paul Gauguin*, 1888, oil on canvas, 61.5 cm x 50.3 cm, Harvard Art Museum, Boston, MA.
© President and Fellows of Harvard College

Vincent sent Gauguin a portrait of himself with close-cropped hair and subtly slanted eyes, giving him the look of a

The Yellow House 123

Japanese monk. He got this idea from Pierre Loti's novel *Madame Chrysanthème* (later adapted into the opera *Madame Butterfly*), which was about French military officers stationed off the coast of Japan, and in which Buddhist monks played only a small role. To Gauguin he wrote:

> If we study Japanese art, we see a man who is undoubtedly wise, philosophic, and intelligent, who spends his time doing what? . . . He studies a single blade of grass. But the blade of grass leads him to draw every plant and then the seasons, the wide aspects of the countryside, then animals, then the human figure. . . . Come now, isn't it almost a true religion which these simple Japanese people teach us, who live in nature as though they themselves were flowers?[8]

Perhaps Vincent chose the likeness of a monk to convey a posture of submission to his French veteran guest, or maybe he was trying to say he was contemplative and austere. Either way, neither man was truly like the image they sent—Gauguin wasn't the hero of a band of rebels, and Vincent could be quite volatile and manic.

When Gauguin knocked on Vincent's door, both men had ideas of what they hoped to get out of their artistic union. And both worried that they might disappoint or that the other might not hold up their end. Their portraits were attempts to prepare the other for who they hoped to be once they came together. But people are who they are, and though we might try to frame ourselves in a certain light, drawing attention to our better qualities, once we let someone get close enough, they will see what we left out, what we tried to hide, as well as those unflattering truths that have become so familiar to us that we no longer notice they're there.

The Yellow House

Vincent took great care and deliberation in decorating the Yellow House—from the art on the walls to the yellow linens and curtains to the green paint on the shutters to the furniture he accumulated over time. He had been renting part of it as his studio since May and had just leased the remaining bedrooms in September. He said, "I have it all planned. I really do want to make it—an *artist's house*, but not affected, on the contrary, *nothing affected*, but everything from the chairs to the pictures full of character."[9]

As Vincent showed Paul Gauguin around, he pointed out the canvases he had painted for the Yellow House. Gauguin's small room featured six—four landscapes of local gardens and two pots of sunflowers. Other works decorated Vincent's bedroom and the hallways. But as they moved from room to room, Gauguin was surprised to find that there were paintings everywhere in stacks on the floor. Vincent was "engaged in one of the most astonishing creative sprints in Western art."[10]

During Vincent's fifteen months in Arles, he produced around two hundred canvases, many of them considered his masterworks: *Starry Night over the Rhône, The Night Café, Café Terrace at Night, Vase with Fifteen Sunflowers, The Sower, A Pair of Shoes*, and *The Red Vineyard*. Most of them were stacked in the Yellow House when Paul Gauguin arrived. The scene must have been simultaneously impressive and disconcerting—evidence of creative insatiability and a manic compulsion to produce at a pace and volume no one had ever seen. Vincent's downstairs studio where he produced these works was a chaotic mess. Gauguin recalled, "I was shocked. His box of colors barely sufficed to contain all those squeezed tubes, which were never closed up."[11]

Both the stacks of art and the unruly studio matched the man himself. Vincent was a twitchy, nervous fellow. One neighbor

said, "He had an extraordinary way of pouring out sentences in Dutch, English, and French, then glancing back at you over his shoulder, and hissing through his teeth. In fact, when thus excited, he looked more than a little mad; at other times he was inclined to be morose, as if suspicious."[12] Another neighbor said, "He was odd, going out to paint in the country, his pipe between his teeth, his big body a bit hunched, a mad look in his eye. He always looked as if he were running away, without daring to look at anyone."[13]

Vincent and Gauguin were both relatively short in stature—Vincent at five feet, nine inches, and Gauguin at five feet, four inches. But Gauguin had the larger personality. For social occasions, he dressed in a dark suit; he painted in a beret and painter's smock. He was stubborn, egotistical, and self-centered.[14] He could be mean, caustic, and arrogant.

Gauguin considered van Gogh an inferior painter—and for good reason. Per his agreement with Theo, Gauguin kept sending new work to Goupil & Cie. His canvases were usually met with an enthusiastic response. Theo sold a few of his paintings, and Gauguin received invitations to exhibit his work in Paris and Brussels.[15] Vincent, meanwhile, could not find a single buyer, no matter how high his stack of canvases got.

All told, Gauguin spent sixty-three days with Vincent in Arles. They were two of the most productive months of each artist's career, and two of the most turbulent. Vincent treated Gauguin as his superior, even as he came to resent Gauguin's tone of superiority that came across as highly critical and magisterial. Vincent felt Gauguin regarded him as a rival, deliberately trying to goad him into anger. He struggled to control his temper and argued back with a stubbornness and bite all his own.[16]

During their time together, Gauguin assumed control of their partnership. He planned their days, cooked their meals, and managed their money, even down to how much they would pay

126 Van Gogh Has a Broken Heart

the women at the brothels. Vincent quickly came to depend on his guest, as though Gauguin were the host. Derek Fell wrote, "Vincent's emotional attachment to Gauguin became so strong that whenever Gauguin threatened to leave, Vincent became agitated, fearful of isolation, once even hurling a glass of absinthe at his friend."[17]

Vincent and Gauguin were, on many occasions, heavy drinkers. When Vincent drank, his behavior became even more mercurial. One afternoon, Vincent and Gauguin sat silently at Giroux's café. They had been arguing over art and politics and had been at it for so long they eventually just stopped speaking to one another. Then without warning, Vincent hurled his glass of absinthe at Gauguin's head. Gauguin dodged the glass, grabbed Vincent by his collar, and dragged him out into the street. Gauguin the boxer was ready to go, but he couldn't bear to strike his glassy-eyed associate, so he went back into the café. Vincent shuffled home and passed out until the next day. He woke up the following morning confused, claiming to have a vague memory of assaulting his friend. He begged Gauguin's forgiveness. Gauguin "replied that he did not mind at all, and that he was accustomed to much rougher treatment. If, however, one of those absinthe glasses should happen to hit him, he was not prepared to answer for the consequences."[18]

After that, Gauguin decided it was time to part ways. He wrote to Theo to let him know, but Vincent pleaded with Gauguin to reconsider. They seemed to reach an agreement, so Gauguin wrote a second letter to Theo withdrawing his decision to leave. He wrote to a friend, "I am staying here for now, but I'm poised to go at any moment."[19]

Awaken This Man with Great Care

It rained nonstop the week before Christmas, leaving Vincent and Gauguin cooped up inside to pick at each other.[20] On

December 23, just a few days after the absinthe incident, Vincent and Gauguin went to the art museum in Montpellier. As they moved through the galleries, their bickering resumed. They argued about the works they saw and the merits of the different painters on display.[21] Their dispute carried over into dinner, and once Gauguin had finished his meal, he got up from the table and left the Yellow House to clear his head and let things calm down.

Vincent wasn't sure if Gauguin had left for good. In a blur of panic, he went into his bedroom, picked up his straight razor, and followed Gauguin out into the dark streets. As Gauguin was walking across the square toward the Rhone, he heard someone running up behind him. Gauguin described the confrontation like this:

> I heard behind me a well-known step, short, quick, irregular. I turned about on the instant as Vincent rushed towards me, an open razor in hand. My look at that moment must have had great power in it, for he stopped and, lowering his head, set off running towards the house.[22]

Gauguin decided to spend the night in a hotel rather than return to a roommate who had just threatened his life. Vincent ran up to his room and stared into his mirror, cursing himself. Then he raised his blade and slashed off a significant portion of his left ear, severing his auricular artery and causing blood to spurt all over the walls and floor.[23]

Vincent grabbed one of the linens he had bought especially for the Yellow House and cut it into strips to absorb and slow the bleeding. After soaking them through, he washed his amputated ear and carefully wrapped it in an envelope made of newspaper. Then he pulled a hat down over his head, crossed the same circle where he'd had his confrontation with Gauguin, and went to the brothel at No. 1, Rue du Bout d'Arles.

128 Van Gogh Has a Broken Heart

That week's *Le Forum Républicain* carried the story of what happened next: "Last Sunday at 11:30 p.m. one Vincent Vangogh painter, of Dutch origin, presented himself at the *maison de tolerance* no. 1, asked for one Rachel, and gave her . . . his ear, saying, 'Guard this object very carefully.' Then he disappeared."[24]

Rachel fainted when she opened the grisly package. The local postman, Vincent's friend Joseph Roulin, found Vincent at the brothel, half-conscious, delirious, and still bleeding badly from his wound. The brothel was in an uproar, and word began to spread to the neighbors of Vincent's shocking presence.[25] Roulin walked Vincent home and put him in bed.[26]

In the early morning hours of Christmas Eve, Virginie Chabaud, who ran the brothel, took the parcel Vincent had given to Rachel and showed it to a police officer, who, upon confirming that it was indeed an ear, summoned his superior. The two officers went to the Yellow House to look for Vincent. They found the blood-soaked painter in his bed in a deep sleep. They called a doctor.

Gauguin knew nothing of the incident until the next morning, when he returned to the Yellow House to find a crowd of neighbors and police officers gathered on the street out front. One bystander asked him what he had done to his roommate. Another told him Vincent was dead. Gauguin went upstairs as calmly as he could. He found police officers and the doctor next to Vincent, who was soaked in blood and sound asleep.[27] Describing the scene, Gauguin later recalled:

> In the bed lay Vincent, rolled up in the sheets, curled up in a ball; he seemed lifeless. Gently, very gently, I touched the body, the heat of which showed that he was still alive. For me it was as if I had suddenly got back all my energy, all my spirit. . . . Then in a low voice I said to the Police Commissioner, "Be kind enough, Monsieur, to awaken this

The Yellow House **129**

man with great care, and if he asks for me tell him I have left for Paris; the sight of me might prove fatal to him."[28] .

Back in Paris, as Vincent was slashing off his ear, his brother was getting engaged. After finding Vincent alive, Gauguin telegrammed Theo, who had just finished writing a euphoric letter to his sister telling her the good news. He left a short note for his fiancée Johanna: "Vincent is gravely ill. I don't know what's wrong, but I shall have to go there as my presence is required. I'm so sorry that you will be upset because of me, when instead I would like to make you happy."[29]

Theo caught the 7:15 p.m. express train south and arrived in Arles on Christmas morning. He found Vincent in the hospital.[30] Gauguin was still in town. Vincent asked Theo over and over if he could see Gauguin,[31] but Gauguin stayed away from Vincent for fear of upsetting him further and likely to avoid any desperate pleas for him to stay. That night, Theo and Gauguin left Arles together on the night train back to Paris. Vincent never saw Paul Gauguin again.[32]

When Vincent regained some lucidity, the doctor asked him about the incidents of the 23rd of December. Vincent claimed not to remember much, and when pressed as to why he severed his ear and gave it to Rachel, he said his reasons were "quite personal."[33] Certainly in the agony of his own anxious mind, he blamed himself for driving Gauguin away. It wasn't just the end of a friendship he so earnestly prized; it was also the end of his dream for the Yellow House.[34] Martin Gayford wrote, "He was responsible for the terrible, solitary life he led (isolated again now that Gauguin had left). . . . Vincent punished himself."[35]

The day after Christmas, while still in the hospital, Vincent learned that Theo and Gauguin had left. He experienced a violent breakdown and had to be restrained in a straitjacket and locked in a solitary room.[36] Joseph Roulin took over the task of looking

130 Van Gogh Has a Broken Heart

after Vincent, sending Theo regular updates. Vincent's condition was fragile. He remained weak and despondent. After one particularly rough evening, Roulin wrote, "He passed a very bad night and they had to put him in an isolated room, he has taken no food and completely refused to talk. That is the exact state of your brother at present."[37]

But within a few days, to everyone's surprise, Vincent experienced a rapid recovery. Though his doctor, Felix Rey, believed Vincent would always retain "the extreme excitability that was the basis of his character,"[38] Vincent's mind cleared. He asked about Gauguin and Theo, not with the same desperation of the previous days, but with the concern of a man who knew he had put them through an ordeal.

A week later, on January 4, Vincent's doctors allowed him to make a short visit to the Yellow House. He walked into his flat to find Gauguin's room bare except for the furniture and paintings Vincent had supplied for his friend. This time, Vincent did not break down. Instead, he sat down and wrote a conciliatory letter to his friend, apologizing for his behavior and wishing him well.[39]

On January 7, Dr. Rey felt Vincent had stabilized and discharged him from the hospital.[40] Vincent fared well enough at first, but not long after returning home in early March, he again began acting erratically. He became the object of his neighbors' ridicule and scorn. Some avoided him as though he were a dangerous madman, while others sought him out to mock him and throw things at him. Then, Meier-Graefe wrote, "eighty-one venerable citizens of the town addressed a petition to the Mayor of Arles with a view to putting an end to the turmoil. They requested that the madman should be removed and taken to an institution specifically designed for such people, for which they as citizens paid taxes."[41] In truth, only thirty people signed the petition, but included was the signature of one Joseph Ginoux,

proprietor of the Café de Nuit—Vincent's former landlord, friend, and purveyor of absinthe.

The mayor did his duty as a servant of the people and ordered that Vincent should be forcibly removed from the Yellow House and committed to the "section for lunatics in the hospital,"[42] where he was once again put into a rubber cell. The Yellow House was sealed by the local officials until Theo could come to gather his brother's property. Vincent never returned to the Yellow House after that.

For all of this, you can buy a coffee mug, where "when you pour in a hot beverage, Vincent's ear magically vanishes right before your very eyes."

To Be Known by Our Pain

One of the most heartbreaking parts of Vincent's story is how he often struggled to remember his outbursts and breakdowns. Some part of his brain was in a fog—perhaps from his drinking, maybe from lead poisoning from ingesting paint, or from any number of other reasons researchers have speculated about over the years. He wasn't always aware of what he was doing. He didn't remember much about the night he cut off his ear, though it is almost certainly one of the most common things we associate with his name today. Many are more aware of his madness than his art.

Be gentle. This is a hard world.

If the Lord, in his kindness, gives us the blessing of friendship, he is most certainly calling us to the holy work of burden bearing. Stick around long enough in any relationship, and you will come to see more than the initial portraits offered. Paul Gauguin presented himself as Jean Valjean, giving us the aspirational vision of a man whose primary challenges came from the unjust world outside of him. Vincent offered himself as a man

132 Van Gogh Has a Broken Heart

who had mastered inner peace. Neither portrait was accurate. But are the portraits we're inclined to lead with ever true? Do they ever tell the full story?

To truly love someone is to move beyond first impressions into the heart of things; it is to take on the sacred work of stewarding another's joys and sorrows. It is to show up for their celebrations and invite them to yours. It is to sit with them when they're sick, nurse them until they are better, and lean on them when you're the one who is hurting. Is there a more sacred calling?

To really know a person is to know them by their sorrows. Consider the ministry of Jesus and the people we meet along the way. If you have spent much time in Scripture, when I mention their names, you will know who I'm talking about. They are all people known, at least in part, by their pain. There's Matthew the tax collector, Simon the leper, blind Bartimaeus, doubting Thomas, and Judas the betrayer. There's the man with the withered hand, the woman caught in adultery, the boy with the unclean spirit, and the girl who had only been asleep. There's the widow from Nain, the rich young ruler, the woman with the issue of blood, the paralytic from Capernaum, the demoniac who lived among the tombs, and the thief on the cross.

We know them by their failures. We know them by their afflictions. We know them by their sorrows. To know someone by their pain is to know them by their need. Even the rich young ruler, whose pain was that he had outperformed everyone, acquired great wealth in the process, had a long life ahead of him, and still felt a curious emptiness that nothing could seem to fill—even that man had a need. What did he and all the others need? Peace. Rest. Hope. Forgiveness. Freedom from affliction. Deliverance. Our sorrows, failures, and afflictions are sacred, not shameful, because they tell the truth about our need for redeeming grace and mercy.

The Yellow House 133

These things, Christ alone can give. And he does give them freely to any who would believe in him.

But what about us? What can we give? How do we care for the husband estranged from his family, the woman who can be found at the brothel, or the painter with the severed ear? We can refuse to allow their pain to be the only thing, or even the main thing, we know them by. We can honor the truth that it is only the visibility of their suffering, not its presence, that sets them apart from anyone else. We can guard their reputations. We can remember, through the example of their tears, that we were created to hope in a joy unseen and seek to remind them of this even as they remind us of our need for hope. We can seek to know the beauty they're contributing to the world, made even more beautiful by the way it kicks against the darkness in them. We can join them in this, thereby making beauty of our own.

And we can, for the love of God, refrain from buying that insulting mug.

CHAPTER 8

CULTIVATE YOUR OWN HALF ACRE

Norman Rockwell and Capturing a Changing Country

Norman Rockwell, *Murder in Mississippi*, 1965, oil on canvas, 134.5 cm x 106.5 cm, Norman Rockwell Museum, Stockbridge, MA.
Artwork Courtesy of the Norman Rockwell Family Agency

The great band of illustrators have shown us to ourselves and I am proud to be among their company.

Norman Rockwell

My grandfather had a model of a Waco CG-4 military glider on a high shelf in his den. As a child, I wanted so badly to play with it but was never allowed to. To me it was a toy plane; to him it was a reminder.

My grandfather flew that particular glider for the US Army in World War II. It was an engineless aircraft that was pulled up by a C-47 in the same way a child runs with a kite. Once the glider was aloft, the tow plane dragged it as close as it could to its intended destination and then released it to sail on the thermals until the law of gravity did its work.

"Every landing was a crash landing," he said during a videotaped interview I learned about after his death. "No engine, and essentially no brakes. You're a pilot while the craft is in the air, but as soon as it touches ground, you're infantry with nothing but your rifle, resolve, and training to carry you out—that and the guy next to you."

Gliders from that era could deposit a group of soldiers and cargo all in the same location as opposed to the scattering that happened when men and gear parachuted down to a particular drop zone. Gliders were silent, giving them the advantage of stealth.

I knew Pop Pop was a soldier in World War II and that the men of his era who served deserved my respect. But I never knew much about his experience or that part of his life because he, like

Cultivate Your Own Half Acre 137

so many of his fellow soldiers from that era, thought it immodest to boast about serving his country, which he regarded as his duty.

We never really think about our grandparents as young people. They come into our lives already old. My grandfather was in his twenties when he flew one of those disposable airplanes made mostly of canvas and wood in World War II's Operation Market Garden, but a twenty-year-old is not what I imagined when this came up in conversation. I pictured the silver-haired, bowlegged man I knew from Thanksgiving visits climbing into the pilot's seat and taking hold of the tiller. I did not know the life he lived apart from me; I only knew him as he was to me—my Pop Pop. Mostly, we only know what's in front of us.

Then one Christmas, Nana and Pop Pop gave our family a Norman Rockwell coffee-table book. I sat with that book for hours, poring over the pictures, picking up little details, occasionally getting some of the jokes embedded in Rockwell's compositions and feeling as certain as a boy could feel that by picking up on the humor, I was becoming a sophisticated young man.

I marveled at Rockwell's detail and realism and wondered how a person could paint so well. I don't remember that book teaching me anything about the academic discipline we call "art appreciation," but it certainly gave me an education. I learned about the World War II generation—Pop Pop's generation. At some point in his life, Pop Pop was like the young man Rockwell showed in his crisp uniform, back from the war, surrounded by people begging for stories, choosing every word with care and modest restraint. Rockwell told me stories about my grandfather and helped me picture what he may have looked like when he was young.

That's not all Norman Rockwell taught me. He taught me the nobility of qualities like courage in action and faith lived out in public. And he taught me about United States presidents, baseball, poverty, skilled trades, medicine, romance, childhood

138 Van Gogh Has a Broken Heart

(and the loss of innocence that accompanies it), religion, and humor all in that one book. He was also one of the first people to teach me about the civil rights movement.

Norman Rockwell was a visual bard, a historian, and an observer. He was also prolific, producing more than four thousand original works over the course of his life. They called him an illustrator. He was born in New York City in 1894. During the school year, he was a city kid. He said he would sometimes go up onto the roof of his building to watch street gangs fight it out with bicycle chains.[1] His family spent many summers in the country, where he would pass his days exploring the countryside and his evenings drawing Charles Dickens characters from the books his father read to him. He much preferred his country time over city life.

At thirteen, he quit high school and started attending the Art Students League of New York, a school for visual artists, actors, and musicians, whose alumnae include names like Jackson Pollock, Winslow Homer, Georgia O'Keeffe, Frederic Remington, Mark Rothko, and Maurice Sendak. There Rockwell studied anatomy and classic illustration technique. He was a natural, and at seventeen he became the lead illustrator for *Boys' Life* magazine. That job led to more opportunities and greater prestige for the young illustrator, including a shot at a cover illustration for one of the most celebrated magazines in the country—*The Saturday Evening Post*. The narrator of "American Chronicles: The Art of Norman Rockwell" said, "For ambitious illustrators, the pinnacle of success was *The Saturday Evening Post*. Paintings of children caught in humorous situations earned Rockwell his first *Post* cover on May 20, 1916. He was twenty-two years old."[2]

Often, a particular technological advance will coincide with the emergence of a particular artist whose work seems designed to leverage that new technology to great effect. This was the case for Norman Rockwell and the four-color press. In the early 1920s,

the invention of this press made it possible to print vivid reproductions of full-color art. The nature of Rockwell's compelling, detailed, story-driven paintings paired perfectly with the press's capability to reproduce them en masse, establishing him as the ideal lead illustrator for the widely distributed magazine.

Rockwell soon became a household name—so much so that, according to Rockwell biographer Christopher Finch, *The Saturday Evening Post* "could automatically increase its print order by 250,000 copies when an issue had a cover by Rockwell."[3] Rockwell was earning the trust of a nation one illustration at a time.

Much of Rockwell's work was dismissed by critics, who considered his paintings to be too idyllic and sentimental to be considered great art.[4] If you look at many of his *Post* covers, it isn't hard to see what the critics were referring to. Many of his figures bordered on caricature—the lanky football player with his protruding Adam's apple, the redhead with the impossible freckles, the middle-aged man with the cigar nub sticking out of his mouth, the old woman and young boy saying grace over their meal. Rockwell accepted this criticism, saying, "The kind of thing I like to do, I know it isn't the highest form of art. There's no doubt in the world about that, and I know it better than anybody else. I love to tell stories in pictures—the story is the first thing and the last thing. That isn't what a fine art man goes for, but I go for it, and I just love to do it that way."[5]

Rockwell painted life in America in the 1900s. His art worked on the American psyche, and his message ran deeper than his early critics gave him credit for—a truth that would be borne out over time. His style was disarming. He set viewers at ease. His illustrations felt familiar. And he had a singular focus—people. Christopher Finch wrote, "In a period so given over to the Romantic School preoccupation with 'nature effects' . . . here is a painter who ignores the non-human scene."[6] Because he believed

140 Van Gogh Has a Broken Heart

in the power of story, Rockwell painted people. He told the story of his country's citizens as they roared through war, depression, inequality, and optimism about the future.

In his book *Norman Rockwell's America*, Finch noted, "There is often a touch of sadness to Rockwell's interiors. His may be an America of eternal optimism, but it is certainly not an America of universal fulfillment."[7] Consider Rockwell's illustration called *Homecoming G.I., 1945*, showing a soldier standing outside his tenement building as his family and neighbors pour out to welcome him home. It is a cheerful, hopeful image set in a context known for struggle and poverty. Finch wrote:

> No one can deny that in many tenement houses the poor are ground down by poverty, disease, or racial injustice into the dreadfulness of wishing, being hurt themselves, to hurt others weaker than they. Our hearts have been frozen by many a powerful book-presentation of this literal but partial truth. Norman Rockwell reminds us that in those same tenement houses are also many homes in which the safe return of a soldier son—insignificant droplet in the military ocean—sets off an explosion of a joy magnificent in its power and purity.[8]

Rockwell's ability to capture the complexity of moments like these—to unfold an entire narrative that shows both the deficiency and optimism that belong to the American people, and to do it all in a single frame—is what set him apart.

Breaking Home Ties

As he grew older, Rockwell started to take on more serious subject matters like basic human freedoms, leaving home, and racial injustice. But these later paintings did not stand alone as his only

substantive work. Rather, they shed light on the depth in his prior works that was often overlooked. Those who dismissed Rockwell took his illustrations to say, "Here is the world. Isn't it a quaint and funny place?" But a deeper look shows the brilliance of an artist whose work echoes what Frederick Buechner once wrote: "Here is the world. Beautiful and terrible things will happen. Don't be afraid."[9].

Rockwell lived in an era where news came slowly, unlike today, when information is immediate, global, and free. For Rockwell's generation in the mid-1950s, limited access to what was happening in other parts of the country, let alone the world, gave people a deeper connection to their own local communities. There were no screens or social media feeds consuming their focus. They looked to each other for entertainment and necessary services. Beautiful and terrible things were happening all around Rockwell, particularly in the realm of civil rights. As issues of equality and systemic racial injustice increasingly rose to the surface of his cultural moment, Rockwell saw that the world was changing, and he wanted to capture that change.

Moments of change were always there in his work—growing up, leaving home, returning from war. Rockwell's use of details carries his stories. He was a student of the details. They're beautiful. They're tragic. They set the temperature in the room. They import the drama in a story. They lay out context. They provide implication, subtlety, and emotional cues.

Consider *Breaking Home Ties* from 1954, a picture of a father dropping his college-bound son off at the train station.[10] In the bottom of the frame, we see the smooth rail of a train track. To the left we see the red flag and lamp the porter will use to signal the inbound train to stop. The father and son sit on the runner boards of the man's old pickup truck. They are waiting for the Pullman that will take the young man away. As the eye travels around the canvas, it encounters a master class in the use of

contrasting detail to lead us to the sad but inevitable main idea of the painting—at some point we will all take our leave from one another.

The old man wears worn denim work clothes and scuffed boots. The son wears a new suit with a playful tie, fancy socks, and polished loafers. He looks brand-new, which really describes what he's doing—stepping into the new unknown, unsullied by this tarnished world. In his lap he holds a meal—sustenance for his travels, no doubt prepared by his mother. The father holds two hats—one a wide-brimmed straw work hat to protect him from the unrelenting sun, and the other a fancy new fedora that matches the boy's outfit. This is the stoic father's way of holding on to his son for these last few moments without the son or anyone else having to know.

Norman Rockwell, *Breaking Home Ties*, 1954,
oil on canvas, 112 cm x 112 cm, private collection.
Artwork Courtesy of the Norman Rockwell Family Agency

The father slumps forward and looks down the track that will carry his boy away. He looks weary and lost in thought. The fob for his truck key dangles from his shirt pocket. In the boy's pocket is his train ticket. He sits upright, almost coiled, searching the opposite direction for the oncoming engine. The bookmarks in his texts show he has already begun his assigned reading. In his mind, he is already a college student. He's already gone.

I find this painting profoundly sad, yet hopeful. Rockwell uses his details to hammer home the fact that everyone gets left at some point. Everyone must let others go on into new things. As human beings, we relate to the hope of the unexplored, the possibility of new beginnings, the economy of leaving everything behind except what we can carry in our hands. We come to know the sorrow of saying goodbye.

To me, this is all present in *Breaking Home Ties*. But in another way, this image captures America in a crucial moment, at the beginning of the civil rights movement. Young faces are looking ahead to the possibility of leaving the old ways behind in the brave hope of embracing something new.

The Problem We All Live With

I'm not suggesting Norman Rockwell intended *Breaking Home Ties* as a direct commentary on the civil rights movement, but the theme of leaving what is known for the possibilities that lie in the untested was a story Rockwell told many times in many ways. He was sensitive to the idea of change. So when the stories of Emmett Till, a black teenager who was brutally lynched and whose mother insisted on an open-casket funeral so the world would be compelled to see what racial hatred did to her son, and *Brown v. the Board of Education* (1954), an early initiative to desegregate schools to create a more equitable education and future for black students, appeared in the paper that same year,

144 Van Gogh Has a Broken Heart

Rockwell paid attention. This was, after all, his America, and he was one of her illustrators.

After Emmett Till and *Brown v. Board* came Rosa Park's refusal to give up her seat on her bus, followed the next day by the Montgomery Bus Boycott of 1955, out of which Martin Luther King Jr. emerged as one of the civil rights movement's most important leaders. Then came the sit-ins from 1958 to 1960 in Atlanta, Nashville, and Greensboro, in which Black patrons occupied seats reserved for White customers at lunch counters in Southern restaurants, and the Freedom Rides of 1961 in which civil rights activists rode interstate buses into segregated Southern states to challenge the nonenforcement of the United States Supreme Court decisions regarding desegregation and the dismantling of Jim Crow laws.

These acts of civil disobedience led to greater national visibility of racial and systemic injustices, which prompted federal legislation to adopt and enforce laws that would promote equity. Out of the civil rights movement came the Civil Rights Act of 1957, which empowered federal prosecutors to obtain court injunctions against interference with any person's right to vote. It also gave them clear authority to investigate possible unfair trials in which White defendants were found not guilty by all-White juries.

Rockwell read these stories, including the 1960 account of the six-year-old Ruby Bridges, who, as the first black girl to attend the all-White, newly desegregated William Franz Elementary School in New Orleans, had to be escorted to school by four United States marshals. Rockwell read the story and saw the photographs of her carrying her lunch box surrounded by armed men with the US marshals' insignia on a band around their coat sleeves. He read the November 15, 1960, *New York Times* article that said, "Some 150 whites, mostly housewives and teenage youths, clustered along the sidewalks across from the William Franz School

Cultivate Your Own Half Acre **145**

when pupils marched in at 8:40 a.m. One youth chanted 'Two, Four, Six, Eight, we don't want to integrate.'" The article went on to describe assembled mothers and school students yelling at police, some carrying signs, one held by a young boy that said, "All I Want for Christmas Is a Clean White School."[11] He read what one of her escorts, United States Deputy Marshal Charles Burks, said: "She showed a lot of courage. She never cried. She didn't whimper. She just marched along like a little soldier, and we're all very proud of her."[12]

The Saturday Evening Post, where Rockwell had worked for nearly fifty years at this point, was reluctant to deviate from the sentimental tone their readers had come to expect from Rockwell. In his article "Norman Rockwell and Race," Abisola Jegede said Rockwell's earlier *Post* covers "depicted a simpler, more wholesome version of America. However, it is important to note who was missing from these illustrations. Due to the rules of the *Post*, Rockwell's America was almost exclusively white, and minorities were only represented if they were in servile positions."[13] In a 1971 interview, Rockwell "explained the unwritten rule laid down by his first editor at the *Post*: 'George Horace Lorimer, who was a very liberal man, told me never to show colored people except as servants.'"[14]

Rockwell abided by this rule in his *Saturday Evening Post* illustration from December 7, 1946—*Boy in a Dining Car*, which depicts a White boy sitting at a dining table counting out the tip for his older, Black waiter. The Norman Rockwell Museum says of the painting, "Using a dining car from the New York Central's Lake Shore Limited as his setting, Rockwell captured a moment in his own son's life that he thought would touch a common cord. Rockwell's painting describes a young boy's first experience of calculating a waiter's tip. At Rockwell's request the New York Central diverted . . . an older car and a twenty-eight-year veteran waiter."[15]

But Rockwell was moved and troubled by the image of Ruby Bridges walking to school with an armed escort, and as an illustrator, he wanted to take on the issue of racial injustice. He wanted America to see Ruby. He began by submitting *Golden Rule* to the *Post*, his first work showing people of color not in positions of service but as racial and religious representatives of entire people groups that made up America's population, with the words of Christ from his Sermon on the Mount in the middle: "Do unto others as you would have them do unto you."[16] At the bottom stands Ruby Bridges holding her school books in her arms. The *Post* ran the image on April 1, 1961.

Norman Rockwell, *Golden Rule*, 1961, oil on canvas, 113.5 cm x 100.5 cm, Norman Rockwell Museum, Stockbridge, MA.
Artwork Courtesy of the Norman Rockwell Family Agency

Rockwell was beginning to question how he fit at *The Saturday Evening Post*. Jegede said, "While the *Post* seemed to relax their rules a bit by the 1960s, publishing Rockwell's

multi-ethnic 'Do unto Others' cover in 1961, their pace of change was not quick enough. In 1963, Rockwell traded his position at the *Post* for one at *Look* magazine, a publication that was more comfortable discussing and illustrating the racial realities of the time."[17]

That year, Rockwell took on the Ruby Bridges story more directly with his seminal work, *The Problem We All Live With* (1963), which depicts Ruby walking to school with two marshals in front of her and two behind. Beside her, rotten tomatoes are splattered on a wall that is covered in racial epithets. *Look* ran the image in the January 14, 1964, issue as a two-page spread in the middle of the magazine without comment except for the title.

Norman Rockwell, *The Problem We All Live With*, 1963, oil on canvas, 91 cm × 150 cm, Norman Rockwell Museum, Stockbridge, MA.
Artwork Courtesy of the Norman Rockwell Family Agency

Murder in Mississippi

On June 21, 1964, deputy sheriff Cecil Price from Neshoba County, Mississippi, pulled over a car carrying three men—twenty-one-year-old James Chaney of Meridian, Mississippi; twenty-four-year-old Mikey Schwerner from New York; and twenty-year-old

148 Van Gogh Has a Broken Heart

Andrew Goodman, also from New York. Chaney was Black and both Schwerner and Goodman were Jewish. Price told the men he had pulled them over for a traffic violation. The Norman Rockwell Museum noted, "Michael Schwerner and his chief aide, James Chaney, were in Philadelphia [Mississippi] to assist with training summer volunteers, one of whom was Andrew Goodman. Schwerner had been targeted by the Klan for his organization of a black boycott of white-owned businesses and for his attempts to register blacks in Meriden [Connecticut]."[18]

Price arrested the three men for speeding and escorted them to jail, where they were detained for several hours. They were released later that evening, but as they left the police station in their car, they were followed by law enforcement and members of the Ku Klux Klan. Before the men left Neshoba County, two carloads of Klansmen forced them to pull over, and the three men were driven to another location where they were beaten and then shot at close range. "Their bodies were then taken to the farm of one of the Klansmen, dumped into a dam site, and covered by tons of dirt pushed over them by tractor."[19]

The three men's disappearance was initially investigated as a missing persons case until their burned-out car was found near a swamp three days after they vanished. The FBI, local and state authorities, and Navy soldiers conducted an extensive search of the area, but the bodies weren't discovered until seven weeks later after the FBI received a tip. The investigation revealed officers from the Neshoba County sheriff's office and members of the Klan were responsible.

The disappearance and subsequent murders of Michael Schwerner, James Chaney, and Andrew Goodman attracted national attention. While trying to help fellow American citizens exercise their constitutional right to vote, these three men were killed by those who had sworn an oath to protect them. The system was broken, and the details of what happened that night were chilling.

Cultivate Your Own Half Acre 149

Rockwell wanted to tell this story too. But it was so much darker than the already terribly dark nightmare Ruby Bridges endured. After hearing about what happened, Rockwell began to conceive what would become *Murder in Mississippi*. In his article "Rockwell and Race," Jack Doyle wrote, "Rockwell typically worked on several projects at once, but with this project, he bore in on the work exclusively for five weeks straight."[20]

The Norman Rockwell Museum described the evolution of the painting: "Rockwell conceived Murder in Mississippi as a horizontal composition to run across two pages. The young men would be pictured on the left page and Philadelphia Deputy Price and the posse of Klansmen wielding sticks (we later learned all were armed with rifles and shotguns) on the right."[21]

Rockwell "borrowed from Hector Rondon's 1963 Pulitzer Prize–winning news photo 'Aid from the Padre' for the pose of Michael Schwerner holding James Chaney."[22] He pulled the shades on his studio windows and brought in spotlights to create the effect of headlights. Rockwell's son Jarvis stood in as the model for Schwerner, and Oliver McCary appeared as the severely wounded Chaney. Rockwell procured actual human blood from an undisclosed source and applied it to a white shirt he was wearing to capture the actual look of a dying man's bloody grip on the arm of his friend. He photographed himself with his bloody hand and smudged sleeve.

The end result is chilling—three men on a desolate patch of dirt in the middle of nowhere, one dying on the ground, another beaten and collapsing upon the third as the last man standing tries to hold him up while he stares into the light coming from beyond the right side of the frame. All we can see on the right side of the canvas are the shadows of men holding guns pointed at the helpless victims.

Rockwell chose to capture the most terrifying and horrific moment of the whole ordeal—the seconds before the three men's

150 Van Gogh Has a Broken Heart

deaths. In choosing to represent the murderers not as actual people but as shadows, Rockwell conveyed the hard reality that this was about more than the decisions of a few men. There was a murderous shadow over justice in the South.

On April 14, 1965, Rockwell sent his final painting to *Look*. A couple weeks later, editors from *Look* told him they had decided to use his color study rather than the final painting. Though Rockwell found this initially upsetting, he said a few years later that they probably chose the study over the finished work because "all the anger that was in the sketch had gone out of it."[23]

Jenna Varner said *Murder in Mississippi*, also known as *Southern Justice* (which was the name of the article the painting accompanied), "received a great deal of animosity after *Look* published the piece, due in part by the 'un-American' values it portrayed. But wasn't that a key factor in the 1960s? Wasn't Rockwell, in fact, continuing to represent America's values during this time by bringing the realities to America's doorsteps? . . . [Rockwell] took the horrors that everyone was talking about that had been taking place in the South and presented them in a visual format."[24]

Rockwell was telling America her story. Jason Shaiman, curator of exhibitions for Miami University's Art Museum, said, "*Murder in Mississippi* is Americana. He was recording real-life taking place on American soil. Murder. Racism. Violence. This was a part of some American values."[25]

Cultivate Your Own Half Acre

Norman Rockwell brought to his work a set of values and a perspective that may be different from how an artist might depict America today, but this was not his era, and as Christopher Finch noted, "Every artist learns early, or he is no artist, that he must drink out of his own cup, must cultivate his own half acre, because he never can have any other."[26]

Cultivate Your Own Half Acre 151

What did Rockwell cultivate? He cultivated trust as a storyteller. Over the course of a sixty-year career, he became a voice Americans listened to. His winsome humor, technical ability, affection for his subjects, and sense of narrative left people wanting to linger over the details he worked into his art. He never committed to any one historical moment; rather, his was a story that changed over time, and that was the story he tried to tell.

I own several books about Norman Rockwell—large-format books with lots of beautiful reproductions throughout. Most of them are from the 1970s and 1980s, and none of them have much to say about his focus on civil rights. Instead, they offer a sanitized version of his body of work, presenting him more as the sentimental, clever illustrator with an eye for humor and a soft spot for young love. They tend to emphasize elements of patriotism, family, and the foibles of small-town living.

But as an illustrator singularly devoted to the subject of people, Rockwell told a story in real time of a changing nation and offered himself not only as part of the solution, but also as someone complicit in the injustices he would never experience personally due to his position of privilege. The irony of the coffee-table books about Rockwell from the '70s and '80s glossing over his foray into the civil rights era is that they don't show who he actually was. While they prize the idealism on which he built his early career, they refuse to allow him to grow and change as a storyteller.

I am not who I was twenty years ago. Neither are you. We change, and the world changes too. Will you allow yourself the freedom to change your perspective on this world? On yourself? On your complicity with injustice? Rockwell's body of work unfolded as history revealed new insights into what was happening around him. And inside of him. He said, "For 47 years, I portrayed the best of all possible worlds—grandfathers, puppy dogs—things like that. That kind of stuff is dead now, and I

think it's about time."[27] Rockwell knew he had changed, and the world with him. He learned as he went and showed America back to us. Beautiful and terrible things happen all around us. And in us.

Long to know the story, and as you learn it, tell the truth.

CHAPTER 9

THROUGH A GLASS DARKLY

Jimmy Abegg, Edgar Degas, and Learning to See as the World Grows Dim

Jimmy Abegg, *Obscured by Clouds*, 1954,
oil on canvas, 112 cm × 112 cm, private collection.
Courtesty of Jimmy Abegg and Ben Pearson

For now we see through a glass, darkly; but
then face to face: now I know in part; but then
shall I know even as also I am known.

1 Corinthians 13:12 KJV

When I was young, I thought my spiritual life would unfold as a plane ascending ever upward to some greater station of maturity with an ever-deepening faith. I would make mistakes and learn from them. I would gather information I lacked and move forward with an understanding of what to do and how to be. I would read my Bible and pray, and the God on the other side would come to life in greater definition and power.

I thought the same would be true of my vocational life. I would find a role someplace where I was able to contribute, grow in experience and skill, and eventually rise to some level of mastery that would bring opportunity, satisfaction, and maybe, after thirty years, a gold watch. Spiritually and vocationally—if I was faithful, I thought—I would be able to look back and see a straight line, more or less, leading me from there to here. Ever upward, fairly clean.

I also thought my spiritual and vocational journeys would run on parallel tracks—near each other, but separate. Then affliction hit—the kind that would require me to release my hold on this world. After that, loss—the kind that would take from me people and things I never expected to lose. And after that, grief that would circle back in the most unexpected ways at the most unexpected times until I began to realize that the God I had put my faith in when I was younger wasn't who I thought he was.

Through a Glass Darkly 155

It wasn't that I felt he wasn't real or that he had somehow failed me. No, the unraveling I experienced seemed to prove to me more than ever just how real, good, and loving he was. But he wasn't who I thought he was. He was more. So much more.

When I was young, I thought my life would be about what I could accomplish—the good I could do in the world. But when affliction came, I felt like I was watching my vocational and spiritual life merge into one thing. Since then, I've come to believe they've always been one, never separate. Who I am to God is who I am. What comes out of this life is his business, but what I do will never be what makes me who I am. Because this is so, when suffering comes, it doesn't have the power to unravel God's design. Instead, the suffering becomes part of the fabric.

When affliction collides with our underway lives, we must stop and learn new ways to live, new ways to think, new ways to see. The God I am discovering now is holy, just, loving, and still the God of the Bible. He has not changed, but I have. And one of the primary catalysts for change in my life has been suffering. I'm learning how to see this life through a new lens that doesn't line up with what my younger self imagined. This is the fruit of pain: we must learn again how to see.

During the Franco-Prussian War of 1870, Edgar Degas looked through the sights on his rifle. What was this strange bend in the trees he saw? He rubbed his right eye and looked again. Still a bend. He switched over to his left eye. This time, no bend. This was how the thirty-six-year-old Impressionist painter discovered he had macular degeneration.

Macular degeneration is a disease that attacks the retina. The back of the human eye, the macula, has thousands of light-discerning cells that send information about the images we see through the optic nerve to the brain. The brain translates that information into the perception of color, dimension, distance, and form—the things we're looking at. It is happening right now

156 Van Gogh Has a Broken Heart

as you read these words. When these cells break down, central vision deteriorates, leaving a blurred and eventually blank field in the center of our sight. If it continues to progress, all but peripheral vision will be lost.

The darkened center of vision is called a scotoma. According to Phyllis Tuchman, "These scotomas make it seem that one is looking at the world, as various artists have described, through 'crinkled wax paper,' a 'cloud in the eyeball,' 'a soapy window,' or a 'dense fog.' Whatever the gaze focuses upon becomes hard or impossible to discern. Gone is the ability to read, recognize a face, see fine detail. Vestiges of sight remain, but the lack of visual acuity of most people with macular degeneration renders them legally blind."[1]

Degas's retinal disorder began in his right eye, but it soon affected his left as well. It started as a perception of unusual curves in objects he knew to be straight and then expanded to blurred vision and light sensitivity. In the early 1870s, while visiting family in New Orleans, Degas complained, "The light is so strong that I have not yet been able to do anything on the river."[2] Degas's friend Daniel Halévy said, "He did all of his painting during that trip in shaded balconies, porches, and indoors, where the light was not bright."[3] He reached a point when he could no longer paint outdoors.

Degas sought advice from the founder of the French Ophthalmological Society, Edmund Landolt, who had a keen interest in art and had treated other painters, including Mary Cassatt.[4] The doctor made several attempts to correct Degas's vision, prescribing "various glasses including blue tints, magnifiers, and slit-occluders. None of these solved his problems, and he still perceived a blurred world."[5] Degas confided in one of his friends, "This infirmity of sight has hit me hard. My right eye is permanently damaged. I expect to remain in the ranks of the infirm until I pass into the ranks of the blind."[6]

Degas's letters give a window of insight into the progression

Through a Glass Darkly 157

of his visual decline. At thirty-seven, soon after he noticed the issue, he wrote, "I have just had and still have a spot of weakness and trouble in my eyes. . . . It made me lose nearly three weeks, being unable to read or work or go out much."[7] Then at forty-three, he noted that he had "begun to see a light cloudiness in front of my eyes."[8] At fifty-six, he said, "I can scarcely read the papers a little, and in the morning when I reach my studio, if I have been stupid enough to linger somewhat over the disciphery, I can no longer get down to work."[9]

The following year, he said, "I see worse than ever this winter, I do not even read the newspaper a little, it is Zoe, my maid, who reads to me during lunch."[10] And then two years later, at fifty-nine, "Just imagine that to re-read what I wrote to you would present such difficulty—even with the magnifying glass—that I should give it up after the first lines."[11] By his mid-sixties Degas could no longer read,[12] and he "descended eventually into total blindness several years before his death in 1917."[13]

Degas's deteriorating vision shows up in his body of work. Michael Marmor, an ophthalmologist who studied Degas's visual decline, wrote, "He continued to paint the same models, the same scenes, and the same postures until the end of his career, and the evidence would suggest that he was still trying to paint in the traditional style of his long-standing inner vision."[14] This limited range of subjects—ballet, nudes, and horses mostly—and the fact that he tried to paint and draw in the same style throughout give us a visual record of his deterioration.

Degas's early works were usually highly refined with precise brushwork and expert use of color and shading, resulting in exquisite, intimate portraits of figures perfect in posture and form. As his eyesight deteriorated, his images became rougher and larger in scale. Marmor said, "Blur at this level does not compromise the ability to walk around, but it is very difficult to read, recognize faces, or see signs. Since general shapes and postures

are still easily visible, Degas was able to envision his subjects in the dance studio and in the bath—but his technique became progressively more coarse."[15]

Anna Gruener, in the *British Journal of General Practice*, wrote, "By the turn of the 20th century, Degas was almost blind with a left central scotoma and residual visual acuity of approximately 6/60. However, this did not stop him from painting. He ... started to use pastels, a medium which required less precision than oil. Increasing the size of his canvases further helped him to magnify the view of his work as much as possible."[16]

Edgar Degas, *The Dance Foyer at the Opera on the rue Le Peletier*, 1872, oil on canvas, 32 cm × 46 cm, Musée d'Orsay, Paris.
Public domain

Compare, for example Degas's *The Dance Foyer at the Opera on the rue Le Peletier*, painted in 1872, with *Two Dancers Resting*, completed in 1910. The first is 32 × 46 centimeters, and the second is double the size at 78 × 96 centimeters. The smaller painting is done in oil, with fine brushwork and intricate features. It features sixteen different people, facial expressions, and architectural detail. *Two Dancers Resting*, however, is a pastel featuring

just two figures. Neither have faces, and their proportions are out of balance. Knowing what we know about Degas's diminished vision, we can see how this one relied on muscle memory more than his ability to see his own canvas. The second painting isn't different because Degas wanted to experiment with a new technique; it is different because he couldn't see anymore.

Edgar Degas, *Two Dancers Resting*, 1910, pastel on paper, 78 cm × 96 cm, Musée d'Orsay, Paris.
carlo-trash / Alamy Stock Photo

Paying Attention

How we see is shaped by so much. Degas knew his failing vision affected his own perception of his work, and yet, as Michael Marmor wrote, "He argued that these effects were inconsequential because it is the artist's inner vision that determines the nature of his art. However, he may have underestimated the difficulty in *evaluating* his own inner vision when the physical machinery of his eye was altered."[17]

160 Van Gogh Has a Broken Heart

Degas said, "People see what they want to see; it is false; and this falseness constitutes art."[18] But could Degas see his own work well enough to know what others saw when they looked at it? Marmor wrote, "Degas could no longer judge whether what he saw was indeed what he wished, at least to the extent that he wanted others to see the same thing. His view of his work may indeed have been what he wished to see, but he could not perceive how the art would appear to everyone else. . . . What we see today with *our* eyes is not what he saw with his."[19] In other words, when a person with good vision looks at a later Degas painting, they are seeing the work with a clarity the painter himself never could.

Degas's eyesight went from clear to blurry, and in the process, he had to release the notion that he could ever again show people what he saw with his own eyes. Not even he could make out what he was looking at. All he could offer were renderings—his translation of what his failing eyes saw, translated then again by the viewer. The gap between them was ever widening.

I have so many things I wish I could show to my children, my friends, and my father who is now gone. It's not what I see with my eyes but what I see with my heart and mind. I wish I knew how to make those clear. How do you show someone what's in your heart without requiring them to translate it into something they can only see in theirs? And then how can you know they've seen what you've tried to show them? This applies even to ourselves. There are things I see now that I never would have been able to understand when I was younger. I hadn't lived enough. I hadn't suffered enough. I wasn't openhanded enough. I don't see the world the same way as I did when I was younger. Even if I tried, I doubt I could. Our vision changes over time.

When I was seventeen, I managed to talk my way into being part of the road crew for a Christian heavy metal band based out of central Indiana. I ran the merch table, helped set up gear, and did whatever else the band asked in exchange for meals, lodging, and

exposure to a world I desperately wanted to be a part of. I was a huge fan of big-hair '80s metal, and I looked the part, so I fit right in.

One summer weekend, we were at a music festival somewhere in Illinois, setting up for a sweaty afternoon show on a remote side stage near the edge of the grassy fairground, and I heard music coming from the main stage a couple of hundred yards away. I puttered around doing my work, but the music wormed its way into my mind, and like a siren song, it drew me over. The music made sense to me, like it was written just for me. But it wasn't the familiar rock I loved so much. This style was simple, elegant—a trio of one guitar and two voices. I stood alone at the back of the main stage amphitheater transfixed by what I was hearing—the Charlie Peacock Trio. Charlie and the transcendent Vince Ebo sang as the only instrumentalist onstage, Jimmy Abegg, filled out their harmonies with the most effortless yet intricate acoustic guitar work I had ever heard. I was mesmerized, and I didn't want to leave until they had finished.

When I walked back to the side stage, my head was spinning. Something in me had changed. Something formative happened that has been unfolding ever since; my brief encounter with that music shaped me that day and continues to shape me still. Allow me to explain. I was a relatively new Christian—eager to serve the Lord with my life but unsure of who I was. I knew I loved music and art. I loved working with words. I was developing an interest in religion but didn't really know where to begin. Though I sensed some form of vocational ministry might be ahead for me, I had no idea how any of it would fit together. But on that stage, though I didn't yet know it, I was seeing a picture of how art and faith could work in harmony through my vocational calling.

When I got home from the festival, I went to my local Christian bookstore and bought Charlie Peacock's *West Coast Diaries, Volume 2*, which featured the trio I'd seen in concert. I studied the songwriting, guitar work, lyrical substance, theology,

harmony, and design of the record. The cover art of a man holding a radio, I noticed, was painted by Jimmy Abegg. *This brilliant guitarist is also a painter?*

Taking my art teacher's advice to pay attention to artists we connect with, I started looking up as much as I could about Jimmy. He was a polymath—a musician, photographer, graphic designer, writer, and painter. That the guitar player also painted the cover art may not seem like that big of a deal, but to me it was like finding the Rosetta Stone. It told me it was possible to be about more than one creative endeavor at a time, and that taken together, those different things could become a singular expression, a way of moving through the world, a unique ministry for a certain kind of person.

Jimmy Abegg, painting used on
Charlie Peacock's *West Coast Diaries 2* album.
Courtesy of Jimmy Abegg and Charlie Peacock

When I later sensed a calling to become a pastor, I knew the arts would need to be part of how I communicated—not just as a side interest in the way a preacher who loves golf might occasionally fold stories about the game into his sermons, but as part of how I approached the whole of my vocational life. Jimmy Abegg became for me an example of someone who found a way to take a range of passions and bring them together into one thing—a vision of a creative, artful life as a follower of Jesus. Standing at the back of that fairground amphitheater all those year ago, I didn't know how deeply Jimmy's art and life would impact mine, or that he and I would live in the same town and later become friends.

But now, thirty years later and well into my vocation as a pastor whose life has been shaped by art and beauty, I think about how this journey I've been on has unfolded in ways I never would have imagined. One of the ways Jimmy's story continues to shape my thinking and to help me navigate this life of creativity, ministry, and mortality comes by means of his suffering—though he might refuse to use that word. I use it here for the sake of clarity, but I'll leave it for you to decide if there may be a better way to say it.

How on Earth Is This Going to Work?

Jimmy said, "I saw myself as a painter early on, as a child in elementary school."[20] Over several decades of work, Jimmy has cultivated a style all his own—a style that one magazine describes as "playful . . . though there's nothing childish about [it]. These works are infused with energy and surprise, pools and sharply cut shapes dueling for our attention as well as, unexpectedly, balancing each other out."[21]

A number of years ago, Jimmy was sorting through some promotional photos he had taken for an insurance company in Memphis. Jessica Bliss of *The Tennessean* wrote, "As he edited

164 Van Gogh Has a Broken Heart

the take, he noticed that each picture seemed to have a strange bend in the middle, almost like an image reflected in a fun house mirror. He assumed his camera lens had broken and marred the entire shoot. But then, as he stewed over the ruined work, he looked out into the backyard of his East Nashville home. The tree trunks, ever tall and straight, had the same weird bend as his photos. That's when he knew it wasn't his camera; it was his eyes."[22] It was the early onset of macular degeneration.

When Jimmy discovered his macular degeneration, he said, "I was really surprised first of all. I was thinking, *How on earth is this going to work?* because I use my eyes to make a living. I was right at 60 and I immediately started figuring out how to do this. I started planning for when I couldn't see at all because I guess I got the memo that I'm only who I am. The good news is, I can still make art and plan to do so for a long time. In fact, some of my favorite pieces have been created during this time. I also have a lot of extra time on my hands now that I don't have to worry about driving or operating a computer."[23]

Jimmy kept working, adapting to accommodate his changing reality. He applied himself to learning new techniques as the light continued to dim, and he made changes to the space where he worked. Bliss, who visited his studio for her interview, noted:

> In a corner cluttered with canvases, he uncaps tubs of paints that have replaced uselessly labeled tubes and pulls on a pair of latex gloves. He has abandoned brushes, lacking the depth perception to control their stroke. Instead, he sticks his hands into sometimes unknown color and runs his fingers across the cloth.
>
> With his new limitations, his images are even more abstract than they once were, but the process is familiar and he has seen enough in his 61 years that he can visualize what he wants to create.[24]

In 1973, a painter named Robert Morris wanted to know what it would be like to paint blind, so he composed a series of paintings blindfolded. Phyllis Tuchman wrote, "Morris could not have made these works with a more elemental process. The artist covered his hands with powdered pigment or graphite mixed with plate oil and then, during a time span measured in minutes or even seconds, completed a straightforward task. . . . This project celebrated another of the five senses: touch. For Morris, the making of these works was intensely physical. . . . He pressed his fingers and palms down hard on the paper beneath his hands."[25]

As the act of creation moves from the brush and eyes to the hands and memory, the work becomes more sensual, intimate, taxing. Morris said the work "required the whole body and was often exhausting. Sometimes rubbing with the hands to the point of fatigue or sensation of burning palms gave a limit. I never considered these works abstract but about a particular kind of representation, a redefinition of representation for myself."[26]

American painter Georgia O'Keeffe also suffered from declining vision. As her eyesight deteriorated, she simplified her forms, but eventually she turned to clay. A'Dora Phillips and Brian Schumacher wrote, "As O'Keeffe's vision began to decline, her means of expression migrated from complex compositions of light and form to a language of flat, graphic symbols, and eventually into her foray into sculpture and the creative domain where she could express visually what was not seen but felt. Sight, in her later works, is rendered from the inside out, recorded by her hands in whatever ways she could, like the needle of a seismograph to paper."[27] This tactile medium enabled her to continue creating well past the loss of her sight, but she, like Robert Morris and Jimmy Abegg, had to use her whole self to do it.

What spurs on these artists as their worlds grow dim? "Many artists persevere, often because they cannot imagine not doing so. Experiencing some degree of blindness, they work less from

observation than they once had and more from a memory of light and form, from muscle memory, imagination, and . . . an inner vision drawn from the artist's obsessions and experience."[28]

The art changes, but not necessarily in a negative way. Often when affliction and compulsion collide, something deeper, truer, and more lasting is born. Tuchman wrote, "Regardless of how dramatically, or not, artists change their approach to artmaking, what emerges is always a new body of work that can be hauntingly, and thrillingly, unlike anything they had created before."[29]

For an artist like Jimmy, his limitation led him to lean in, confident that his body of work born from a lifetime of creating had prepared him for this moment. He said, "I saw for a long time, so I figured I could learn to see in a new way because I've got really good hands and really good muscle memory from my habits over time. I've always been very optimistic about it. I believe in God's hand totally covering and caring for me and my wife and my offspring and my grandchildren. You know, all of this I blame on God, I mean the good and the bad, because the bad isn't so bad when you recognize the goodness that will emerge from it, whatever trail that leads me down."[30]

This Newfound Vision

Affliction stirs us awake to things we might not have seen otherwise. Several years ago, I faced an unexpected medical crisis—a failing heart. When I first learned of the severity of my condition, I felt afraid. But the prevailing sensation wasn't fear; it was wonder. Curiosity. Even exhilaration. I felt that I was at the beginning of a great adventure—one I instinctively did not want to miss, one that would change me. I wanted to interrogate my affliction. I wondered what would happen when I was forced to stand at the edge of my mortality and look out into the eternal. What happens when a doctor tells a man he is dying? If that person

believes in God (which I do), what will come of his faith? Will the spiritual premises he trusted as dependable foundations all those years earlier suddenly fail? And if so, is that even faith? Or is that nothing more than a house of cards too easily toppled by the breath of suffering?

I do not want to simply endure the afflictions that come my way; I want to look for God in them. I want to experience them. I sat down with Jimmy Abegg in his studio to talk about this. He said, "I can't see the future. I'm not a prophet, but I can see God moving, and as a result of that, something new is going on in me. I don't know what glory is, but I might be in the front door right now, you know. I mean it's so incredible. I am able to observe how special things are. Even you being here in my studio with me right now."[31]

As he said this, he leaned in close to my face until we were eye to eye, almost nose to nose. As he moved toward me, he said, "I'll tell you when I can see you. I have to get eight inches from you to see your eyes. I don't look at this as a hardship now. I see it as an opportunity to connect." As he leaned in, I thought about how when I first saw Jimmy, he was a stranger a hundred yards away on a stage. Now I was in his home, and he was less than a foot from my face, and my friend.

As I write these words, I think of all I've learned to see since that day at that festival in Illinois. I think of how my life has not been a straight line ascending ever upward, but an unexpected lesson in how rich, full, painful, and beautiful life has become. I think of confident positions I once held that I've since had to release. I think about how I used to feel like I belonged to the past—to the places and people of my childhood—and how most of that is now gone and I feel like I belong to the future, to what lies ahead. And I think about the courage and humility required if we want to learn to see through new eyes. There's nothing automatic about it.

168 Van Gogh Has a Broken Heart

In the early 1700s, doctors in the West discovered how to remove cataracts from the eyes of blind patients, giving them the ability to see. Annie Dillard, in her Pulitzer Prize–winning *Pilgrim at Tinker Creek*, wrote about what the experience of seeing for the first time was like for many who had been blind since birth. One might imagine the sensation would have been like someone turning on a light—bringing clarity and information to an otherwise bewildering existence. But many of these newly sighted people had already learned how to navigate the world through their senses, and the sudden ability to see confused them.

For the majority of patients, concepts such as depth, size, shape, and space were nearly impossible to comprehend. Dillard wrote, "For the newly sighted, vision is pure sensation unencumbered by meaning."[32] These patients had no categories for what they were seeing, and this was more than many of them could bear. Some became depressed because in gaining the ability to see, they lost the world as they knew it. This newfound vision became a new form of blindness.

In response to their frustration, some simply refused to use their eyes. One doctor said of his patient, "Her unfortunate father, who had hoped for so much from this operation, wrote that his daughter carefully shuts her eyes whenever she wishes to go about the house, especially when she comes to a staircase, and she is never happier or more at ease than when, by closing her eyelids, she relapses into her former state of total blindness."[33]

For those who did not refuse their new sight, they had to learn how to use it. One man "practiced his vision in a strange fashion; thus he takes off one of his boots, throws it some way off in front of him, and then attempts to gauge the distance at which it lies; he takes a few steps toward the boot and tries to grasp it; on failing to reach it, he moves on a step or two and gropes for the boot until he finally gets hold of it."[34]

Through a Glass Darkly **169**

For those who practiced using their new eyes, the world they learned to see was filled with wonder. One twenty-two-year-old was so overwhelmed by the world's brightness that she kept her eyes shut tight for two weeks following her surgery. When at last she gathered the courage to open them, "she did not recognize any objects, but the more she directed her gaze upon everything about her, the more it could be seen how an expression of gratification and astonishment overspread her features; she repeatedly exclaimed: 'Oh God! How beautiful!'"[35]

It is as though the same is happening to Jimmy Abegg, though his visual journey is headed in the opposite direction. He said, "There's a letting go that's going on with me right now that's really particular. I've been a lifetime music maker. I haven't stopped. I play more, I write more, and as a courtesy of this blindness, I think more. I have something to say. It's just a remarkable discovery for me that most anything can be turned into meaningful expression, whether it's writing or art or music or stone or flour and water and salt and yeast."[36]

Whether a person goes from blind to seeing or seeing to blind, either way they must learn again how to navigate this new world. Jimmy said, "When Christ got some mud and healed the blind man, the blind man said, 'I can see,' but he never said, 'I can see *you*,' or 'Mount Sinai,' or any other thing. He said, 'I can see.' I feel like I'm that guy in that Scripture because I'm seeing a plane that is unavailable to most people, and I think that applies to my art as well. I believe it has brought me to joy. I'm not even sure I have the right word for how confident and how content and how forward-thinking I am now compared to when I could see. For me, it's an advantage to not see reality, because what I see now is more."

I wonder if Edgar Degas, in response to his macular degeneration, ever thought he was seeing more. I wonder what afflictions will come my way in life that will leave me feeling like I'm losing

170 Van Gogh Has a Broken Heart

my hold on this world, and what suffering will lift my eyes to see the changing world and draw from me that same, "Oh God! How beautiful!"

I want to know those moments when confusion or frustration give way to beauty and wonder. I believe moments like these come for us in our seasons of affliction, if only we will look for them. When one such moment happened for Annie Dillard herself, she said, "I had been my whole life a bell, and never knew it until at that moment I was lifted and struck."[37] Though I may stumble for a time like a man reaching for his boot, I want to learn to see the world through the eyes of whatever afflictions may come.

We can't help but see this world and our place in it through the lens of what we already know. A horse is a horse, and a pear is a pear. We can't see "Eden before Adam gave names."[38] But affliction has the power to quiet the voices in our heads that insist we already know everything. Seeing through our suffering won't show us a new world, but it will show us more of the world we think we already know. And affliction is bound to find us. When it does, whatever faith we profess, along with all its convictions regarding the meaning of this life and the next, will be tested.

Some affliction comes suddenly and lasts only a moment. Other affliction comes as a bend in a photo or a slow dimming of the world we've known our entire lives. Affliction shapes us. It comes for us all—in our own personal distress or in the sufferings of those we love. It has come for me before, and I know it will come again. The least we can do is pay attention. I want to learn to see the world in new ways through it.

I do not wish to waste my pain.

CHAPTER 10

OUR PERSONAL COLLECTIONS

Jeremiah's Lament, the Works We Carry, and the Words on Which We Rest

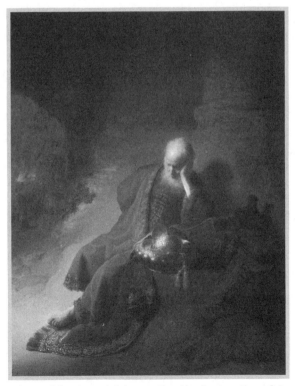

Rembrandt van Rijn, *Jeremiah Lamenting the Destruction of Jerusalem*, 1630, oil on panel, 58 cm × 47 cm, Rijksmuseum, Amsterdam.
Rijksmuseum, Amsterdam

> The allotted function of art is not, as is often
> assumed, to put across ideas, to propagate thoughts,
> to serve as example. The aim of art is to prepare
> a person for death, to plough and harrow his
> soul, rendering it capable of turning to good.
>
> **Andrey Tarkovsky, *Sculpting in Time***

Between 1995 and 2001, Stéphane Breitwieser, a traveling waiter, stole 239 works of art from 172 museums, cathedrals, exhibits, and auctions across Europe—an average of one theft every two weeks. *The Guardian* called him "arguably the world's most consistently successful art thief."[1] He did it, he said during his trial, out of love: "I enjoy art. I love such works of art. I collected them and kept them at home." During that same trial, he demonstrated that he was able to recall every single work he stole, even correcting the magistrates when there was an error in their records.[2]

Breitwieser never attempted to sell any of the works he took. He "considered himself an art liberator, freeing masterpieces from uncomfortable and crowded confines,"[3] displaying them in his home instead, which is why he emphasized the importance of taking only what he loved. He told *Time* magazine's Michael Finkel, "Taking on all this risk for an object you don't like . . . is the mark of a fool."[4]

Sometimes I think about *Mona Lisa* in that trunk under those blankets in Vincenzo Peruggia's living room. For two years, she lay in that dark tomb of a place, safe but hidden away from the world. If anyone tried to steal her today, she would become

Our Personal Collections 173

a suffocating burden, a millstone around the neck of the fool who might try to own her. To possess her would be to possess unimaginable misery. Yet when the power of art meets the ache of the human spirit, we want to seize what can never really be owned—not in the material sense anyway. With all due respect to Mr. Breitwieser, the man *GQ* called "one of the most prolific and successful art thieves who has ever lived,"[5] you don't need to steal great art to have it in your personal collection. You can carry the greatest works ever created in your heart. There is no limit here, and it won't cost a dime.

But it will cost *you*.

If you pay attention to art over the course of your life, you will find more than "favorites." You will find works and artists you connect with, not merely stylistically, but narratively. You will start small. Certain works will come into your life at such specific times that they will serve as an illustration on the facing page of the tale your life is telling in that moment. That work will always be joined to that part of your story—like the song that was playing when you first danced with that person you loved, or the one that was always on the radio that summer when you worked outside with your hands. Sometimes it will be the work you connect with; other times it will be the artist themselves—their suffering, endurance, or need to connect with beauty in any way they could. Sometimes it will be both the artist and their work coming together in that compulsion to create joined to a comfortable color palette that pleases you for reasons you can't yet explain.

As these works come into your life, you'll find that they travel well, moving from place to place, easily accessible in your mind's eye. The acquisition of one piece will lead to the gathering of others related by theme, creator, style, mood, or story. You'll find your sense of taste developing—that combination of knowledge and passion where the head and heart meet. You will discover

174 Van Gogh Has a Broken Heart

that you even carry some works with you that you dislike, if you're being honest, done by artists you don't necessarily admire. But they came along at a certain time and somehow fit into an empty space in the diorama of your life, like that song you can't stand but still know every word by heart.

Your tastes will evolve as your life takes unexpected turns, and you'll grow to love things you weren't able to connect with when you were younger. All the while, your personal collection will be growing—the art you carry with you. It will work in you, and it will work on you. Go find it.

The Rijksmuseum, May 2023

In the summer of 2023, I took a trip to Amsterdam with my daughter Kate. The plan was to walk around the city and visit the Van Gogh Museum, Rembrandt House, and Rijksmuseum. Neither of us had been to any of them. One morning, we set off from our hotel, walked along the canals that form the shape of the city center, and stopped at Hans Egstorf, the oldest bakery in Amsterdam, for a coffee and a chocolate croissant, which we ate on a bench in a tiny town square in front of the Athenaeum bookstore. Then we made our way across the Singelgracht canal to the Rijksmuseum, with its limestone and redbrick facade and pair of matching towers, each adorned with giant banners advertising their Vermeer exhibit.

Before I go into a museum, I have to get my head right. I have to prepare to engage with transcendence while standing next to perfect strangers. It's an intimate experience, being with all those people who have this strange mix of wonder, anxiety, energy, and weariness radiating from their being. We make our way through the permanent collection, knowing there is no way to absorb all of it. So we take in what we can in the best ways we know how, working together as we shuffle around the room making space

Our Personal Collections 175

for each other, yielding, and saying, "May I?" as we step in front of one another apologetically. We dance.

When I go to a museum I've never visited, I don't typically look beforehand to see what they have in their permanent collection. I don't want to know. I want to be surprised. Over the years, I have become familiar with hundreds of works and artists, many of which I carry inside myself like a personal collection—*my* collection. There's nothing like walking around the corner in an unfamiliar gallery and seeing a familiar painting for the first time, not knowing I would be in the same room with it. It's exhilarating.

Once inside, I bounce from room to room, painting to painting, barely spending more than a minute or two in front of each before feeling a compulsion to move on—like a gentle hand tugging on my sleeve, hurrying me on to the next thing. It's a constant pull to approach, pause, look, and go. The romantic ideal I used to have for myself was that I would be the sort of person who could sit in front of a painting for hours, studying every detail, taking it in, sorting out the complexities of whatever it had to teach me in that instant. But that's not me.

Instead, I gather up these little moments, usually take a picture, and move on, contented. Just having been in the same room with some of these works—having made that personal connection to the art and the artist—brings a kind of satisfaction I will always love, and always struggle to understand. But every so often, I encounter a work that stops me cold as the world seems to tilt me in its direction until all that remains is me and the painting. It's rare, but what a joy when it happens. I had this experience recently with a piece that has long been part of my own personal collection.

Kate and I followed the crowd to the Rijksmuseum's main entrance, produced our tickets, checked our backpacks, grabbed a couple of maps, and headed up to the Gallery of Honour. A familiar feeling of anticipation built in my whole body as I climbed the

stairs; I always feel this way when I enter an art museum—a physiological response to the expectation of what's coming. I knew I was about to see Rembrandt's *The Night Watch*. It's hard to go to the Rijksmuseum and not know *The Night Watch* is there. *The Night Watch* is to that museum what *Mona Lisa* is to the Louvre.

Rembrandt van Rijn, *The Night Watch*, 1642, oil on canvas, 363 cm × 437 cm, Rijksmuseum, Amsterdam.
Rijksmuseum, Amsterdam

The Night Watch is massive—12 feet by 14 feet—and for that alone, it holds a special place in Rembrandt's body of work. A much smaller copy painted by Gerrit Lundens in 1662 reveals that the original was actually around two feet wider but was trimmed down "when it was moved in 1715 from the large hall in Kloveniersdoelen to the Amsterdam Town Hall. It had to fit between two doors in its new location. The strips of canvas that were cut away were never found."[6]

Think about that, four strips of canvas painted by the Dutch master himself were cut away and discarded—2 feet from the

left side, 9 inches from the top, 12 centimeters (4.72 inches) from the bottom, and 7 centimeters (2.76 inches) from the right.[7] It makes me think of Leonardo da Vinci's *The Last Supper* and how the feet of the Lord, which were said to have been posed in the form of his crucifixion, were cut away in 1652 to make room for a doorway that has since been bricked over. In both cases, these works were altered to accommodate doorways. I'm sure there's a metaphor in there somewhere about how humanity's compulsion to pass through from one place to another often takes precedent over our need to stop and behold, but that's for another time. I've got to keep moving.

Leonardo da Vinci, *The Last Supper*, 1498, tempera on plaster, 460 cm × 880 cm, Santa Maria delle Grazie, Milan. The area at the bottom by the feet of Christ was cut away to make room for a door that has since been bricked in.
Public domain

We reached the landing on the second floor, turned the corner, and there it was. *The Night Watch* was enclosed in a glass room so the museum could study the effects of vibration on the old canvas. The explanation on the gallery wall said, "The air around *The Night Watch* is in motion, caused, for example, by visitors and the air conditioning system. Because the surface of

178 Van Gogh Has a Broken Heart

the painting is so large, the canvas vibrates with the air currents. Although on a much smaller scale, this movement can be compared to the flapping sail of a ship."[8] Once researchers map the vibration patterns of the canvas, they will use that information to determine the best backing to support the nearly four-hundred-year-old painting. All very fascinating, but what it means for me is I will not be able to get as close to this one as I like. I love to hear the docent say, "Sir, could you please step back? Thank you."

Kate and I admired *The Night Watch* from a distance and then agreed to split up so we could take in the rest of the museum at our own pace. She headed down a hall as I turned to the rest of the Gallery of Honour. I saw Rembrandt's *Isaac and Rebecca (The Jewish Bride)*, his self-portrait as the apostle Paul, Flinck's *Isaac Blessing Jacob*, and a bunch of other Dutch Renaissance mainstays. After about twenty minutes, Kate found me and, with a note of urgency, said, "Come with me." I didn't ask why. Something about the way she said it made me just nod and follow. She led me through one gallery after another until we were on the opposite side of the second floor from *The Night Watch*. Then she led me into a room, pointed to the wall on her left, and said, "There."

That's One of Yours

When I saw what she was pointing at, I began to weep. By now you might think I'm a person who cries easily when I am around art. Not so. I can become solemn, a little misty-eyed, even dumbfoundedly silent. But I can't remember the last time I openly wept in a museum. Yet there I was, wiping at tears that weren't stopping. When she saw me crying, she welled up too because that's how she is—she feels what others are feeling. It's one of her gifts. She said, "That's one of yours." And she was right. It was. Kate had led me to Rembrandt's *Jeremiah Lamenting the Destruction of Jerusalem*.

As far as Rembrandt paintings go, *Jeremiah Lamenting the Destruction of Jerusalem* isn't that remarkable. It's incredible, don't get me wrong, but it doesn't rise to the masterwork level of *The Storm on the Sea of Galilee* or *The Return of the Prodigal Son*. Nevertheless, Rembrandt's portrait of the grieving prophet is one I have been paying attention to for decades. It's in my personal collection. Nearly thirty years ago, I ordered a print of this work from a local bookstore, and it has been on our wall for Kate's entire life—making the move from house to house, city to city. She has never known a day when *Jeremiah Lamenting the Destruction of Jerusalem* wasn't on display in our home, and every time I see it, it reminds me of the Lord's call on my life into pastoral ministry.

Back in my early twenties, I was working for the Art House, a ministry founded by Charlie Peacock and his wife, Andi, which was devoted to promoting a vision of a seamless life of Christian discipleship and imaginative living. Ligonier Ministries, founded by R. C. Sproul, had donated copies of its entire cassette library of Dr. Sproul's lectures, which covered everything from Scripture to church history to theology to art and culture. One of my jobs was to catalog these lectures for the Art House library. I took home one series at a time and listened to every single talk. It was the most formative theological education I had ever received. It was in listening to those tapes that I sensed God was calling me to become a pastor. I remember the gravity and fear I felt. And also the resolve.

In one of those lectures, Dr. Sproul talked at length about Rembrandt's *Jeremiah Lamenting the Destruction of Jerusalem*. He was teaching about the call to be a minister of the gospel, and how that vocation is often filled with sorrow. He described the expression of grief on Jeremiah's face, how Rembrandt had captured a depth of pain in the eyes and wrinkles on the prophet's forehead, poignantly illustrating the hard truth that our deepest

180 Van Gogh Has a Broken Heart

pains are often suffered alone. I had never seen the painting before, but I knew I wanted a copy so it could remind me of the holy weight of serving the Lord in this way. I hadn't yet known any of the sorrow Dr. Sproul spoke of, but I knew it would come if I were to go down this road, and I wanted Jeremiah to remind me to lean hard on Scripture when it did.

As the title suggests, this painting captures Jeremiah's grief as the holy city burns, Solomon's temple with it. The prophet had been calling the people of Judah to repent for more than forty years. No one listened. Jeremiah had been beaten and imprisoned and had his books destroyed. Five different kings came and went— the last of which was King Zedekiah, Judah's final king, who stood atop Rembrandt's temple steps, fists buried into his eye sockets, in agony after being blinded by King Nebuchadnezzar.[9] The doom Jeremiah foretold was happening. Rembrandt presented him sitting in a cave with some of the relics from the temple at his feet, treasured items of precious metal now without their place of usefulness beside him, glowing in the light of the burning city.

His left arm leans on a book. The spine bears the word *Bibel*, a detail probably added later. The book is likely intended to be a combination of the prophetic book bearing Jeremiah's name and the book of Lamentations, his insistent, poetic, yet unheeded call to repent—a book in which the Lord tells his people,

> I have loved you with an everlasting love;
> I have drawn you with unfailing kindness.
> I will build you up again,
> and you, Virgin Israel, will be rebuilt.[10]

I wasn't expecting to see Jeremiah at the Rijksmuseum. I didn't know he was there. After my tears subsided, I began to study him. This time I got close enough that the docent had to come over and tell me to back up. The painting was smaller than

I imagined—smaller than my copy. The colors were nothing like I had imagined either. Mine had washed out to a mostly beige palette, but the original was rich with deep reds, cool greens, and soft blues. In the background, I saw a woman weeping I had never noticed. The detail of the textures and filigree and the depth of color came together to capture this moment when the world was burning in a cacophony of chaos as a man sat alone in the silence of his sorrow, leaning on the word of God, weary of soul.

But it wasn't just the composition of the painting that moved me. It was that I had been thinking about this painting for decades, applying it to my life, regarding it as a touchstone throughout my vocational journey. I felt that Rembrandt's *Jeremiah Lamenting the Destruction of Jerusalem* showed up to see me that day, not the other way around.

I have been a pastor for twenty years now, and I've known a range of joys and sorrows—those belonging to my congregation and those that are my own. That particular season—the one in which Kate and I went to Amsterdam—carried an unusual burden of grief along with an ever-rising promise of hope, and I felt that I had been sitting like the prophet, silent in prayer while the world raged on around me, pleading for peace.

Kate didn't know this—not really. Children rarely know what's going on in the minds and hearts of their parents. For the vast majority of her life, Kate has mostly known me in terms of who I am to her—her father. This is right. That's who I always want to be to her. But she's nineteen now. As our relationship deepens, I want her to come to know more about me, just as I get to know more about her. What she saw in me that day in that museum was the overflow of a heart full of lament—the grief I felt about the brokenness of this world, the longing for the renewal of all things, the ache that comes from knowing we cannot love perfectly here, which often translates into pain in the lives of those we love and yet fail.

182 Van Gogh Has a Broken Heart

We talked about my response, and the reason we were able to is that, for Kate's entire life, Rembrandt's *Jeremiah Lamenting the Destruction of Jerusalem* had been hanging on our living room wall and had become part of her permanent collection too. I will be forever grateful that she was the one who led me to it. When she did, she wasn't just showing me one of my paintings; she was showing me one of hers too. That's how she knew it was one of mine.

After spending some time with Jeremiah, I peeled myself away. There were other things to see. But for the rest of our time at the Rijksmuseum, I could still feel it pulling at me, a physical response of spiritual connection. I brushed past Rubens, Dürer, Bol, and countless others I might have normally driven two hours to see, but I couldn't take them in because the prophet in his grief had occupied all my imagination. This may sound melodramatic, but the truth is that we connect to works of art. We assign meaning to those connections, and those meanings can have a lot to do with what is happening in that moment and how our lives are shaped moving forward.

I'm fascinated by Johannes Vermeer, and the Rijksmuseum was hosting the largest collection of Vermeers ever gathered—twenty-eight of his thirty-seven existing works. This special exhibit had been sold out for months. People told us there was no way we'd get in. But nothing is ever really sold out if you're willing to ask and ask again. After Kate and I had seen the permanent collection, we went to the ticket counter to ask if they would be releasing any unclaimed tickets to Vermeer. To our delight, they said they would, so we hopped in line.

People had flown across the world to visit this special exhibit. It was a once-in-a-lifetime experience for those who love the Dutch Renaissance, and we were in line to see it—this rare body of work from a painter I have admired, studied, written about, and scrutinized. But even as I went from room to room in the Vermeer collection, as impressive as it was, my mind was on

Jeremiah, how surprised I was to see it, how beautiful it was, how I couldn't breathe, how it broke my heart, how I had to look away to weep and my own daughter's tears in response.

Singing in the Midst of the Stream

Art leads us into our most tender thoughts. It invites us to hold with an open hand the things we're learning about our pain and trials. It tells us to look in a certain direction while so much happens outside of the frame. It invites us to consider our own limits and mortality. Peter Schjeldahl, of the *New Yorker*, said, "Death is like painting rather than like sculpture, because it's seen from only one side."[11] So much has happened in my personal and vocational life in the past year or two that has led me to a place of deep lament. And yet art has a way of freezing moments in time, holding them in a still frame as we seek to understand them. Art makes a statement we can return to when we struggle to find the words. Even in our places of deepest lament, hope is there, and art plays a role in stirring that longing.

The book on which Rembrandt's *Jeremiah* leans resounds with hope:

> Remember my affliction and my wanderings,
>> the wormwood and the gall!
> My soul continually remembers it
>> and is bowed down within me.
> But this I call to mind,
>> and therefore I have hope:
>
> The steadfast love of the LORD never ceases;
>> his mercies never come to an end;
> they are new every morning;
>> great is your faithfulness.

184 Van Gogh Has a Broken Heart

"The LORD is my portion," says my soul,
"therefore I will hope in him."[12]

Hope abounds. But Jeremiah's lament is not filled with hope alone. It's also filled with art, with poetry. The book of Lamentations is one of the most lyrically complex masterworks, not only in the Old Testament, but in all ancient texts. The book is comprised of five intricately connected poems that lead the reader from a place of loss and shame to hope and renewal, both for individuals and for the entire community of God's people.

Describing the complexity of Lamentations' poetic construction and meter, the *ESV Study Bible* notes that much of the "rhythm is based on lines of two unequal parts. The first part normally consists of three words and the second part usually includes two words. This pattern creates three accents, then two, thereby creating a falling, rising, and falling cadence. In this way, the poems seem to 'limp,' as if the reader is walking haltingly along behind a funeral procession."[13]

The book is also filled with acrostic poetry that not only is contained within each chapter but arcs over the entirety of the book. Hebrew acrostic poetry uses the Hebrew alphabet to organize poetic thought. Lamentations features four different types. Chapter 1 consists of twenty-two lines, each beginning with the next letter in the Hebrew alphabet, starting with *aleph*, then *beth*, and so on. Chapters 2 and 4 imitate chapter 1 by opening each stanza with the next consecutive letter in the Hebrew alphabet. Chapter 3 is a sixty-six-line acrostic with "stanzas of three lines each that begin with the same letter of the alphabet. Thus, chapter 3 has sixty-six lines, like chapters 1 and 2. But each line in 3:1–3 begins with *aleph*; 3:4–6 has each line begin with *beth*; and so forth."[14]

Look up the Hebrew text of Lamentations 3 to see this poetry for yourself. Even if you don't read Hebrew, you will see how each

group of three lines starts with the same letter, which reads from right to left. The complexity of this kind of poetry reveals a mastery of both thought and language, and also a sort of divine playfulness even when the world would insist that all was lost.

Why does this matter? Why am I concluding this book by talking about ancient Hebrew poetry? In Judah's worst moments, the words the Lord gave to call them to repentance and restoration were filled with beauty and artistry. They glimmer as the city burns. The prophet didn't just say, "The steadfast love of the LORD never ceases; his mercies never come to an end; they are new every morning; great is your faithfulness." He said it in a pair of acrostic triads. The form of the words themselves lifts our heads from the dust and leads us to wonder about the creative power behind their meaning. They aren't just words. They are chosen words, crafted words, ordered words, risen words.

The Lord has no ordinary words for us. They are all gilded in beauty and glory. Why? Because even in our darkest moments, he created us to lean into who he is: beautiful and glorious. So Rembrandt's *Jeremiah*, struck with the grief of Jerusalem's destruction, leans his weight on a book filled with poems about the mercies of the Lord, how they are new every morning, and how hope threads through until the end.

The great English preacher Charles Spurgeon said, "It is my business, as best I can, to kill dragons, and cut off giants' heads, and lead the timid and trembling. I am often afraid of losing some of the weaklings. I have the heartache for them, but by God's grace, and your kind and generous help in looking after one another, I hope we shall all travel safely to the river's edge. Oh, how many have I had to part with there! I have stood on the brink, and I have heard them singing in the midst of the stream, and I have almost seen the shining ones lead them up the hill and into the celestial city."[15]

As a pastor, I've found that much of my work is preparing

186　Van Gogh Has a Broken Heart

people to die. They don't necessarily know that, but I do. I've been to the river's edge. I've said goodbye to friends there, releasing them to cross on over. Battling the onset of heart failure, I had to prepare to bid farewell myself—to put my house in order, write letters to my loved ones, and accept the possibility of death. I wrote an entire book about that experience chronicling my own collision of affliction and faith.[16] Though I survived, I heard the singing in the midst of the stream and saw the shining ones in my periphery. And ever since, I have longed for the return of Christ and the renewal of all things.

Vincent van Gogh said of his art, "I am trying to get at something utterly heartbroken."[17] Many artists live at the river's edge. Their work explores the perilous seam where suffering falls off into despair, where affection wells up into passion, where the winds of heaven blow through the stuff of earth. They provide high-relief compositions of the ordinary and matter-of-fact portrayals of the transcendent. They help us see the wonder of being alive and the inevitability of having to die. They read our story back to us, and we, in turn, ask to see the pictures.

We live in a world alive with beauty, but it is filled with suffering too. Some of the beauty is hidden in the pain we come to know in this life. It resides in the tears of loss, the unfinished business of love, the affection that remains for those who leave too soon, and the ebb and flow of success and failure. It's in the sacrifices we make to care for a newborn, nurture a marriage, parent a young adult, and maintain a household. It's in the stories Rockwell told of a generation reticent to boast in their own heroism at war. It's in the way Rembrandt held his granddaughter at her baptism—his last connection to his first love. It's in the secrets Turner kept in his sketchbooks—his inner life concealed from the rest of the world. It's in sublime wilderness the Hudson River School painters attempted to warn us about. It's in Vincent's desire to be accepted by his friend Rachel as he gave her a part

of himself. It's in Jimmy's fading vision that makes him see this world in a new way.

Adjusting to the limits of our mortality is sobering, humbling, and sorrowful, but it's also inevitable. Everyone I've ever watched grow old has, at some point, had to surrender what once came naturally. They've had to lay things down and die before they die. Think about the physiology of growing old. If the Lord grants us many years, the way to eternal glory will include the dimming of our vision, the slowing of our bodies, the dulling of our minds, and the diminishing of our appetites. It's a path that requires us to loosen our grip on this world, preparing us to leave it before we leave it.

Is this not mercy?

Is there not an art to this?

APPENDIX 1

I DON'T LIKE DONATELLO, AND YOU CAN TOO

Donatello, *David*, ca. 1440, bronze, 158 cm height, Bargello Museum, Florence.
alex postovski / 123RF.com

Donatello, the fifteenth-century Italian sculptor from Florence (1386–1466), has done nothing to offend me personally. Still, I don't much care for his work. I find it off-putting. Maybe it's my reaction to his work that bothers me most. He is widely considered one of the world's greatest sculptors and even occupies that rarified air of having a Ninja Turtle named after him along with Raphael, Michelangelo, and Leonardo. His greatness should be self-evident. But when I look at his work, most of what I feel is ambivalence. He doesn't stir anything in my soul. I don't get it. I've tried.

I believe it's a valid form of art criticism to stand in front of a work and say, "I like this one." Or "I don't like this one." Or "I don't get this at all." There are no rules that say we must like everything we see. Art is subjective. People are different. Contexts vary. But is it possible that all those people from all around the world for the last six hundred years who have esteemed Donatello as one of the greats just couldn't see the shortcomings that are so plain to me? That can't be right, can it?

When it comes to aversion or ambivalence toward art, often the problem lies with us. There's an old parable about an art student who took a field trip to the Louvre. As his class shuffled into the gallery with the *Mona Lisa*, the student looked at the painting for a while and told the docent standing nearby that he didn't see what was so special about Leonardo's masterpiece. The docent said, "Son, this is the *Mona Lisa*. The art student doesn't judge the *Mona Lisa*; the *Mona Lisa* judges the art student."[1]

There is a difference between "liking" and "appreciating" art. What we like has to do with our personal preferences and tastes. These vary from person to person, as do our levels of passion for what we love and abhor. But appreciating something, Alan

Gartenhaus said, "refers to an objective esteem for something's intrinsic value, sentiment, or nature."[2] We can appreciate things that fall outside the bounds of what we like. And we should. This is a good skill to develop. We may find that we do like green eggs and ham after all.

Still, what do we do when we don't like a work of art or an artist or even an entire style of art? Here are four strategies that may help.

First, try to understand the work (or artist) in its (or their) original context. Personal taste is often influenced by the cultural moment we are in. This applies to both the viewer and the artist. You come to a work of art with a particular point of view, and the artist who made that work created it with their point of view. Those points of view are different. This applies to Andy Warhol's lithographs from the 1960s as much as to William Blake's paintings from the 1700s. Sometimes the reason we're put off by a work is that the message or style is out of fashion or even offensive to some because it says something we would never say in that same way in our particular cultural moment. If you try to understand a work in its original context and try to understand the artist's intent, you may find that our disinterest is born out of ignorance. Read the tombstones on the walls that describe the works. Those exist to help the viewer gain context.

Second, see if there is anything you do like about the piece. You may surprise yourself. You may find that you came to a particular work or an artist with a preconceived notion that you wouldn't like what they had to offer, only to find that prejudice melt away when you see their work in person. I had this experience with Mark Rothko's work. I had only seen images of his paintings online and couldn't help but wonder why people adored him so much. When a friend who loved Rothko heard I was going to the MET in New York City, she told me not to miss his work there. I confessed my disinterest, and she protested that his work is not meant to be seen on a laptop screen.

192 Van Gogh Has a Broken Heart

She shared a quote from Rothko, who said, "I'm interested only in expressing basic human emotions—tragedy, ecstasy, doom, and so on—and the fact that lots of people break down and cry when confronted with my pictures shows that I communicate those basic human emotions. . . . The people who weep before my paintings are having the same religious experience that I had when I painted it." You have to stand in front of a Rothko for a few minutes and let it wash over you. I can't explain it, but I left the MET loving Rothko. Now I seek him out.

Third, ask what you can learn from a work you dislike. This question takes your engagement deeper than matters of personal preference. Perhaps you will come away with some wisdom or knowledge you would not have found lying along the well-worn paths of the familiar and comfortable. Maybe you'll learn about history—the pressing issues or conflicts of a bygone era. Maybe you'll learn how people are different, and that your point of view may not be as universal as you thought. This is certainly a valuable lesson, is it not? If you approach any work of art with curiosity, there will always be something for you to take away.

Fourth, use your personal displeasure with a particular work or artist to develop a deeper understanding of why you don't like it. Consider what sort of response the artist was after. Did they want you to like it? Is the work meant to confront, shock, or question things in a way that makes you uncomfortable? Do you dislike the work because it is poorly conceived? Does the artist lack skill? Or are you reacting to the message or worldview? Use your aversions as an opportunity to learn to articulate your perspective and build your critical vocabulary.

The goal here is not to learn to like everything you find off-putting; it's to come to art with a posture of openness, willing to learn and grow. As you cultivate that posture of humility when it comes to art, you'll discover that you're cultivating it in other

areas of life too. In a world short on humility and teachability, surely this is a worthy endeavor.

I have no plans to learn to like Donatello. We can have art we don't care for. That's allowed. But I can appreciate him. He was, after all, a master sculptor, working with wood, marble, and bronze. I already appreciate the difficulty and skill sculpture requires. So from across the gallery, I suppose I can find it in myself to raise my glass to the Florentine master and say, "Kudos to being one of the greats. I don't get it, but that's probably my issue, not yours."

APPENDIX 2

A BEGINNER'S GUIDE TO SYMBOLS IN ART

Symbols are metaphorical objects or references often incorporated into works of art to help tell the story the artist intends. Learning the meaning behind some common symbols helps us gain some interpretive clues when we look at art. Not every painting has them, and I certainly would not want to imply that unless you can decipher the incorporation of certain cryptic references in a work of art, you'll never understand it. On the contrary. Seldom does a work of art rely predominantly on symbols. That said, knowing what some of the more common symbols mean can help shed light on the overall meaning of a work. Art historian Paul Crenshaw wrote, "By employing symbols, allegories, and other means of association and allusion, artists were able to expand the intellectual appeal of their work."[1] Here is a brief overview of some of the more common symbols you will encounter.

Apples

Apples symbolize temptation, as seen in René Magritte's *The Son of Man*. Magritte said, "You have the apparent face, the apple, hiding the visible but hidden, the face of the person. . . . Everything

196 Van Gogh Has a Broken Heart

we see hides another thing, we always want to see what is hidden by what we see."[2]

Example: René Magritte, *The Son of Man*, 1946

Bare Feet

In an interior scene, bare feet or the presence of shoes that have been removed symbolize intimacy and domestic peace.[3] For a person outside, bare feet convey a sense of transcendence and divinity—a lesser ability to be hurt by this world.

Examples:
 Bare feet inside: Jan van Eyck, *The Arnolfini Portrait*, 1434
 Bare feet outside: Eugène Delacroix, *Liberty Leading the People*, 1830

Books

Books symbolize learning and knowledge. Van Gogh's *Still Life with Bible*, painted after his father's death, is of a Bible, another book, and candles burnt down. The books represent the whole of a life, and the candles represent the end of life.

Example: Vincent van Gogh, *Still Life with Bible*, 1885

Bread and Wine

Bread and wine are the common elements of the Eucharist, or the Lord's Supper, and represent Communion, the sacrifice of Christ, and the fellowship of believers.

Example: Peter Paul Rubens, *The Last Supper*, ca. 1632

Butterflies

Butterflies symbolize transformation, metamorphosis, change, and resurrection.

Example: Dosso Dossi, *Jupiter Painting Butterflies, Mercury and Virtue*, ca. 1522–1524

Candles

Candles represent and even measure the passing of time. A new, unlit candle conveys youth, with an abundance of time ahead. A candle burnt down speaks to the limits of our mortality and the nearness of our end.

Example: David Bailly, *Self-Portrait with Vanitas Symbols*, 1651

Dead Animals

Dead animals are fascinating symbols. They convey the contradiction of abundance by way of destruction, which is another way of showing dominion, one creature meeting its need by way of a creature losing its life.

Example: Juan Sánchez Cotán, *Still Life with Game Fowl, Vegetables and Fruit*, 1602

Dogs

Dogs represent loyalty. They can also represent restrained ferocity if they are on a leash or wearing a muzzle. Pay attention to what a restrained dog is looking at. This will often give you a valuable clue about the drama of the scene.

198 Van Gogh Has a Broken Heart

Example: Gentile da Fabriano, *Adoration of the Magi*, 1423

Flowers

Flowers represent growth, life, and happiness. If they are just blooming, they can represent new life, and if they are beginning to wilt, they signify the decline and end of life.

Example: Rachel Ruysch, *Still Life of Flowers*, ca. 1726

Floor Tiles

Floor tiles can be used to create lines of separation between figures in a painting. Jan van Eyck's *Madonna of Chancellor Rolin* offers a great example of the chancellor sitting across a room from Mary with the Christ-child on her lap. A single, unencroached-upon line of floor tiles separates them, emphasizing her holy unapproachability.

Example: Jan van Eyck, *Madonna of Chancellor Rolin*, ca. 1435

Halos

Halos represent connection to the divine, or sainthood. Round halos are given to biblical saints who have entered into glory, like Mary the mother of Jesus, angels, and the Old Testament prophets. Triangular halos are given to members of the triune Godhead—the Father, Son, and Holy Spirit. Square halos are given to saints who are still living; the square shape represents this world in which they live with its four directions.

What if a person has no halo, but light radiates from them? Ned Bustard wrote, "Beatified figures not yet canonized are sometimes shown in medieval Italian art with linear rays radiating out

A Beginner's Guide to Symbols in Art 199

from the head, but no circle."[4] Also, some examples of radiant light as a halo represent the physical presence of the divine.

Examples:
> Round halo: Leonardo da Vinci (attributed), *Benois Madonna*, 1475–1478
>
> Triangular halo: Antoniazzo Romano, *God the Father*, from the Altarpiece of the Confraternity of the Annunciation, ca. 1489–1490
>
> Square halo: Mosaic of Pope Paschal I (ca. 820) in the Basilica of St. Praxedes in Rome
>
> Radiating halo: Rembrandt, *Supper at Emmaus*, 1648

Insects (see also Butterflies)

Some insects represent decay. They can be found in scenes that are otherwise teeming with life, but their mere presence reminds us that this moment of life is fleeting.

Example: Balthasar van der Ast, *Still Life of Flowers, Fruit, Shells, and Insects*, ca. 1629

Instruments

Instruments represent beauty, celebration, and leisure—unless the strings are broken, in which case they convey the opposite: discord.

Examples:
> Instrument as a symbol of leisure: Johannes Vermeer, *Lady Standing at a Virginal*, 1670–1672
>
> Instrument with broken strings: Hans Holbein the Younger, *The Ambassadors*, 1533

200 Van Gogh Has a Broken Heart

Lambs

Lambs often symbolize Christ.

Example: Jan Provost, *Christian Allegory*, 1510–1515

Mirrors

Mirrors were considered luxury items, and they often symbolized wealth and vanity. If you see a mirror in a painting, pay careful attention to the reflection, as the reflections will sometimes differ from what you see—revealing a hidden truth or exposing a lie. A broken mirror is a symbol of bad luck.

Example: Edouard Manet, *A Bar at the Folies-Bergère*, 1881–1882

Posture

Look at people's postures in a painting. Are any of them imitating a famous position? Posture can convey attitude and outlook, of course, but it can also be used to link a person to another historical or mythological figure. For example, does anyone have the outstretched arms of the crucified Christ?

Example: Caravaggio, *The Entombment of Christ*, 1602–1603

Purple Clothing or Curtains

Purple represents royalty and wealth. If you see a painting of a room with purple drapes, it is not a commoner's house. It is likely a royal palace or a seat of political power. And if you see a person

wearing purple, it means they are royalty. The same applies to crowns and scepters, but you already knew that, didn't you?

Example: Christ, as depicted in Michelangelo's *The Last Judgment* in the Sistine Chapel, 1536–1541

Rivers

Rivers represent the ongoing rhythm and flow of life and ever-present change.

Example: Thomas Cole, *The Oxbow*, 1836

Shells

Shells often symbolize birth, purity, and fertility, or good fortune in the case of an oyster shell. Scallop shells often signify baptism in particular.

Example: Clara Peeters, *Still Life with Fish, Sea Food and Flowers*, ca. 1612–1615[5]

Silver and Gold

Silver, gold, precious metals, and gems signify wealth, opulence, and luxury. They may also be incorporated to serve as a clue to vanity and the folly that comes with it. If you see someone surrounded by gold, look to see if the opulence is used as a compliment or a critique.

Example: Alexandre François Desportes, *Still Life with Silver*, ca. 1715–1723

Skulls and Bones

Skulls and bones speak to mortality and death.

Example: Paul Cézanne, *Still Life with Skull*, 1896–1898

APPENDIX 3

LOST, STOLEN, AND RECOVERED ART

A rt theft fascinates me. And it offends me. It is such a strange behavior. In my previous book, *Rembrandt Is in the Wind*, I wondered what must have been going through the thief's mind as he cut the irreplaceable Rembrandt from its frame:

> Whoever cut *The Storm on the Sea of Galilee* from its frame did so with Rembrandt looking straight at him. Did the two men make eye contact? Did the man disguised as a Boston police officer understand what Rembrandt was trying to say?
>
> This is a hard world, where children die and widows grieve. This is the nature of the storm we are all painted into. The same sea that lures us in with its beauty and bounty surges with a power that can destroy us without warning. And eventually there comes a reckoning. Rembrandt knew this well. So did Isabella Stewart Gardner. So did every man in the boat.
>
> Has the thief learned this yet?[1]

Stolen art is a burden few can manage. What can a thief do with millions of dollars in stolen art when the paintings he took

204 Van Gogh Has a Broken Heart

are featured all over social media and in every newspaper, magazine, and news outlet around the world? The average law-abiding citizen gets stuck on this question because they assume the point is for the thief to try to get some amount of money close to what the art is worth. That's not usually how it works. These are the most common uses of stolen art:

- The thief attempts to sell it at a fraction of its true value.
- It is held as collateral for immunity regarding other crimes.
- It is held for a potential ransom offered by the museum or authorities.
- It is traded as currency on the black market for illicit items like guns or drugs.
- In the case of war or colonialization, it is put on display in the victor's most prominent locations to emphasize their might and cultural importance.
- The thief attempts to repatriate the work to its country of origin.
- The thief displays it at home, or if the thief was hired, the commissioner of the theft displays it in their home.

Not all missing art is stolen art, however. Here are some of the most common ways art goes missing:

- art heists in which one or multiple works are stolen from one location, usually a museum
- burglaries or home invasions in which a particular work is targeted from a private collection
- looting, plundering, or bombing during wartime
- fires
- shipwrecks
- decay or failure of the materials from which the work was made

- earthquakes, especially in the case of stone sculptures and works permanently affixed to architecture
- permanent works like frescoes destroyed during renovations (see the bottom of Leonardo da Vinci's *The Last Supper*, which was cut away to make room for a door)
- a work lost, misplaced, or stored indefinitely by someone who doesn't know the value or significance of the piece (In 2019, a London man found an original Caravaggio covered in dust in the attic of a home he had just purchased; the painting was worth an estimated $171,000,000.)

Lost art is a tragedy. It is also an ongoing reality. It is a kind of poverty that comes from living in a broken world, which, as Jesus said, is something we will always have with us.[2] Following is a list of some notable works of art that have gone missing, along with their estimated value and status.

Caravaggio

Nativity with St. Francis and St. Lawrence (1609)

Loss Event: Stolen in October 1969 from a church in Palermo, Sicily. Thieves removed this large painting, measuring almost six square meters, from its frame to get it outside without raising suspicion.
Estimated Value: $20,000,000
Status: Missing, presumed destroyed.

Caravaggio

Saint Jerome Writing (1607)

Loss Event: This painting was cut from its frame in St. John's Co-Cathedral in Valletta, Malta, on December 29, 1984.

206　Van Gogh Has a Broken Heart

Estimated Value: $30,000,000
Status: Recovered on August 4, 1988, and restored in 1990. Currently on display at St. John's Co-Cathedral in Valletta.

Cezanne, Paul

The Boy in the Red Vest (1889)

Loss Event: Stolen in February 2008 from the Foundation E. G. Bührle, Zürich, Switzerland.
Estimated Value: $91,000,000
Status: Recovered in Serbia, April 2012.

Da Vinci, Leonardo

Mona Lisa (1503–1506)

Loss Event: Stolen from the Louvre on August 21, 1911. The thief kept the painting under the false bottom of a trunk in his apartment for two years, during which time he painted copies. He was arrested when he attempted to sell it. The thief spent seven months in prison and was regarded by many as a folk hero.
Estimated Value: $782,000,000 (otherwise, priceless)
Status: Recovered in December 1913. Currently on display in the Louvre in Paris.

Degas, Edgar

Les Choristes (The Chorus Singers) (1877)

Loss Event: Stolen in 2009 from the Musée Cantini in Marseille while on loan from the Musée d'Orsay in Paris, France.
Estimated Value: $800,000
Status: Recovered in Paris in February 2018. Currently on display at Musée d'Orsay.

Gentileschi, Artemisia

Hercules and Omphale (1628)

Loss Event: This painting was commissioned for Philip IV of Spain. It was destroyed in a fire at the Royal Alcázar of Madrid on December 24, 1734.

Estimated Value: Unknown

Status: Destroyed by fire.

Klimt, Gustav

Portrait of a Lady (1917)

Loss Event: Stolen in February 1997 from the Galleria Ricci Oddi in Piacenza in Italy. This painting was hidden inside the gallery wall for twenty-three years until it was discovered in 2019 by gardeners who were clearing away old ivy on the museum's outer wall. They came upon a metal door, behind which, in a black bag, was the Klimt, slightly damaged but in relatively good shape.

Estimated Value: $58,000,000

Status: Found in December 2019. Currently on display at Galleria Ricci Oddi in Piacenza.

Kooning, Willem de

Woman-Ochre (1955)

Loss Event: Cut from its frame and stolen in 1985 from the University of Arizona Museum of Art, Tucson.

Estimated Value: $100,000,000

Status: Recovered in 2017. After its recovery, it was placed in a temporary exhibit at the J. Paul Getty Museum in Los Angeles through August 2022 and has since returned to the University of Arizona Museum of Art.

Monet, Claude

Charing Cross Bridge (1901)

Loss Event: Stolen on October 15 or 16, 2012, from the Kunsthal in Rotterdam, the Netherlands. Presumed burnt.
Estimated Value: Priceless
Status: Whereabouts unknown.

Munch, Edvard

The Scream (1893)

Loss Event: Stolen twice, once in 1994 from the National Gallery in Oslo, Norway, and again in 2004 from the Munch Museum in Oslo. The painting was recovered both times.
Estimated Value: $110,000,000
Status: Recovered in 1994 and 2006, respectively. Currently on display at the Munch Museum in Oslo.

Oudry, Jean-Baptiste

White Duck (1753)

Loss Event: Stolen in 1992 from Houghton Hall in Norfolk, England.
Estimated Value: $8,800,000
Status: Whereabouts unknown.

Picasso, Pablo

Le pigeon aux petits pois (Pigeon with Peas) (1911)

Loss Event: One of five paintings stolen on May 20, 2010, from the Musée d'Art Moderne, Paris, France. The thief was apprehended and claimed he threw this painting in a dumpster

soon after he took it, which wasn't known until it was too late to track it down.

Estimated Value: $28,000,000

Status: Whereabouts unknown. Likely destroyed.

Poussin, Nicholas

The Martyrdom of Saint Erasmus (1630)

Loss Event: Destroyed in World War II during the bombing of Dresden, Germany, in February 1945.

Estimated Value: Unknown

Status: Destroyed, lost to war.

Raphael

Portrait of a Young Man (1514)

Loss Event: Plundered by the Nazis in Poland in the 1940s.

Estimated Value: $100,000,000

Status: Formerly displayed at the Czartoryski Museum, Kraków, Poland. Whereabouts unknown.

Rembrandt van Rijn

The Storm on the Sea of Galilee (1633)

Loss Event: Stolen from the Isabella Stewart Gardner Museum in Boston in 1990 as part of a heist that claimed thirteen pieces. The Gardner heist was, at the time, the single biggest property theft in American history—at a value of more than $500,000,000. Other works taken in the heist include Rembrandt's *A Lady and Gentleman in Black*, Manet's *Chez Tortoni*, Vermeer's *The Concert*, and Degas's *La Sortie de Pesage*. Despite the museum's offer of a $10,000,000 reward,

210 Van Gogh Has a Broken Heart

none of the works taken in the Gardner heist have been recovered.
Estimated Value: Over $100,000,000
Status: In the wind.

Renoir, Pierre-Auguste

Madeleine Leaning on Her Elbow with
Flowers in Her Hair (1918)

Loss Event: Stolen at gunpoint from a private residence by an intruder on the night of September 8, 2011.
Estimated Value: $1,000,000
Status: Whereabouts unknown.

Rubens, Peter-Paul

The Crucifixion (1601–1602)

Loss Event: This painting was commissioned for the Church of Santa Croce in Rome. It was later imported to England in 1811 and was auctioned in 1812 and again in 1820. It was lost at sea shortly after it was purchased in 1820.
Estimated Value: Unknown
Status: Lost at sea.

Van Gogh, Vincent

Congregation Leaving the Reformed Church
in Nuenen (1884, a very early van Gogh)

Loss Event: Stolen in 2002 from the Van Gogh Museum in Amsterdam.
Estimated Value: Part of a $30,000,000 art heist.
Status: Recovered in Naples on September 30, 2016. It is currently on display at the Van Gogh Museum in Amsterdam.

Van Gogh, Vincent

The Painter on His Way to Work (1888)

Loss Event: Taken by the Nazis from the salt mines art repository near Magdeburg, Germany, in April 1945, as seen in the 2014 film *The Monuments Men*. During World War II, more than 20 percent of the art in European art museums in German-occupied cities was plundered by the Nazis.

Estimated Value: Unknown

Status: Whereabouts unknown, probably destroyed.

Van Gogh, Vincent

Poppy Flowers (1887)

Loss Event: Stolen in 1977 from Mohamed Mahmoud Khalil Museum, Cairo, Egypt. Recovered in Kuwait in 1987. Stolen again in August 2010, from the same museum in Egypt.

Estimated Value: $50,000,000

Status: Whereabouts unknown.

Vermeer, Johannes

The Concert (ca. 1664)

Loss Event: One of the most valuable paintings ever stolen. It is one of only thirty-seven Vermeers in existence. *The Concert* was stolen during the Isabella Stewart Gardner Museum heist in 1990, along with Rembrandt's *The Storm on the Sea of Galilee.*

Estimated Value: $200,000,000

Status: Whereabouts unknown.

DISCUSSION GUIDE

General Discussion Guide for *Van Gogh Has a Broken Heart*

1. Before reading this book, what was your overall approach to engaging with art? After reading it, were you inspired to do anything new or different? Explain your answer.

2. The opening lines of this book read, "This is a book of stories, each of them filled with beauty, and most of them sad. It's not a sad book, but what story doesn't have some measure of sorrow, and what great story doesn't contain great sadness?" Would you describe this book in the same way Ramsey did? If not, how would you describe it to someone who hasn't read it?

3. Why do you think Ramsey opens by emphasizing that the stories contained within are sad? Do you agree that great stories contain great sorrow? If so, why? If not, why not?

4. In chapter 2, Ramsey says, "No one can own *Mona Lisa*. . . . Still, there is something in us that makes the thought of owning *Mona Lisa* compelling. . . . There is something in the human condition that leads us to believe that possessing external things regarded as precious and desired by the world will somehow add to our intrinsic value, even when it costs us dearly. In what ways do we ask of life more than it can give?" How would you answer that question? Why do you think we want what we cannot have?

214 Van Gogh Has a Broken Heart

5. In your own words, what do you think the author intends to communicate with the title, *Van Gogh Has a Broken Heart*? If you could give this book a different title, what would you name it?

6. What themes did you notice throughout the book? Did you highlight any quotes? What particular passages or chapters stood out to you most, and why?

7. Did your opinions or expectations concerning this book change as you read it? If so, in what ways?

8. What was your favorite chapter, and why? What was your least favorite chapter, and why?

9. What in this book surprised you? What questions, if any, did it raise for you? What clarity, if any, did it provide for you?

Chapter 1

Something Utterly Heartbroken: Gustave Doré and the Beauty of Sad Stories in a Complicated World

1. How would you describe the main theme of this chapter?

2. Did you highlight any quotes from this chapter? What particular passages stood out to you most, and why?

3. Ramsey asks, "What great story doesn't contain great sorrow?" Do you agree with this statement? Why or why not? What role does sorrow play in a compelling story?

4. Ramsey makes the claim that "people don't connect to vague concepts in the same way we connect to specific details." Do you agree? Why or not? In what ways do the details of someone else's story help us see our own stories with greater specificity?

5. A lot of the world's art is born out of sadness and suffering. Why do you think there is a compulsion in human beings to create beauty in response to sad things?

6. In what ways is beauty persuasive, and what does its existence persuade people to believe?

Chapter 2

Owning *Mona Lisa*: Leonardo's Masterpiece and the Desire to Possess More Than Life Can Give

1. Did you highlight any quotes from this chapter? What particular passages stood out to you most, and why?
2. Why do you think Picasso and Apollinaire couldn't bring themselves to destroy the stolen busts they had in their possession? What would you have done if you were in their position?
3. The *Mona Lisa* became known for being famous. What are some other examples in our culture of things that are famous for being famous? Why is this a phenomenon? What is it about people that draws us to fame?
4. Ramsey says, "We want to possess what is not meant to be owned. . . . Why do we want what we cannot have?" How would you answer that question?
5. What do you think it was like for Peruggia to have the *Mona Lisa* in his trunk all that time? What would that have been like for you?
6. How would you describe the main theme of this chapter?

Chapter 3

Now Let Your Servant Go in Peace: Rembrandt's *Simeon in the Temple* and the Power of Suffering

1. Did you highlight any quotes from this chapter? What particular passages stood out to you most, and why?
2. Rembrandt showed remarkable artistic prowess at a young age. What were you particularly adept at when you were young?
3. Rembrandt painted himself into several of his paintings, including *Rembrandt and Saskia in the Scene of the Prodigal Son in the Tavern*. If you were to put yourself into a painting, what would it depict?

216 Van Gogh Has a Broken Heart

4. As you read about Rembrandt's treatment of Geertje Dircx, how did you respond? Does seeing character flaws in your heroes discourage you or help you in some way? Explain.

5. In this chapter, Ramsey discusses two Rembrandt self-portraits—one of an eager, confident young man, the other of an older, defiant yet humbled man. Which one would you paint yourself into now, and why wouldn't you put yourself in the other?

6. What are some ways you practice your life? Your faith? As you have practiced, what changes have you noticed in yourself over the years?

Chapter 4

The Allegory of Painting: Artemisia Gentileschi and Inhabiting a Discipline in an Unjust World

1. Did you highlight any quotes from this chapter? What particular passages stood out to you most, and why? As you read, did this chapter unfold in unexpected ways?

2. How did you respond to the description of thumbscrews and the court transcript that opened this chapter? Why do you think Ramsey chose to open the chapter in this way?

3. What particular injustices and inequities did Artemisia face that were specific to her era, and which of them remain today—particularly when it comes to the experience of women?

4. What are some present-day values and assumptions we often impose on other eras in history, and how does this complicate our understanding of history?

5. What did you make of the idea of seeing Artemisia as a working painter whose primary objective was to obtain and fulfill commissions? Was this enlightening? Disappointing?

6. In what ways was Artemisia's life an allegory for the life of an artist?

Chapter 5

Keep Them Together: Joseph Mallord William Turner and the Evolution of an Inner Life

1. How would you describe the main ideas of this chapter? What resonated most with you?
2. Turner mastered the fundamentals of composition, design, and perspective. Why is mastery of fundamentals important for an artist? What is lost without that foundational understanding and skill?
3. Turner wanted to be known for his greatness. Would you describe this as a character flaw or a positive quality? Explain your response.
4. Where in your life have you changed your approach to something important? One change for Turner is that he slowed his output. Why do you think he might have slowed down as he got older?
5. What is the value of keeping the two halves of Turner's body of work together? What would be lost if they were separated?
6. In what ways might it be important or helpful to deconstruct your faith? In what ways could it be potentially unhelpful? What fundamentals would you say would need to remain in place if you were to change your perspective?

Chapter 6

A Sort of Delightful Horror: The Hudson River School, the Beautiful, and the Sublime

1. What, if any, impression did you have of the Hudson River School before you read this chapter? Did your impression change after reading? If so, in what ways?
2. What in this chapter surprised you? What questions, if any, did it raise for you? What clarity, if any, did it provide for you?
3. How would you articulate the difference between the

218 Van Gogh Has a Broken Heart

beautiful and the sublime? In what ways do you encounter beauty in your life? In what ways do you encounter the sublime? How do they differ?

4. German philosopher Immanuel Kant said we often respond to the sublime with "a feeling of displeasure arising from the inadequacy of imagination." What do you think he meant by that, and have you experienced this feeling of displeasure personally? If so, describe the feeling.

5. In this chapter, Ramsey argues that the Native American way of life that Bierstadt painted, though primitive in appearance to the European eye, was in fact quite sophisticated. In what ways were Native Americans sophisticated?

6. Did you highlight any quotes from this chapter? What particular passages stood out to you most, and why?

Chapter 7

The Yellow House: Vincent van Gogh, Paul Gauguin, and the Sacred Work of Stewarding Another's Pain

1. Did you highlight any quotes from this chapter? What particular passages stood out to you most, and why?

2. Have you ever joked around about van Gogh cutting off his ear? Why do you think people make jokes about this? What are we trying to express when we make light of another's suffering?

3. Were you familiar with van Gogh's plan for the Yellow House and his artist colony in the south of France? What factors do you think would potentially complicate such a vision?

4. Van Gogh wrote about Christ with great affection. What do you make of knowing he visited brothels considering his professed affection for Jesus?

5. What was your reaction to the story of why van Gogh cut off his ear? What did you feel for him? In what ways does knowing this story impact how you think about van Gogh?

6. What in this chapter surprised you? What questions, if any, did it raise for you? What clarity, if any, did it provide for you?

Chapter 8

Cultivate Your Own Half Acre: Norman Rockwell and Capturing a Changing Country

1. Before reading this chapter, what was your general impression of Norman Rockwell? What in this chapter surprised you? What questions, if any, did it raise for you? What clarity, if any, did it provide for you?
2. Did you highlight any quotes from this chapter? What particular passages stood out to you most, and why?
3. Many Norman Rockwell paintings might be considered culturally insensitive today. To what degree should we expect artists from a different era to uphold our current values? What do we gain from seeing the world as depicted by artists of a different era?
4. Based on the story this chapter tells, how would you describe Rockwell's journey through the issue of equality and civil rights?
5. In what ways is the world changing around us right now? What would it look like for you to lend your voice to influence the changes you want to see in this world?
6. At several places throughout this chapter, we see examples of Rockwell's humility. Can you name an example? What role does humility play in being a voice for change?

Chapter 9

Through a Glass Darkly: Jimmy Abegg, Edgar Degas, and Learning to See as the World Grows Dim

1. Did you highlight any quotes from this chapter? What in this chapter surprised you?

220 Van Gogh Has a Broken Heart

2. How has your view of spiritual growth changed over time? What role does suffering play in spiritual development?

3. What are your primary modes of creative expression, and how do they work together in your life?

4. If you were a painter recently diagnosed with macular degeneration, how do you think you would respond? What is something you can't imagine no longer doing? What makes that thing so significant to you? If you had to learn a new way to approach it, would you?

5. In what ways does affliction help us see the world in new ways? Are there ways you have suffered that have shaped how you see the world that you would be willing to share?

6. Why do you think Ramsey chose to write a chapter about painters who lost their sight?

Chapter 10

Our Personal Collections: Jeremiah's Lament, the Works We Carry, and the Words on Which We Rest

1. Do you relate to the idea that we build our own personal collections of art over time? Are there any particular pieces of art you would consider part of your own personal collection? Why?

2. Name a time when you were surprised by an encounter with beauty. Describe what that experience was like. Why does beauty cause us to react?

3. Why do you think Ramsey chose to highlight the forms of ancient Hebrew poetry at the close of this chapter—particularly from the book of Lamentations?

4. Ramsey said a lot of his work as a pastor is preparing people to die. To what degree is the work of navigating this life a preparation for leaving this world?

5. Ramsey wrote, "We live in a world alive with beauty, but it is

Discussion Guide 221

filled with suffering too. Some of the beauty is hidden in the pain we come to know in this life." In what ways is beauty hidden in pain?

6. Did you find this chapter that focuses on the art we carry with us until we die a fitting end to this book as a whole? What ideas do you wish the author would have developed more fully? Name an idea or image you will take with you after reading this book.

SELECTED WORKS

Bailey, Anthony. *Standing in the Sun: A Life of J. M. W. Turner.* New York: Abrams, 2013.

Bailey, Martin. *The Sunflowers Are Mine: The Story of Van Gogh's Masterpiece.* London: White Lion, 2019.

Barker, Sheila. *Artemisia Gentileschi.* Los Angeles: Getty Publications, 2022.

Barrs, Jerram. *Echoes of Eden: Reflections on Christianity, Literature, and the Arts.* Wheaton, IL: Crossway, 2013.

Copplestone, Trewin. *The Hudson River School.* New York: Gramercy, 1999.

Crenshaw, Paul. *Discovering the Great Masters: The Art Lover's Guide to Understanding Symbols in Paintings.* New York: Universe, 2009.

Edsel, Robert M. *Rescuing Da Vinci: Hitler and the Nazis Stole Europe's Great Art—America and Her Allies Recovered It.* Miller Place, NY: Laurel, 2006.

Fell, Derek. *Van Gogh's Women: His Love Affairs and Journey into Madness.* London: Pavilion, 2015.

Finch, Christopher. *Norman Rockwell's America.* New York: Abrams, 1985.

Garrard, Mary D. *Artemisia Gentileschi and Feminism in Early Modern Europe.* London: Reaktion, 2023.

224 Van Gogh Has a Broken Heart

———. *Artemisia Gentileschi around 1622: The Shaping and Reshaping of an Artistic Identity.* Berkeley: University of California Press, 2001.

———. *Artemisia Gentileschi: The Image of the Female Hero in Italian Baroque Art.* Princeton, NJ: Princeton University Press, 1989.

Gayford, Martin. *The Yellow House: Van Gogh, Gauguin, and Nine Turbulent Weeks in Provence.* New York: Little, Brown, 2009.

Gentileschi, Artemisia, Orazio Gentileschi, Cristofano Bronzini, Pierantonio Stiattesi, Filippo Baldinucci, Averardo dé Medici, and Alessandro Morrona. *Lives of Artemisia Gentileschi.* Los Angeles: Getty Publications, 2021.

Gowing, Lawrence. *Turner: Imagination and Reality.* New York: Museum of Modern Art, 1966.

Graham-Dixon, Andrew. *Caravaggio: A Life of Sacred and Profane.* New York: Norton, 2010.

Guptill, Arthur Leighton. *Norman Rockwell, Illustrator.* New York: Watson-Guptill, 1970.

Hockney, David. *Secret Knowledge: Rediscovering the Lost Techniques of the Old Masters.* New York: Avery, 2006.

Hoobler, Dorothy and Thomas. *The Crimes of Paris: A True Story of Murder, Theft, and Detection.* New York: Little, Brown, 2009.

Kuenzel, Helga. *Rembrandt.* Milan: Uffici, 1967.

Marmor, Michael F. *Degas through His Own Eyes: Visual Disability and the Late Style of Degas.* Paris: Somogy éditions d'art, 2002.

Mee, Charles L., Jr. *Rembrandt: A Life.* Boston: New Word City, 2016.

Meier-Graefe, Julius. *Vincent van Gogh: A Biographical Study.* London: Medici Society, 1922.

Nicholas, Lynn H. *The Rape of Europa: The Fate of Europe's Treasures in the Third Reich and the Second World War.* New York: Vintage, 2009.

Selected Works 225

Phillips, A'Dora, and Brian Schumacher, eds. *The Persistence of Vision: Early and Late Works by Artists with Macular Degeneration.* Cincinnati: University of Cincinnati Press, 2018.

Reff, Theodore. *Degas: The Artist's Mind.* New York: Metropolitan Museum of Art, 1976.

Reynolds, Graham. *Turner.* New York: Oxford University Press, 1969.

Roberts, Russell. *Rembrandt.* Newark, DE: Mitchell Lane, 2009.

Rosenberg, Jakob. *Rembrandt: Life and Work.* London: Phaidon, 1964.

Selz, Jean. *Turner.* Norwalk, CT: Easton, 1987.

Silverman, Debora. *Van Gogh and Gauguin: The Search for Sacred Art.* New York: Farrar, Straus and Giroux, 2000.

Updike, John. *Still Looking: Essays on American Art.* New York: Knopf, 2005.

Wilton, Andrew, and T. J. Barringer. *American Sublime: Landscape Painting in the United States, 1820–1880.* Princeton, NJ: Princeton University Press, 2002.

NOTES

Foreword
1. John Berger, *The Shape of a Pocket* (New York: Vintage, 2001), 164.
2. Flannery O'Connor, *Mystery and Manners: Occasional Prose*, ed. Sally Fitzgerald and Robert Fitzgerald (New York: Farrar, Straus and Giroux, 1970), 96.

Chapter 1: Something Utterly Heartbroken
1. "634: To Theo van Gogh. Arles, on or about Thursday, 28 June 1888," Vincent van Gogh: The Letters, https://vangogh letters.org/vg/letters/let634/letter.html, author's translation.
2. Genesis 23:2.
3. Genesis 23:6.
4. See Genesis 23:13–16.
5. Quoted in Ralph C. Wood, *Flannery O'Connor and the Christ-Haunted South* (Grand Rapids: Eerdmans, 2005), 7.
6. Eugene H. Peterson, *Leap Over a Wall: Earthy Spirituality for Everyday Christians* (New York: HarperOne, 2011), 3.
7. C. S. Lewis, *A Grief Observed* (New York: HarperCollins, 2001), 3.
8. Gilbert Keith Chesterton, "The Red Angel," in *Tremendous Trifles* (New York: Dodd, Mead, 1909), 129–30.

Chapter 2: Owning *Mona Lisa*
1. Dorothy and Thomas Hoobler, *The Crimes of Paris: A True Story of Murder, Theft, and Detection* (New York: Little, Brown, 2009), 210.
2. Hoobler, *Crimes of Paris*, 193.
3. Hoobler, *Crimes of Paris*, 178.

228 Van Gogh Has a Broken Heart

4. Frank Zöllner and Johannes Nathan, *Leonardo: The Complete Paintings and Drawings* (Cologne, Germany: Taschen, 2019), 71.

5. See Zöllner and Nathan, *Leonardo*, 71–72.

6. John Lichfield, "The Moving of the *Mona Lisa*," Independent, April 2, 2005, www.independent.co.uk/news/world/europe/the-moving-of-the-mona-lisa-530771.html.

7. See Terence McArdle, "How the 1911 Theft of the *Mona Lisa* Made It the World's Most Famous Painting," *Washington Post*, October 20, 2019, www.washingtonpost.com/history/2019/10/20/how-theft-mona-lisa-made-it-worlds-most-famous-painting.

8. See Jennifer Rosenberg, "The Day the Mona Lisa Was Stolen," ThoughtCo., July 17, 2019, www.thoughtco.com/mona-lisa-stolen-1779626.

9. Quoted in James Zug, "Stolen: How the *Mona Lisa* Became the World's Most Famous Painting," *Smithsonian Magazine*, June 15, 2011, www.smithsonianmag.com/arts-culture/stolen-how-the-mona-lisa-became-the-worlds-most-famous-painting-16406234.

10. Cited in Hoobler, *Crimes of Paris*, 177. The letter printed in the *Paris-Journal* omitted meeting time, location, and sum.

11. Hoobler, *Crimes of Paris*, 178.

12. See Lucas Reilly, "When Pablo Picasso Was Suspected of Stealing the *Mona Lisa*," Mental Floss, January 3, 2019, www.mentalfloss.com/article/568706/pablo-picasso-was-suspected-of-stealing-the-mona-lisa.

13. Quoted in Hoobler, *Crimes of Paris*, 179.

14. See McArdle, "Theft of the *Mona Lisa*."

15. Hoobler, *Crimes of Paris*, 202.

16. Ian Shank, "When Picasso Went on Trial for Stealing the *Mona Lisa*," Artsy, August 1, 2017, www.artsy.net/article/artsy-editorial-picasso-trial-stealing-mona-lisa.

17. Quoted in John Richardson and Marilyn McCully, *A Life of Picasso*, vol. 2, *1907–1917: The Painter of Modern Life* (New York: Random House, 2007), 203.

18. See Christopher P. Jones, "How the *Mona Lisa* Became a Cultural Icon: The Theft of the World's Most Famous Painting,"

Medium, December 22, 2021, https://christopherpjones.medium
.com/did-picasso-steal-the-mona-lisa-731c0eb80fe9.

19. See Hoobler, *Crimes of Paris*, 252.
20. Rosenberg, "Day the *Mona Lisa* Was Stolen."
21. Hoobler, *Crimes of Paris*, 256.
22. See McArdle, "Theft of the *Mona Lisa*."
23. See Richard Cavendish, "The *Mona Lisa* Is Stolen from the Louvre," *History Today* 61, no. 8 (August 2011), www.history today.com/archive/months-past/mona-lisa-stolen-louvre.
24. Hoobler, *Crimes of Paris*, 257.
25. McArdle, "Theft of the *Mona Lisa*."
26. Quoted in Sheena McKenzie, "*Mona Lisa*: The Theft That Created a Legend," CNN, November 19, 2013, www.cnn.com /2013/11/18/world/europe/mona-lisa-the-theft/index.html.
27. Quoted in Don Thompson, *The Supermodel and the Brillo Box: Back Stories and Peculiar Economics from the World of Contemporary Art* (New York: St. Martin's, 2014), 45.
28. See Lynn H. Nicholas, *The Rape of Europa: The Fate of Europe's Treasures in the Third Reich and the Second World War* (New York: Vintage, 2009), 87.
29. Quoted in Ben Davis, "The Whitney's Warhol Show Strives to Spotlight His Human Side. But It's His Cynicism That Remains Most Surprising," ArtNet, November 26, 2018, https://news .artnet.com/art-world/andy-warhol-whitney-review-1400113.
30. Davis, "Whitney's Warhol Show."
31. See Kelsey McKinney, "The *Mona Lisa* Is Protected by a Fence That Beyoncé and Jay-Z Ignored," *Vox*, October 13, 2104, www.vox.com/xpress/2014/10/13/6969099/the-mona-lisa-is -protected-by-a-fence-that-beyonce-and-jay-z-ignored.
32. Quoted in McArdle, "Theft of the *Mona Lisa*."
33. Corky Siemaszko, "Here's Why Art Thieves Steal Paintings They Can't Sell," NBC News, September 30, 2016, www.nbcnews.com /news/world/here-s-why-art-thieves-steal-paintings-they-can-t -n657656.
34. Quoted in Ratiba Hamzaoui, "Could France Sell the *Mona Lisa* to Pay Off Its Debts?" France 24, February 9, 2014, www.france24 .com/en/20140902-could-france-sell-mona-lisa-pay-off-its-debts.

230 Van Gogh Has a Broken Heart

35. Derek Kidner, *The Message of Ecclesiastes*, rev. ed. (Downers Grove, IL: IVP Academic, 2023), 58.

36. Paraphrasing a line from Jason Isbell's song "Alabama Pines," which says, "I tried to be some ancient kind of man, one that's never seen the beauty in the world. But I tried to chase it down, tried to make the whole thing mine."

37. Edgar Allan Poe, *The Best of Poe: The Tell-Tale Heart, The Raven, The Cask of Amontillado, and 30 Others* (Clayton, DE: Prestwick House, 2006), 83.

Chapter 3: Now Let Your Servant Go in Peace

1. The author has adapted and slightly modernized the preceding prayer and liturgical details from *Liturgy of the Reformed Churches of the Netherlands*.

2. Helga Kuenzel, *Rembrandt* (Milan: Uffici, 1967), 9.

3. Hourly History, *Rembrandt: A Life from Beginning to End* (n.p.: Amazon Digital, 2021), 90.

4. Kuenzel, *Rembrandt*, 21.

5. Russell Roberts, *Rembrandt: Art Profiles for Kids* (Newark, DE: Mitchell Lane, 2009), 13.

6. See Ludwig Münz, *Rembrandt* (New York: Abrams, 1954), 8.

7. See Charles L. Mee Jr., *Rembrandt: A Life* (Boston, MA: New Word City, 2016), 272.

8. Kuenzel, *Rembrandt*, 21.

9. Christopher White and Quentin Buvelot, eds., *Rembrandt by Himself* (London: National Gallery Publications, 1999), 45.

10. Quoted in Charles River Editors, *History's Greatest Artists: The Life and Legacy of Rembrandt* (North Charleston, SC: CreateSpace, 2017), 64.

11. See Jakob Rosenberg, *Rembrandt: Life and Work* (London: Phaidon, 1964), 24.

12. See Mee, *Rembrandt: A Life*, 272.

13. Charles L. Mee Jr., *Rembrandt's Portrait: A Biography* (New York: Simon and Schuster, 1988), 229.

14. See Mee, *Rembrandt's Portrait*, 229.

15. Henri J. M. Nouwen, *The Return of the Prodigal Son: A Story of Homecoming* (New York: Crown, 2013), 65.

Notes 231

16. Quoted in Charles M. Rosenberg, *Rembrandt's Religious Prints* (Bloomington: Indiana University Press, 2017), 14.
17. Mee, *Rembrandt: A Life*, 327.
18. See Mee, *Rembrandt: A Life*, 332.
19. Mee, *Rembrandt: A Life*, 336.
20. Mee, *Rembrandt: A Life*, 336–37.
21. Mee, *Rembrandt: A Life*, 346.
22. Kuenzel, *Rembrandt*, 31.
23. White and Buvelot, eds., *Rembrandt by Himself*, 138.
24. See Dr. Saskia Beranek, "Rembrandt, *Self-Portrait with Two Circles*," Smart History, October 6, 2019, https://smarthistory .org/rembrandt-self-portrait-kenwood.
25. Cited in White and Buvelot, *Rembrandt by Himself*, 204.
26. Kuenzel, *Rembrandt*, 46.
27. See Luke 2:22–38.
28. See Exodus 13:1–2.
29. Luke 2:29–32, author's paraphrase.
30. White and Buvelot, eds., *Rembrandt by Himself*, 25.
31. Münz, *Rembrandt*, 56.
32. Louis Évely, *Suffering* (New York: Herder and Herder, 1967), 71.
33. Évely, *Suffering*, 96.
34. See James 1:2.

Chapter 4: The Allegory of Painting

1. The author adapted this portion of the trial of Agostino Tassi from the English translation of Artemisia Gentileschi et al., *Lives of Artemisia Gentileschi* (Los Angeles: Getty Publications, 2021), 55–58.
2. See Mary D. Garrard, *Artemisia Gentileschi: The Image of the Female Hero in Italian Baroque Art* (Princeton, NJ: Princeton University Press, 1989), 13.
3. Gentileschi, *Lives of Artemisia Gentileschi*, 9.
4. Daniel 13:22–23 NRSVCE.
5. Mary D. Garrard, *Artemisia Gentileschi around 1622: The Shaping and Reshaping of an Artistic Identity* (Berkeley: University of California Press, 2001), 85.
6. This quote was taken from an interview the author conducted

232 Van Gogh Has a Broken Heart

with Dr. Weichbrodt on March 29, 2023, on the campus of Covenant College. All other quotes from Dr. Weichbrodt are from that same interview.

7. Quoted in Gentileschi, *Lives of Artemisia Gentileschi*, 20.
8. Quoted in Gentileschi, *Lives of Artemisia Gentileschi*, 22.
9. See Garrard, *Artemisia Gentileschi around 1622*, 77–113.
10. Sheila Barker, *Artemisia Gentileschi* (Los Angeles: Getty Publications, 2022), 33.
11. Quoted in Andrew Graham-Dixon, *Caravaggio: A Life Sacred and Profane* (New York: Penguin, 2011), 170.
12. See Beverly Louise Brown, *The Genius of Rome: 1592–1623* (London: Royal Academy of Arts, 2001).
13. Gentileschi, *Lives of Artemisia Gentileschi*, 22.
14. Barker, *Artemisia Gentileschi*, 33.
15. See Gentileschi, *Lives of Artemisia Gentileschi*, 11.
16. See R. Ward Bissell, *Artemisia Gentileschi and the Authority of Art* (University Park: Pennsylvania State University Press, 1999), 195.
17. Gentileschi, *Lives of Artemisia Gentileschi*, 11.
18. See Barker, *Artemisia Gentileschi*, 53.
19. See Barker, *Artemisia Gentileschi*, 68.
20. Barker, *Artemisia Gentileschi*, 71.
21. See Barker, *Artemisia Gentileschi*, 75–76.
22. See Barker, *Artemisia Gentileschi*, 79.
23. See Gentileschi, *Lives of Artemisia Gentileschi*, 14.
24. Desiree Zenowich, "Getty Museum Conserves Recently Rediscovered Painting by Artemisia Gentileschi," Getty, updated December 14, 2023, www.getty.edu/news/getty -museum-conserves-recently-rediscovered-painting-by -artemisia-gentileschi.
25. Gentileschi, *Lives of Artemisia Gentileschi*, 15–17.
26. Guido Alfani, "Plague in Seventeenth-Century Europe and the Decline of Italy: An Epidemiological Hypothesis," *European Review of Economic History* 17, no. 4 (November 2013): 408–30.
27. Artemisia Gentileschi, from a letter to her patron Don Antonio Ruffo, November 13, 1649, in H. W. Janson and Anthony F. Janson, *History of Art*, 6th ed. (New York: Abrams, 2001), 627.

Notes **233**

28. See Mieke Bal, ed., *The Artemisia Files: Artemisia Gentileschi for Feminists and Other Thinking People* (Chicago: University of Chicago Press, 2005), 65.
29. See Barker, *Artemisia Gentileschi*, 43.
30. Quoted in Barker, *Artemisia Gentileschi*, 79.
31. See Garrard, *Artemisia Gentileschi*, 365.
32. Interview with Elissa Weichbrodt.
33. Garrard, *Artemisia Gentileschi*, 97.
34. Ripa said painting should be represented as "a beautiful woman, with full black hair, disheveled, and twisted in various ways, with arched eyebrows that show imaginative thought, the mouth covered with a cloth tied behind her ears, with a chain of gold at her throat from which hangs a mask, and has written in front 'imitation'" (Anna Reynolds, Lucy Peter, and Martin Clayton, *Portrait of the Artist* [London: Royal Collection Trust, 2016], 178).
35. From Cesare Ripa's description of the allegory of painting.
36. Garrard, *Artemisia Gentileschi*, 96.
37. Interview with Elissa Weichbrodt.

Chapter 5: Keep Them Together

1. Graham Reynolds, *Turner* (New York: Oxford University Press, 1969), 130.
2. Reynolds, *Turner*, 129–30.
3. See Reynolds, *Turner*, 170.
4. Jean Selz, *Turner* (Norwalk, CT: Easton, 1987), 8.
5. See Reynolds, *Turner*, 43.
6. Eric Shanes, *Young Mr. Turner: The First Forty Years, 1775–1815* (New Haven, CT: Yale University Press, 2016), 27.
7. See Reynolds, *Turner*, 44.
8. Selz, *Turner*, 88.
9. Lawrence Gowing, *Turner: Imagination and Reality* (New York: Museum of Modern Art, 1966), 7.
10. See Selz, *Turner*, 12.
11. See Reynolds, *Turner*, 10.
12. Gowing, *Turner: Imagination and Reality*, 9.
13. See Reynolds, *Turner*, 14.

234 Van Gogh Has a Broken Heart

14. Selz, *Turner*, 25.
15. Quoted in Selz, *Turner*, 25.
16. Quoted in Selz, *Turner*, 93.
17. Quoted in Reynolds, *Turner*, 182–83.
18. See Reynolds, *Turner*, 183.
19. See Reynolds, *Turner*, 90.
20. Reynolds, *Turner*, 191.
21. Reynolds, *Turner*, 53.
22. Quoted in Gowing, *Turner: Imagination and Reality*, 42.
23. See Reynolds, *Turner*, 62.
24. See Selz, *Turner*, 18.
25. See Selz, *Turner*, 45.
26. Reynolds, *Turner*, 153.
27. See Reynolds, *Turner*, 67.
28. See Reynolds, *Turner*, 66.
29. See Reynolds, *Turner*, 56.
30. Quoted in Reynolds, *Turner*, 110.
31. Quoted in Reynolds, *Turner*, 110.
32. See Reynolds, *Turner*, 112.
33. See Reynolds, *Turner*, 109–10.
34. See Selz, *Turner*, 48.
35. Martin R. F. Butlin and Mary Chamot, "J. M. W. Turner," *Encyclopedia Britannica*, last updated April 21, 2024, www .britannica.com/biography/J-M-W-Turner.
36. Selz, *Turner*, 67, 69.
37. See Reynolds, *Turner*, 24.
38. See Reynolds, *Turner*, 120.
39. See Selz, *Turner*, 66.
40. Selz, *Turner*, 69–70.
41. Selz, *Turner*, 53–54.
42. Selz, *Turner*, 55–56.
43. See Reynolds, *Turner*, 112.
44. Quoted in Selz, *Turner*, 61.
45. Quoted in Reynolds, *Turner*, 74.
46. Gowing, *Turner: Imagination and Reality*, 7.
47. Quoted in Selz, *Turner*, 48.
48. See Reynolds, *Turner*, 115.

Notes 235

49. Selz, *Turner*, 62.
50. See Reynolds, *Turner*, 100.
51. Anthony Bailey, *Standing in the Sun: A Life of J. M. W. Turner* (New York: Abrams, 2013), 286.
52. Reynolds, *Turner*, 144.
53. Gowing, *Turner: Imagination and Reality*, 42.
54. Bailey, *Standing in the Sun*, 288.
55. Quoted in Bailey, *Standing in the Sun*, 297.
56. Quoted in Reynolds, *Turner*, 144, italics in original.
57. See Martin Butlin, *Turner 1775–1851* (London: Tate Gallery Publications, 1974), 16.
58. See Selz, *Turner*, 5.
59. Andrew Wilton and T. J. Barringer, *American Sublime: Landscape Painting in the United States, 1820–1880* (Princeton, NJ: Princeton University Press, 2002), 42.
60. See Reynolds, *Turner*, 203.
61. See Reynolds, *Turner*, 187.
62. Quoted in Reynolds, *Turner*, 206.
63. Ian Shank, "What You Need to Know about J. M. W. Turner, Britain's Great Painter of Tempestuous Seas," Artsy, April 27, 2018, www.artsy.net/article/artsy-editorial-jmw-turner-britains -great-painter-tempestuous-seas.
64. Quoted in Bailey, *Standing in the Sun*, 399.
65. Reynolds, *Turner*, 205.
66. Quoted in Reynolds, *Turner*, 206.
67. Shank, "What You Need to Know."
68. Quoted in Reynolds, *Turner*, 207.
69. Quoted in Gowing, *Turner: Imagination and Reality*, 31.
70. See Butlin and Chamot, "J. M. W. Turner," 804.
71. Selz, *Turner*, 8.
72. Reynolds, *Turner*, 178.
73. Mike Cosper, "Bonus Episode: A Conversation with Dan Allender," *The Rise and Fall of Mars Hill* podcast, episode 18, August 26, 2022, www.christianitytoday.com/ct/podcasts/rise -and-fall-of-mars-hill/bonus-episode-conversation-with-dan -allender.html.
74. Gowing, *Turner: Imagination and Reality*, 7.

236 Van Gogh Has a Broken Heart

Chapter 6: A Sort of Delightful Horror

1. Quoted in Andrew Wilton and T. J. Barringer, *American Sublime: Landscape Painting in the United States, 1820–1880* (Princeton, NJ: Princeton University Press, 2002), 14.
2. Quoted in Fitz Hugh Ludlow, *The Heart of the Continent: A Record of Travel across the Plains and in Oregon with an Examination of the Mormon Principle* (New York: Hurd and Houghton, 1870), 130–31.
3. Quoted in Wilton and Barringer, *American Sublime*, 234.
4. John Updike, *Still Looking: Essays on American Art* (New York: Knopf, 2005), 27.
5. Trewin Copplestone, *The Hudson River School* (New York: Gramercy, 1999), 22.
6. Copplestone, *Hudson River School*, 15.
7. Copplestone, *Hudson River School*, 15.
8. Copplestone, *Hudson River School*, 27.
9. Wilton and Barringer, *American Sublime*, 42.
10. Updike, *Still Looking*, 41.
11. William Gilpin, *Three Essays: On Picturesque Beauty; On Picturesque Travel; and On Sketching Landscape*, 2nd ed. (London: Blamire, 1794), 6.
12. Wilton and Barringer, *American Sublime*, 13.
13. Edmund Burke, *A Philosophical Inquiry into the Origins of Our Ideas of the Sublime and the Beautiful* (1757; repr., New York: Harper, 1863), 112–13.
14. Burke, *Philosophical Inquiry*, 51.
15. Burke, *Philosophical Inquiry*, 168.
16. Immanuel Kant, *Critique of Judgement* (New York: Oxford University Press, 2007), 88.
17. See Wilton and Barringer, *American Sublime*, 31.
18. See Updike, *Still Looking*, 41.
19. Copplestone, *Hudson River School*, 47–48.
20. Wilton and Barringer, *American Sublime*, 31.
21. Wilton and Barringer, *American Sublime*, 17.
22. *"A Storm in the Rocky Mountains, Mt. Rosalie,"* Brooklyn Museum, www.brooklynmuseum.org/opencollection/objects /1558, accessed January 2, 2024.

Notes **237**

23. Updike, *Still Looking*, 43.
24. Updike, *Still Looking*, 43.
25. See Wilton and Barringer, *American Sublime*, 33.
26. Wilton and Barringer, *American Sublime*, 33.
27. George Catlin, *Letters and Notes on the Manners, Customs, and Condition of the North American Indians* (London: George Catlin, 1841), 256.
28. Talia Boyd, "Native Perspectives: Land Ownership," Grand Canyon Trust, June 29, 2021, www.grandcanyontrust.org/blog /native-perspectives-land-ownership.
29. Wilton and Barringer, *American Sublime*, 49.
30. Quoted in Wilton and Barringer, *American Sublime*, 14.
31. Exodus 32:13.
32. See Exodus 32:15–20.
33. Exodus 33:13.
34. Exodus 33:14.
35. Exodus 33:16.
36. Exodus 33:20–23.
37. See Exodus 34:1–9.
38. See Exodus 34:29–35.
39. Perhaps a little bit of pun intended . . .
40. See John 16:33.
41. See Hebrews 10:31.

Chapter 7: The Yellow House

1. "656: To Theo van Gogh. Arles, Monday, 6 August 1888," Vincent van Gogh: The Letters, https://vangoghletters.org/vg /letters/let656/letter.html, accessed January 2, 2024.
2. On October 23 in Arles, France, the sun rises at 8:05 a.m.
3. Martin Gayford, *The Yellow House: Van Gogh, Gauguin, and Nine Turbulent Weeks in Arles* (New York: Little, Brown, 2009), 2.
4. Julius Meier-Graefe, *Vincent van Gogh: A Biographical Study* (London: Medici Society, 1922), 112.
5. See Derek Fell, *Van Gogh's Women: His Love Affairs and Journey into Madness* (2004; repr., London: Pavilion, 2015), 130.
6. Gayford, *Yellow House*, 3.

7. Quoted in Debora Silverman, *Van Gogh and Gauguin: The Search for Sacred Art* (New York: Farrar, Straus and Giroux, 2000), 32.
8. Quoted in Silverman, *Van Gogh and Gauguin*, 42.
9. Quoted in Gayford, *Yellow House*, 20–21, italics in original.
10. Gayford, *Yellow House*, 12.
11. Quoted in Fell, *Van Gogh's Women*, 132.
12. Quoted in Gayford, *Yellow House*, 9.
13. Gayford, *Yellow House*, 10.
14. See Fell, *Van Gogh's Women*, 124–25.
15. See Silverman, *Van Gogh and Gauguin*, 270–71.
16. See Fell, *Van Gogh's Women*, 134.
17. Fell, *Van Gogh's Women*, 135.
18. Quoted in Meier-Graefe, *Vincent van Gogh*, 29.
19. Quoted in Gayford, *Yellow House*, 271.
20. Silverman, *Van Gogh and Gauguin*, 271.
21. See Fell, *Van Gogh's Women*, 137.
22. Quoted in Gayford, *Yellow House*, 275.
23. See Martin Bailey, *The Sunflowers Are Mine: The Story of Van Gogh's Masterpiece* (London: White Lion, 2019), 83.
24. Quoted in Gayford, *Yellow House*, 278.
25. See Fell, *Van Gogh's Women*, 138.
26. See Gayford, *Yellow House*, 278.
27. See Meier-Graefe, *Vincent van Gogh*, 103.
28. Gayford, *Yellow House*, 284.
29. Quoted in Gayford, *Yellow House*, 285.
30. See Fell, *Van Gogh's Women*, 138.
31. See Gayford, *Yellow House*, 286.
32. See Gayford, *Yellow House*, 286.
33. Gayford, *Yellow House*, 278.
34. See Silverman, *Van Gogh and Gauguin*, 304.
35. Gayford, *Yellow House*, 281–82, parentheses in original.
36. See Fell, *Van Gogh's Women*, 138–39.
37. Quoted in Gayford, *Yellow House*, 287.
38. Quoted in Gayford, *Yellow House*, 290.
39. See Bailey, *Sunflowers Are Mine*, 84.
40. See Meier-Graefe, *Vincent van Gogh*, 102.

Notes 239

41. Meier-Graefe, *Vincent van Gogh*, 40.
42. Meier-Graefe, *Vincent van Gogh*, 41.

Chapter 8: Cultivate Your Own Half Acre

1. See "American Chronicles: The Art of Norman Rockwell (Remastered)," YouTube, December 12, 2017, www.youtube.com /watch?v=qcV-b2aSt_I.
2. "American Chronicles."
3. Christopher Finch, *102 Favorite Paintings by Norman Rockwell* (New York: Crown, 1978), 11.
4. See Jim Windolf, "Keys to the Kingdom," *Vanity Fair*, January 2, 2008, www.vanityfair.com/news/2008/02/indianajones200802.
5. Cited in "American Chronicles."
6. Quoted in Arthur Leighton Guptill, *Norman Rockwell, Illustrator* (New York: Watson-Guptill, 1970), x.
7. Christopher Finch, *Norman Rockwell's America* (New York: Abrams, 1985), 42.
8. Quoted in Guptill, *Norman Rockwell, Illustrator*, ix.
9. Frederick Buechner, *Beyond Words: Daily Readings in the ABC's of Faith*. San Francisco: HarperSanFrancisco, 2009), 139.
10. *Breaking Home Ties* is my favorite Norman Rockwell painting.
11. Quoted in Jack Doyle, "Rockwell and Race, 1963–1968," PopHistoryDig.com, September 22, 2011, https://pophistorydig .com/topics/rockwell-and-race-1963-1968.
12. Quoted in History Nerds, *The History of America* (Vienna, VA: History Nerds, 2021), 107.
13. Abisola Jegede, "Norman Rockwell and Race: Complicating Rockwell's Legacy," Washington University Libraries, November 23, 2016, https://library.wustl.edu/news/norman-rockwell-and -race-complicating-rockwells-legacy.
14. Quoted in Doyle, "Rockwell and Race."
15. Norman Rockwell Museum, *"Boy in a Dining Car, 1946,"* https:// prints.nrm.org/detail/260984/rockwell-boy-in-a-dining-car -1946, accessed January 2, 2024.
16. See Matthew 7:12.
17. Jegede, "Norman Rockwell and Race."
18. "Norman Rockwell: *Murder in Mississippi*," Norman Rockwell

240 Van Gogh Has a Broken Heart

Museum, www.nrm.org/2020/06/norman-rockwell-murder-in
-mississippi, accessed January 2, 2024.

19. "Norman Rockwell: *Murder in Mississippi*."
20. Doyle, "Rockwell and Race."
21. "Norman Rockwell: *Murder in Mississippi*," parentheses in
 original.
22. "Norman Rockwell: *Murder in Mississippi*."
23. Norman Rockwell Museum, *"Murder in Mississippi,"* https://
 prints.nrm.org/detail/499705/rockwell-murder-in-mississippi
 -1965, accessed January 2, 2024.
24. Jenna Varner, "Rockwell Painting Exposes 'Murder in
 Mississippi,'" Journalism of Freedom Summer, February 2014,
 https://journalismoffreedomsummer.files.wordpress.com/2014
 /02/rockwell-painting-exposes-_murder-in-mississippi_1.pdf.
25. Quoted in Varner, "Rockwell Painting Exposes 'Murder in
 Mississippi.'"
26. Quoted in Guptill, *Norman Rockwell, Illustrator*, xi.
27. Quoted in Doyle, "Rockwell and Race."

Chapter 9: Through a Glass Darkly

1. Phyllis Tuchman, "Blind Time," in *The Persistence of Vision:
 Early and Late Works by Artists with Macular Degeneration*
 (Cincinnati: University of Cincinnati Press: (n.d.), 11; see https://
 visionandartproject.org/about-us/publications.
2. Quoted in Gail Feigenbaum et al., *Degas and New Orleans:
 A French Impressionist in America* (New Orleans: New Orleans
 Museum of Art in conjunction with Ordrupgaard, 1999), 126.
3. Daniel Halévy, *Degas parley* [English translation, *My Friend
 Degas*] (Middletown, CT: Wesleyan University Press, 1964).
4. See James G. Ravin and Christie A. Kenyon, "Degas' Loss of
 Vision: Evidence for a Diagnosis of Retinal Disease," *Survey
 of Ophthalmology* 39, no. 1 (July–August 1994): 57–64, www
 .surveyophthalmol.com/article/S0039-6257(05)80045-1/fulltext.
5. Michael F. Marmor, *Degas through His Own Eyes: Visual
 Disability and the Late Style of Degas* (Paris: Somogy éditions
 d'art, 2002), 66.
6. Quoted in Zeynel A. Karcioglu, "Did Edgar Degas Have an

Inherited Retinal Degeneration?" *Ophthalmic Genetics* 28, no. 2 (June 2007): 51–55, https://pubmed.ncbi.nlm.nih.gov/17558845.

7. Quoted in Marmor, *Degas through His Own Eyes*, 66.
8. Quoted in Marmor, *Degas through His Own Eyes*, 66.
9. Quoted in Marmor, *Degas through His Own Eyes*, 67.
10. Quoted in Marmor, *Degas through His Own Eyes*, 67.
11. Quoted in Marmor, *Degas through His Own Eyes*, 67.
12. See Marmor, *Degas through His Own Eyes*, 13.
13. Zeynel Karcioglu, "Edgar Degas' Light Sensitivity and Its Effects on His Art," *Hektoen International: A Journal of Medical Humanities*, Spring 2019, https://hekint.org/2019/04/12/edgar-degas-light-sensitivity-and-its-effects-on-his-art.
14. Marmor, *Degas through His Own Eyes*, 100.
15. Marmor, *Degas through His Own Eyes*, 67.
16. Anna Gruener, "Degas' 'Exercise of Circumvention,'" *British Journal of General Practice* 64, no. 622 (May 2014): 246–47, www.ncbi.nlm.nih.gov/pmc/articles/PMC4001143.
17. Marmor, *Degas through His Own Eyes*, 100, italics in original.
18. Quoted in Karcioglu, "Edgar Degas' Light Sensitivity."
19. Marmor, *Degas through His Own Eyes*, 100, italics in original.
20. "Jimmy Abegg," Locals at Sewanee, https://localsatsewanee.com/pages/artist-jimmyabegg, accessed January 2, 2024.
21. "Jimmy Abegg," *Nashville Arts Magazine*, August 2011, https://nashvillearts.com/2011/08/jimmy-abegg.
22. Jessica Bliss, "Nashville Artist Losing His Eyesight, Not His Creative Spirit," *The Tennessean*, February 20, 2016, www.tennessean.com/story/life/2016/02/20/nashville-artist-losing-his-eyesight-not-his-creative-spirit/80310910.
23. The majority of this quote is from an interview I had with Jimmy on the afternoon of December 5, 2022; see also "About Jimmy," Jimmy Abegg Art, https://jimmyabegg.com/pages/about-us.
24. Bliss, "Nashville Artist."
25. Tuchman, "Blind Time," 5.
26. Quoted in Tuchman, "Blind Time," 5–6.
27. A'Dora Phillips and Brian Schumacher, introductory essay in *The Persistence of Vision: Early and Late Works by Artists with Macular Degeneration* (Cincinnati: University of Cincinnati Press, (n.d.), 9.

28. Phillips and Schumacher, introductory essay, 11.
29. Tuchman, "Blind Time," 12.
30. Interview with Jimmy.
31. Interview with Jimmy.
32. Annie Dillard, *Pilgrim at Tinker Creek* (New York: Harper & Row, 1985), 25.
33. Dillard, *Pilgrim at Tinker Creek*, 28.
34. Dillard, *Pilgrim at Tinker Creek*, 26–27.
35. Dillard, *Pilgrim at Tinker Creek*, 29.
36. From my interview with Jimmy Abegg on December 5, 2022.
37. Dillard, *Pilgrim at Tinker Creek*, 30.
38. Dillard, *Pilgrim at Tinker Creek*, 30.

Chapter 10: Our Personal Collections

1. Jon Henley, "Priceless Art Haul Destroyed by Thief's Mother," *Guardian*, May 15, 2002, www.theguardian.com/world/2002/may/16/worlddispatch.france.
2. John Hooper, "Connoisseur Turned Crook Who Plundered Europe's Galleries for the Simple Love of Art," *Guardian*, February 5, 2003, www.theguardian.com/world/2003/feb/05/arts.artsnews2.
3. Michael Finkel, "How to Steal a Masterpiece: Advice from the World's Greatest Art Thief," *Time*, June 14, 2023, https://time.com/6286931/how-to-steal-a-masterpiece-advice-from-the-worlds-greatest-art-thief.
4. Finkel, "How to Steal a Masterpiece."
5. Michael Finkel, "The Secrets of the World's Greatest Art Thief," *GQ*, February 28, 2019, www.gq.com/story/secrets-of-the-worlds-greatest-art-thief.
6. From the tombstone on the wall beside Gerrit Lundens's copy of Rembrandt's *The Night Watch*, on display in the Rijksmuseum, Amsterdam.
7. Caroline Goldstein, "Rembrandt's Revered 'Night Watch' Was Cut Up to Fit through a Door. With AI, You Can See It Whole for the First Time in 300 Years," ArtNet, June 23, 2021, https://news.artnet.com/art-world/operation-night-watch-1982686#.

Notes 243

8. From the display on the Rijksmusem wall beside Rembrandt's *The Night Watch*.
9. See 2 Kings 25:7.
10. Jeremiah 31:3–4 NIV.
11. Peter Schjeldahl, "The Art of Dying," *New Yorker*, December 16, 2019, www.newyorker.com/magazine/2019/12/23/the-art-of-dying-peter-schjeldahl.
12. Lamentations 3:19–24.
13. *ESV Study Bible*, introduction to Lamentations.
14. *ESV Study Bible*, introduction to Lamentations.
15. C. H. Spurgeon, "Taking Care of Others," *Sword and Trowel*, no. 2 (2008), https://metropolitantabernacle.org/articles/taking-care-of-others.
16. See Russ Ramsey, *Struck: One Christian's Reflections on Encountering Death* (Downers Grove, IL: InterVarsity, 2017).
17. "634: To Theo van Gogh. Arles, on or about Thursday, 28 June 1888," Vincent van Gogh: The Letters, https://vangoghletters.org/vg/letters/let634/letter.html, author's translation.

Appendix 1: I Don't Like Donatello, and You Can Too

1. I wonder how you, dear reader, feel about this little anecdote after having made it to this point in this book. Does *Mona Lisa* truly judge the art student? Or is the emperor not wearing any clothes? It's a great question to ponder, particularly while reading this appendix about what to do if you don't like something everyone else seems to fawn over.
2. Alan Gartenhaus, "'Liking' versus 'Appreciating'—An Important Distinction," *Docent Educator* 13, no. 1 (Autumn 2003): 2–3, www.museum-ed.org/liking-versus-appreciating-an-important-distinction.

Appendix 2: A Beginner's Guide to Symbols in Art

1. Paul Crenshaw, Rebecca Tucker, and Alexandra Bonfante-Warren, *Discovering the Great Masters: The Art Lover's Guide to Understanding Symbols in Paintings* (Milford, CT: Universe, 2009), 13.

244 Van Gogh Has a Broken Heart

2. "*The Son of Man*, 1946 by Rene Magritte," ReneMagritte.com, www
.renemagritte.org/the-son-of-man.jsp, accessed January 2, 2024.
3. See Crenshaw, Tucker, and Bonfante-Warren, *Discovering the Great Masters*, 29.
4. Recorded by the author from Ned Bustard's lecture, "Secret Decoder Rings: The Use of Symbolism in Art," delivered at the Rabbit Room's Hutchmoot conference on October 7, 2022, in Franklin, Tennessee.
5. I found several of the examples listed in this appendix in Emily Snow's helpful article "10 Common Symbols in Still-Life Paintings and What They Mean," Collector, March 21, 2021, www.thecollector.com/still-life-paintings-what-they-mean.

Appendix 3: Lost, Stolen, and Recovered Art

1. Russ Ramsey, *Rembrandt Is in the Wind: Learning to Love Art through the Eyes of Faith* (Grand Rapids: Zondervan, 2022), 84.
2. See Matthew 26:11.